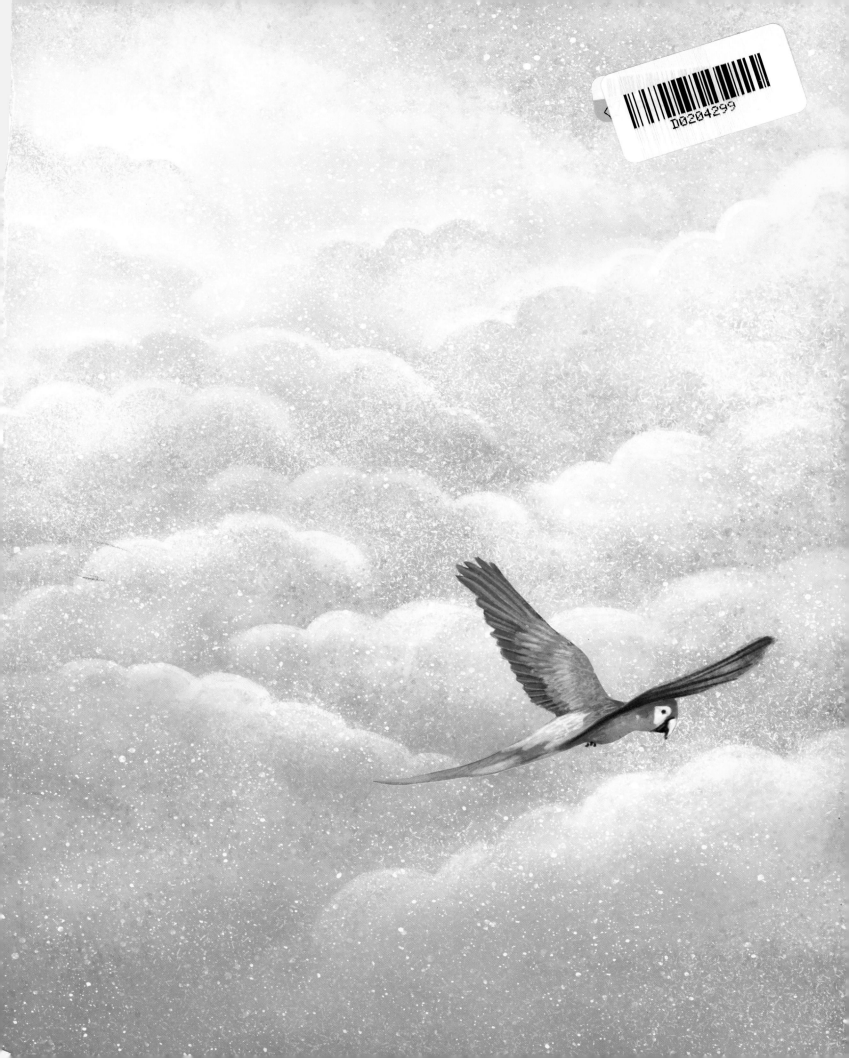

BIRDS OF THE WORLD

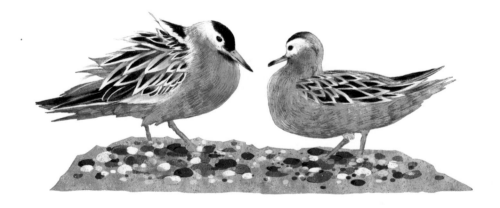

Black Dog & Leventhal Publishers
Hachette Book Group
1290 Avenue of the Americas
New York, NY 10104

www.hachettebookgroup.com
www.blackdogandleventhal.com

Originally published in 2019 by NuiNui in Italy.

First U.S. Edition: July 2020

Black Dog & Leventhal Publishers is an imprint of Perseus Books, LLC, a
subsidiary of Hachette Book Group, Inc. The Black Dog & Leventhal
Publishers name and logo are trademarks of Hachette Book Group, Inc.

The publisher is not responsible for websites (or their content) that are
not owned by the publisher.

The Hachette Speakers Bureau provides a wide range of authors for
speaking events. To find out more, go to www.HachetteSpeakersBureau.com
or call (866) 376-6591.

Print book interior design by Marissa Raybuck.

LCCN: 2019949896

ISBNs: 978-0-7624-9810-9 (paper over board),
978-0-7624-9811-6 (ebook), 978-0-7624-9816-1 (ebook),
978-0-7624-9817-8 (ebook)

Printed in Thailand

IM

10 9 8 7 6 5 4 3 2 1

BIRDS OF THE WORLD

250 OF EARTH'S MOST MAJESTIC CREATURES

CESARE DELLA PIETÀ

ILLUSTRATIONS BY SHISHI NGUYEN

BLACK DOG
& LEVENTHAL
PUBLISHERS
NEW YORK

CONTENTS

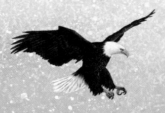
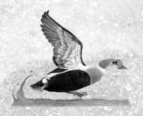

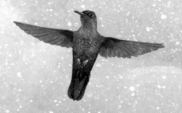

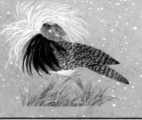

Birds have always held a great fascination for us humans. We envy their flying skills, we're moved by the beautiful melodies of birdsong, and we admire the splendid colors of their plumage.

There are about 10,000 different bird species on Earth today. They live in every type of environment—from deserts to the ice of the South Pole, from the open sea to impenetrable tropical forests, from marshes to mountain peaks. There are even birds in cities, like pigeons and sparrows, that live in close contact with us. From the largest—the ostrich, five feet (1.5 m) tall and weighing some 344 pounds (156 kg)—to the smallest—the tiny rufous hummingbird, which lives in the Alps and in Africa, is three to four inches (8–10 cm) and weighs only 0.10–0.15 ounce (2.9–3.9 g)—they vary enormously in appearance, habits, and behavior. There are birds like penguins or ostriches that have lost the ability to fly, some like great albatrosses that spend most of their lives in flight and land only to nest, and others like swifts that can even fall asleep while gliding through the air. Many migrate at the end of summer toward more hospitable lands, making trips as long as tens of thousands of miles. Others remain in their territories all year round, managing to survive the coldest winters.

It would be impossible to squeeze the tale of all this extraordinary variety into a single book. So we have chosen 15 different geographical regions that present different environments, from the Sahara Desert to the impenetrable forests of New Guinea, from the mountains of Europe to the marshes of South America, and with each one we will introduce you to some of the typical birds that live there, and explain the most important features of their appearance and lives.

The following pages will be a journey through these very different environments, to discover the wonderful variety of the winged world. But first, let's get to know a little more about birds—the way they're built, and what features they all have in common.

NORTH AMERICA

CENTRAL AMERICA

ATLANTIC OCEAN

SOUTH AMERICA

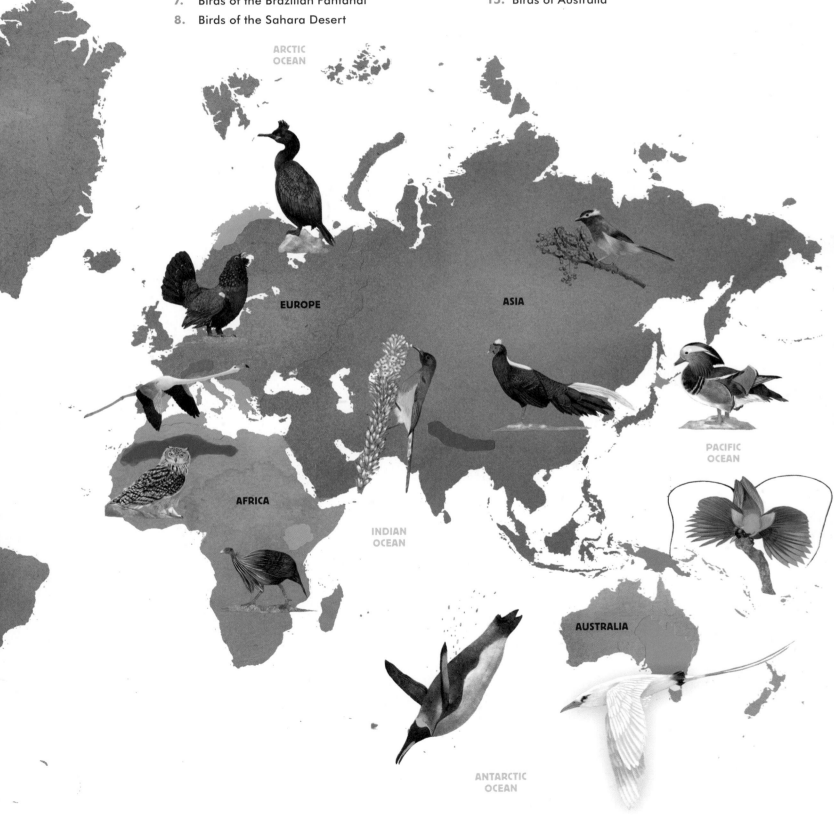

ARCTIC
OCEAN

EUROPE

ASIA

AFRICA

INDIAN
OCEAN

PACIFIC
OCEAN

AUSTRALIA

ANTARCTIC
OCEAN

Birds come in every shape and size, but there are some features they all have in common. The most important common feature is that their front limbs turn into wings. Even birds that don't fly have wings. The bodies of birds are covered with down and feathers, which is unique in the entire animal kingdom. They all have a beak— covered in a thin sheath of keratin called the rhamphotheca––which includes the bones of the jaw, and they have no teeth. They also all reproduce by means of eggs, which do not fully develop inside the mother's body like mammal babies, but instead are covered with a hard shell and have to be brooded until they hatch.

Now let's imagine that the feathers and flesh were removed from the body of a bird and we could have a look at its skeleton. One thing that's immediately clear is that it's very lightweight, which is what allows birds to fly. To reduce their weight even more, some bird bones are hollow, which means they are empty inside. The sternum or breastbone, on the other hand, grows very large because the powerful muscles that move the wings will need to be attached to it.

Overall, bird skeletons look quite different from those of most mammals, but they actually are similar to those of dinosaurs. In fact, birds are thought to be the descendants of small dinosaurs that first appeared on Earth 100 million years ago.

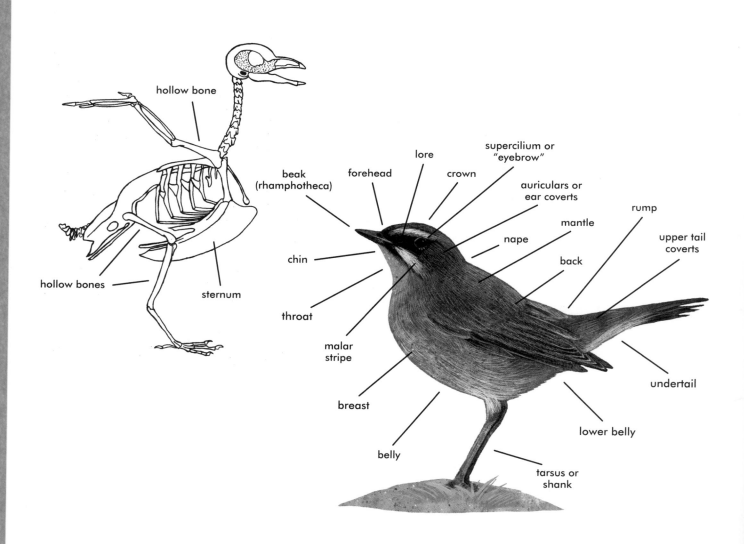

hollow bone

hollow bones

sternum

beak (rhamphotheca)

chin

throat

malar stripe

breast

belly

forehead

lore

crown

supercilium or "eyebrow"

auriculars or ear coverts

nape

mantle

back

rump

upper tail coverts

undertail

lower belly

tarsus or shank

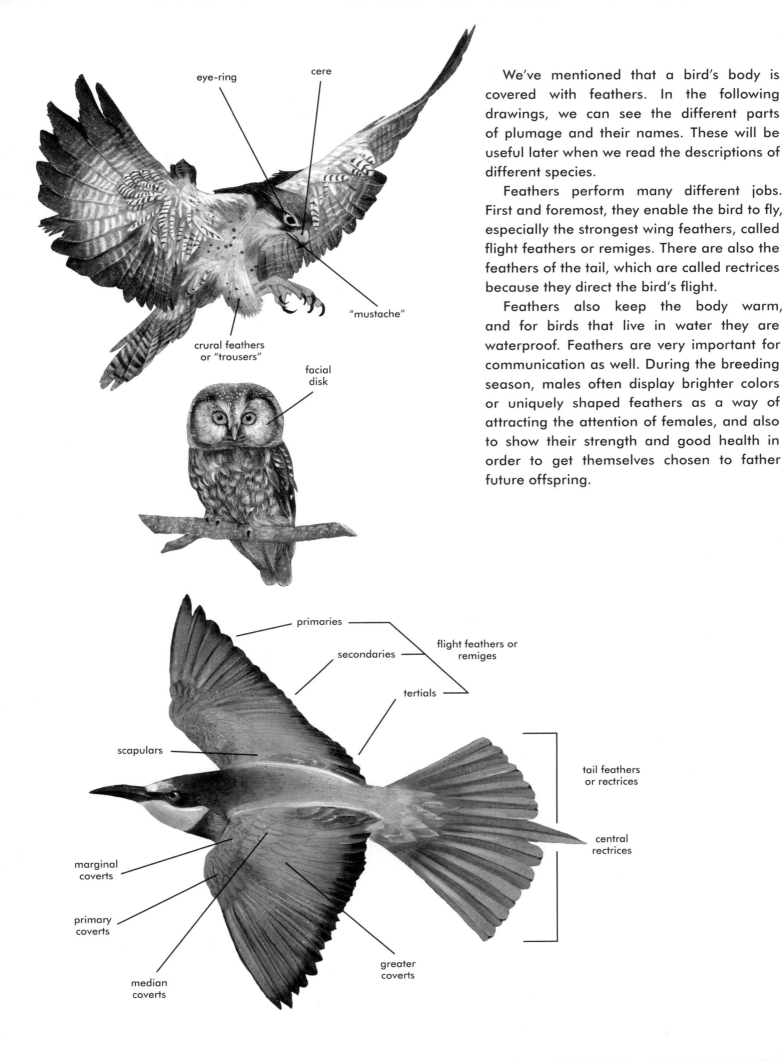

eye-ring

cere

"mustache"

crural feathers
or "trousers"

facial
disk

We've mentioned that a bird's body is covered with feathers. In the following drawings, we can see the different parts of plumage and their names. These will be useful later when we read the descriptions of different species.

Feathers perform many different jobs. First and foremost, they enable the bird to fly, especially the strongest wing feathers, called flight feathers or remiges. There are also the feathers of the tail, which are called rectrices because they direct the bird's flight.

Feathers also keep the body warm, and for birds that live in water they are waterproof. Feathers are very important for communication as well. During the breeding season, males often display brighter colors or uniquely shaped feathers as a way of attracting the attention of females, and also to show their strength and good health in order to get themselves chosen to father future offspring.

primaries

secondaries

flight feathers or
remiges

tertials

scapulars

tail feathers
or rectrices

central
rectrices

marginal
coverts

primary
coverts

median
coverts

greater
coverts

9

It's not just a bird's feathers, though, that have the task of communicating: In the breeding season, the males of some species also display areas of brightly colored bare skin (caruncles) or throat sacs.

Females often have much less showy plumage—a feature that makes them less visible when they are sitting on the nest to brood—but there are also many species in which males and females have similar coloring. In some cases, the females even have the more striking plumage and perform courtship displays. In these species, it is often the male that broods and raises the chicks.

The chicks, as we mentioned earlier, develop inside the egg—usually placed in a nest built by the parents, but sometimes simply placed in a hole, hollow, or even just on the ground. Depending on the species, when chicks hatch they may be naked and blind and completely dependent on their parents (in this case, they are said to be *nidicolous* or *altricial*), while others are already covered with down, have their eyes open, and are able to follow the parents around within a few hours (they are then called *nidifugous* or *precocial*).

Birds live in every kind of environment and use a wide range of resources, from seeds to fruits, from live prey to dead animals and garbage. In the course of evolution birds have developed the most advantageous features and behaviors to adapt to different living conditions. Observing the shape of the beak and feet often provides useful clues to understand the lifestyle of a particular species.

There are thick, sturdy beaks for cracking seeds; thin, pointed beaks for catching insects; daggerlike beaks for stabbing fish and frogs; sharp-tipped and razor-edged beaks for tearing prey apart; beaks as tough as chisels for drilling into tree trunks; and beaks like straws for sucking the nectar of flowers.

The shape of the legs and especially the feet tells us a lot about the environment a bird lives in and its way of life. Some have the very strong legs of a runner, or climber's feet with strong sharp claws for gripping tree trunks. Some have webbed feet for swimming or long toes to avoid sinking in the mud. Others have feather-covered feet like snowshoes for walking on snow or razor-sharp talons for catching living prey.

Every bird in this book will include a short description as well as its English name, its scientific name, and its size. A scientific name is made up of two words: The first one—the *generic* name—tells us the genus, which groups together several species with similar characteristics, and the second one—the *specific* name—tells us the individual species. These words are based on Latin, which was once the language that all scholars knew—a bit like English today. The scientific name is very important. The same bird can have very different names in all the different languages spoken on Earth, but the scientific name enables us to identify each one for certain because it is unique to each species.

You are now ready to set out on our journey to discover the wonderful world of birds!

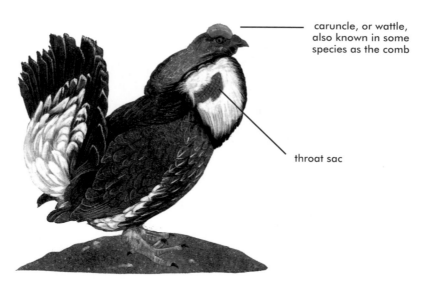

caruncle, or wattle, also known in some species as the comb

throat sac

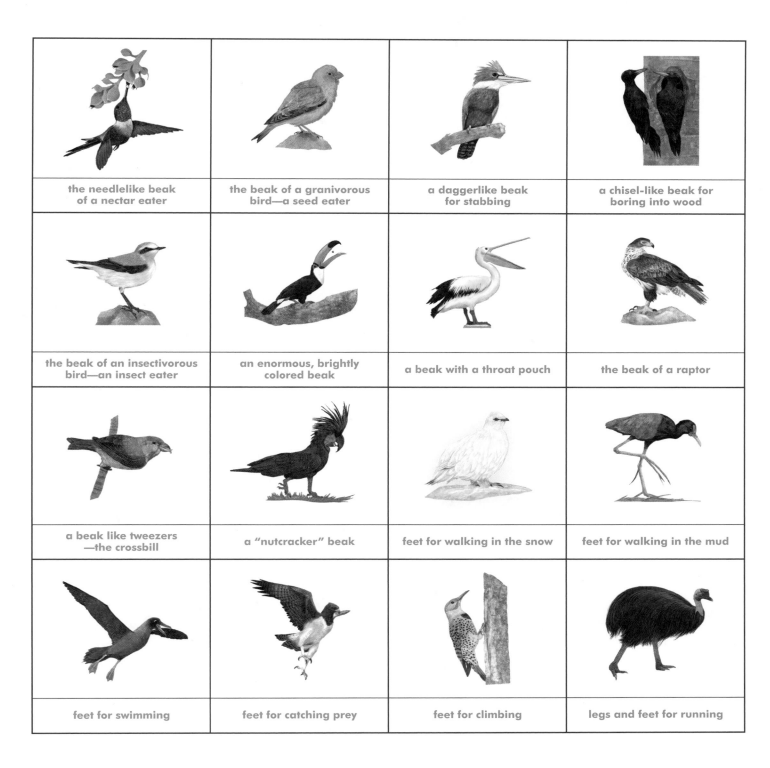

the needlelike beak of a nectar eater	the beak of a granivorous bird—a seed eater	a daggerlike beak for stabbing	a chisel-like beak for boring into wood
the beak of an insectivorous bird—an insect eater	an enormous, brightly colored beak	a beak with a throat pouch	the beak of a raptor
a beak like tweezers —the crossbill	a "nutcracker" beak	feet for walking in the snow	feet for walking in the mud
feet for swimming	feet for catching prey	feet for climbing	legs and feet for running

BIRDS OF THE MEDITERRANEAN AND ITS COASTS

EUROPE AND
AFRICA

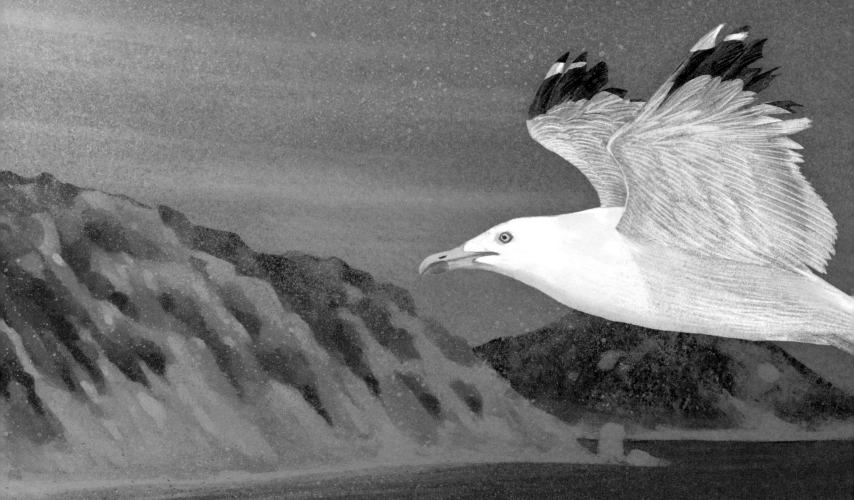

The Mediterranean is a landlocked sea, connected to the oceans only via two small openings: the Strait of Gibraltar, which links it to the Atlantic Ocean, and the Suez Canal, which links it to the Indian Ocean via the Red Sea. Its shores are densely populated with cities, towns, and ports, large and small, as well as the seaside resorts to which millions of tourists throng every summer. Despite this, nature still manages to offer a patchwork of different environments and picturesque scenery: cliffs overlooking the sea, long beaches of white sand, dunes covered with the scented shrubs of the maquis brushland, shoreline pine forests, and coastal lagoons.

There are many birds closely linked to these environments. Some are very numerous and widespread, such as the ubiquitous seagulls (in the drawing: the YELLOW-LEGGED GULL), always ready to take advantage of all the garbage that people throw away and leave lying around. Others are now rare and threatened with extinction, such as Bonelli's eagle, a large bird of prey that survives in a few mountain ranges, or the curious red-faced hermit ibis with its long tuft of feathers on the nape, of which only a few specimens remain. Every environment has its own particular guests. Out on the open sea you can admire the effortless flight of Scopoli's shearwater and the yelkouan or Mediterranean shearwater; in the coastal lagoons you can see great flamingos with their pink and purple plumage, or the black-winged stilt with its very long red legs. On the islands and the rocky islets nests Eleonora's falcon, which raises its chicks at the end of summer, when it can feed them on migratory birds that fly over the sea in great numbers. The Mediterranean maquis is home to many small, shy songbirds that are easier to hear when they sing in the thick of the bushes than they are to see out in the open. The colorful bee-eaters nest among the dunes, where they catch bees and wasps in flight, while in the coastal pine forests you can see the hoopoe with its large orange crest, or the green woodpecker announcing its presence with a cry almost like loud, cackling laughter.

1. ALPINE SWIFT
(TACHYMARPTIS MELBA)

This swift has brown and white plumage and lives both in the mountains and on the coast, where it uses cracks and little holes in the rocks to make its nest. Like all swifts, it has long, narrow wings in the shape of a sickle, a short tail, and very short legs with all four toes facing forward. It spends most of the day in the air, hunting mosquitoes, gnats, and small spiders carried by the wind, which it catches while flying with its beak open. At the end of summer it leaves the Mediterranean to spend the winter in Africa.

LENGTH: 8–9 inches (20–23 cm)
WEIGHT: 2.5–4.5 ounces (76–125 g)

Brown band across a white chest; short and very wide beak

1

2. BONELLI'S EAGLE
(AQUILA FASCIATA)

Bonelli's eagle is a medium-sized eagle that is agile and powerful in flight. Its wingspan exceeds five feet (1.5 m). Although it is a rare sight anywhere, it lives in mountainous and rocky areas around the Mediterranean. Its upper parts are fairly dark brown, with white spots on the back that form a poorly defined triangle, while the underside is white with dark streaks and the legs are covered with feathers. The flight and tail feathers are grayish with dark bars. Both sexes are similar in appearance, but the female is larger. Bonelli's eagle is a powerful and daring predator: Its main prey are wild rabbits, partridges, and pigeons, but it also attacks many other birds, such as the large heron.

LENGTH: 22–30 inches (55–75 cm)
WEIGHT: 3–5.5 pounds (1.5–2.5 kg)

3. COMMON RAVEN
(CORVUS CORAX)

The common raven is another species found both in the mountains and on the rocky coasts by the sea. Large and sturdy, it has black and iridescent plumage with a metallic sheen; its tarsi and large beak are also black. It has a wedge-shaped tail, long, broad wings, and a wingspan of up to five feet (1.5 m). It is powerful and acrobatic in flight. The raven is omnivorous, eating anything from waste and carrion to large insects, young birds, and small mammals. Males and females are similar in appearance, and pairs stay together for life.

LENGTH: 20–25 inches (52–64 cm)
WEIGHT: 2–3.5 pounds (900–1,560 g)

Strong, heavily built black beak; nostrils covered with bristle-like feathers; pointed feathers on chin and throat form a "beard"

2

Grayish beak with black tip; yellow cere; pale yellow eye (yellow orange in the female); yellow tarsi with long black claws

3

4. ELEONORA'S FALCON
(FALCO ELEONORAE)

Eleonora's falcon is named in honor of Queen Eleanor of Arborea, who issued the first laws to protect birds of prey in Sardinia in the 14th century. This is a slender falcon with long, narrow wings, a long tail, and two types of plumage: The lighter variety has slate-gray upper parts and reddish, streaked underparts, while the darker variety has entirely blackish-brown plumage. They nest in colonies on rocky cliff walls along the coast or on small uninhabited islands, raising chicks starting in the late summer, when they can feed them birds migrating over the sea. Several individuals will collaborate and hunt together. For the rest of the year they feed mainly on large flying insects, and they winter in Madagascar.

LENGTH: 14–17 inches (35–44 cm)

WEIGHT: 11–16 ounces (300–460 g)

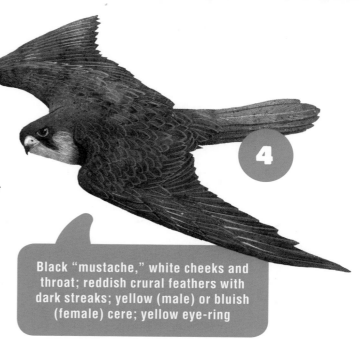

Black "mustache," white cheeks and throat; reddish crural feathers with dark streaks; yellow (male) or bluish (female) cere; yellow eye-ring

5. HERMIT IBIS OR NORTHERN BALD IBIS
(GERONTICUS EREMITA)

The hermit ibis or northern bald ibis has an unmistakable appearance. The plumage is black with shimmers of metallic green and purple on the wings and back; the head is naked, with reddish skin, and the beak and legs are also red. Long thin feathers form a collar and long tuft on the nape, which the bird can raise. Once widespread all around the Mediterranean, today the hermit ibis is almost extinct and only a few small colonies survive in Morocco. Reintroduction projects have been started in an effort to save the species, with individuals hatched in specialized centers and then released.

LENGTH: 28–31 inches (70–80 cm)

WEIGHT: 3–3.5 pounds (1.4–1.6 kg)

6. BLUE ROCK THRUSH
(MONTICOLA SOLITARIUS)

The blue rock thrush is slightly smaller than a blackbird and has a more slender body. The male has grayish-blue plumage, with a blue head and blue-black wings and tail; the female is grayish brown with hints of blue on the upper parts and lighter coloring on the underparts, which are patterned with pale spots giving the appearance of scales. It lives on rocky cliff walls but also in the ruins and walls of towers and castles, nesting in cracks in the rocks or in gaps in stone walls. It eats insects, spiders, earthworms, mollusks, and small reptiles, and in the summer and fall it also eats fruits and berries. It has a melodious, fluting song and sings both while perched and in flight.

LENGTH: 8–8.5 inches (20–21 cm)

WEIGHT: 1.5–2 ounces (47–63 g)

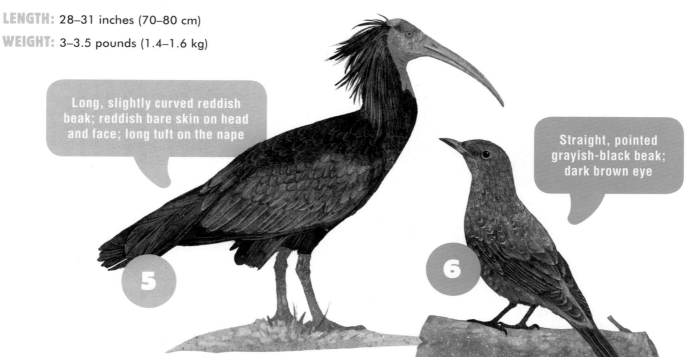

Long, slightly curved reddish beak; reddish bare skin on head and face; long tuft on the nape

Straight, pointed grayish-black beak; dark brown eye

7. SCOPOLI'S SHEARWATER
(CALONECTRIS DIOMEDEA)

Scopoli's shearwater is a bird with a squat body and long wings that spends its life out at sea, skimming the waves as it flies, constantly changing direction in search of fish and cephalopods (such as squid, octopus, and nautilus). It follows fishing boats to take advantage of the fish waste that gets dumped, and is also able to dive up to 50 feet (15 m) deep after its prey. The plumage is gray-brown on the upper parts and white on the throat and belly. It comes back to land only to nest on rocky and barren coasts or on islets; adults return to the nest to feed the chicks at night, so as not to reveal the location of the nest to winged predators, such as seagulls. It utters its plaintive call at night, which sounds almost like a baby crying.

LENGTH: 17–19 inches (44–49 cm)

WEIGHT: 1–1.5 pounds (544–738 g)

Yellowish hooked beak with a blackish band at the tip; tubular nostrils; pinkish or pale yellow legs

8. MEDITERRANEAN GULL
(ICHTHYAETUS MELANOCEPHALUS)

The Mediterranean gull is a medium-sized member of the gull family, distinguished in the breeding season by a shiny black cap against which two small white crescents stand out around the eye. These gulls nest in colonies on the shores of lagoons, salt marshes, and coastal lakes; the nest is a small depression lined with grasses, dried seaweed, and a few feathers. They feed on insects, larvae, fish, and even garbage. In winter they form large flocks that usually stay near the coasts.

LENGTH: 15–16 inches (37–40 cm)

WEIGHT: 8–13 ounces (220–380 g)

Black cap; white patch around the eye; fine red eye-ring; coral-red beak and legs

9. YELLOW-LEGGED GULL
(LARUS MICHAHELLIS)

The yellow-legged gull is a large and heavily built white bird with a gray back and gray wings. The terminal part of the primary flight feathers or remiges is black, with a white tip. These gulls are a common presence on the coast and in ports, but they also venture inland along rivers and on lakes and are to be found in the countryside and even in cities, where they now often nest. They are great opportunists and take advantage of every type of food available. They frequent landfills in search of garbage, ransack the nests of other birds to eat their eggs and chicks, follow fishing boats and ships to collect waste from the catch, hunt insects and small reptiles in the fields, and eat carrion on the beach or scavenge for roadkill.

LENGTH: 20–27 inches (52–68 cm)

WEIGHT: 1–3.5 pounds (550–1,600 g)

10. YELKOUAN SHEARWATER
(PUFFINUS YELKOUAN)

The yelkouan shearwater is a medium-sized bird with long wings. It spends most of its life in flight over the sea, eating fish, shellfish, and crustaceans that it catches on the surface of the water or by diving up to 100 feet (30 m) deep. It lands only to breed, nesting in large colonies on rocky island coasts, in holes, caves, or cracks between the boulders. Like other birds in the Procellariidae family, it has nostrils protected by tubular structures that contain glands that are able to eliminate excess salt.

LENGTH: 12–15 inches (30–38 cm)

WEIGHT: 12–17 ounces (330–480 g)

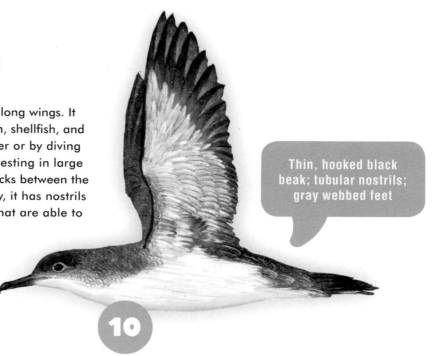

Thin, hooked black beak; tubular nostrils; gray webbed feet

Yellow beak with a red spot; yellow eye surrounded by a red circle; bright yellow legs with webbed feet

11. AUDOUIN'S GULL
(LARUS AUDOUINII)

This medium-sized gull nests exclusively on the coasts of the Mediterranean and northern Africa, where it occupies mainly rocky ridges and islets. Unlike most gulls, it does not venture inland or out onto the open sea but always stays close to the coast, where it catches mainly what are known as the "oily" fish, especially sardines and anchovies. Its plumage is white, with the back and upper surface of the wings light gray and the tips of the flight feathers black. Its distinguishing feature is the beak, which is dark red with a black patch toward the wend and a yellowish hooked tip.

LENGTH: 19–20 inches (48–52 cm)

WEIGHT: 1–1.5 pounds (451–770 g)

Dark red beak with black and yellow tip; black eye; edge of the eyelid is red; dark gray tarsi and feet

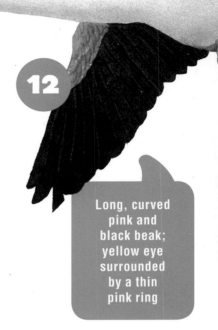

12. GREATER FLAMINGO
(PHOENICOPTERUS ROSEUS)

The flamingo is an unmistakable bird thanks to its size, its pinkish-white color, and its very long legs and neck. Flamingos frequent salt marshes and lagoons with shallow, brackish water, where they nest in colonies that can number as many as 1,000 pairs. They have a very particular way of feeding: Each flamingo walks slowly with its head submerged, gathering up water and mud in its big beak, and then uses its tongue like a pump to expel the water and keep back crustaceans, mollusks, and seeds. Thanks to its lamellae—thorny plates that form a sieve along the edges of the beak—the water and mud are filtered out while the tiny organisms are trapped. In flight, flamingos stretch out their legs and neck to their fullest extent, with eye-catching wings that stand out for their red coverts and black primaries.

LENGTH: 47–57 inches (120–145 cm)

WEIGHT: 4.5–9 pounds (2–4 kg)

Long, curved pink and black beak; yellow eye surrounded by a thin pink ring

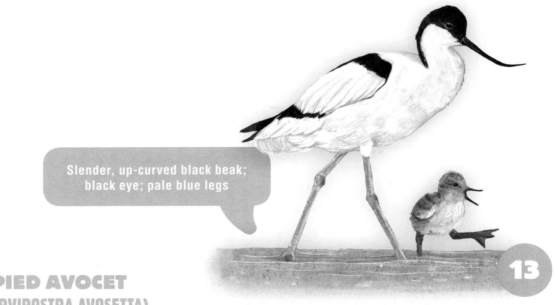

Slender, up-curved black beak; black eye; pale blue legs

13. PIED AVOCET
(RECURVIROSTRA AVOSETTA)

The avocet is a slender and elegant shore-dwelling bird with white and black plumage. Its head, back, shoulders, and back of the neck are black, as are its primary flight feathers, while the rest of the body is white. It has a very unusual and distinctive beak, thin and curved upward, which it uses to catch small crustaceans and aquatic insects by "sweeping" the surface of bodies of water or the mud at the bottom with a movement like a reaper wielding a scythe. Both sexes are similar in appearance, but the black plumage on the head is shinier in the male and the beak slightly longer and less curved. It frequents lagoons and pools of shallow, brackish water, and in winter it is also found on estuaries and mudflats left uncovered at low tide.

LENGTH: 17–18 inches (42–45 cm)

WEIGHT: 9–10 ounces (260–290 g)

14. BLACK-WINGED STILT
(HIMANTOPUS HIMANTOPUS)

The black-winged stilt is a medium-sized shore-dwelling bird with an unmistakable appearance, thanks to its black and white plumage and red legs, which are as long as its body and make it look as though it were walking on stilts. The back is glossy black in the male and dark brown in the female; the wings are black and there is often a black patch—usually larger in the male—on the crown of the head and on the neck. It feeds mainly on aquatic insects, small mollusks, and worms. The species nests in small colonies in swamps, lagoons, rice paddies, and salt marshes, and they migrate to spend the winter in sub-Saharan Africa.

LENGTH: 13–15 inches (34–38 cm)

WEIGHT: 5.5–7 ounces (160–200 g)

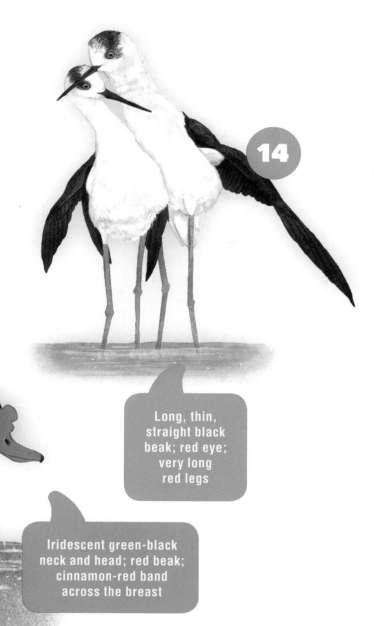

14

> Long, thin, straight black beak; red eye; very long red legs

15. COMMON SHELDUCK
(TADORNA TADORNA)

The common shelduck is a large member of the Anatidae family (ducks, geese, and swans) with intermediate characteristics between those of ducks and geese; it has eye-catching plumage, mainly black and white. It inhabits coastal marshes and brackish lagoons, where it nests in holes in the ground, often using the abandoned dens of foxes (which gives the bird its Italian name, *volpoca*—the fox-goose). The male is larger than the female, and during the breeding season can be distinguished by a red protuberance above the beak. Shelducks feed on water snails, crustaceans, worms, and waterweeds.

LENGTH: 23–26 inches (58–67 cm)

WEIGHT: male 2–3.5 pounds (830–1,500 g); female 1.5–3 pounds (600–1,250 g)

15

> Iridescent green-black neck and head; red beak; cinnamon-red band across the breast

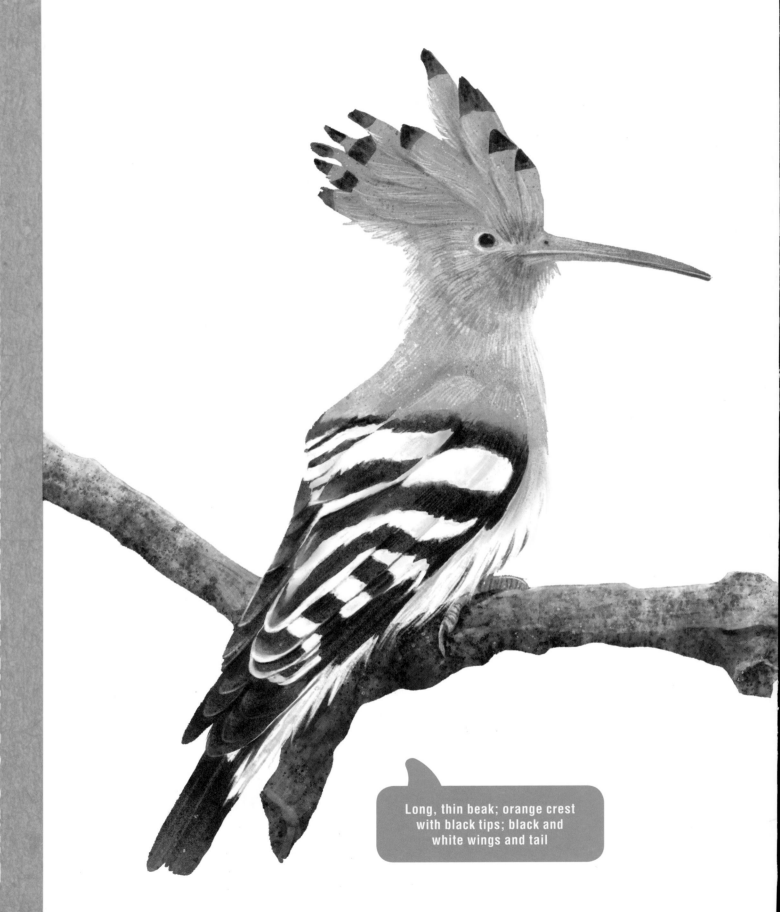

Long, thin beak; orange crest with black tips; black and white wings and tail

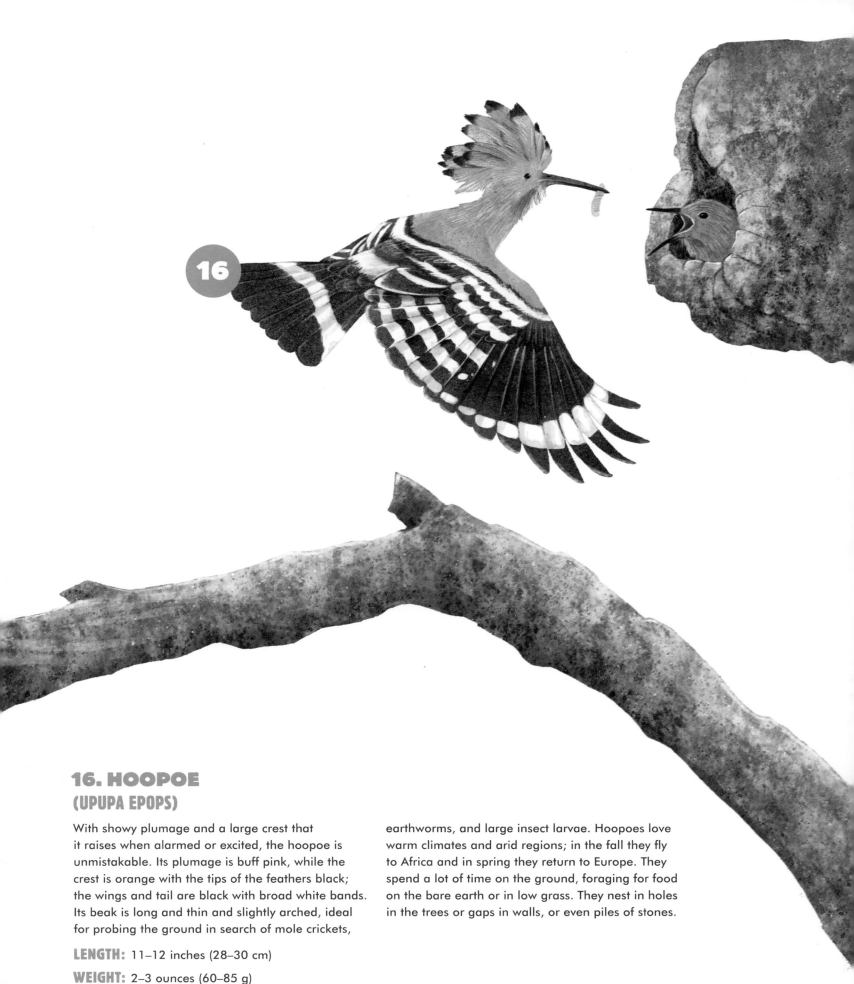

16. HOOPOE
(UPUPA EPOPS)

With showy plumage and a large crest that it raises when alarmed or excited, the hoopoe is unmistakable. Its plumage is buff pink, while the crest is orange with the tips of the feathers black; the wings and tail are black with broad white bands. Its beak is long and thin and slightly arched, ideal for probing the ground in search of mole crickets, earthworms, and large insect larvae. Hoopoes love warm climates and arid regions; in the fall they fly to Africa and in spring they return to Europe. They spend a lot of time on the ground, foraging for food on the bare earth or in low grass. They nest in holes in the trees or gaps in walls, or even piles of stones.

LENGTH: 11–12 inches (28–30 cm)

WEIGHT: 2–3 ounces (60–85 g)

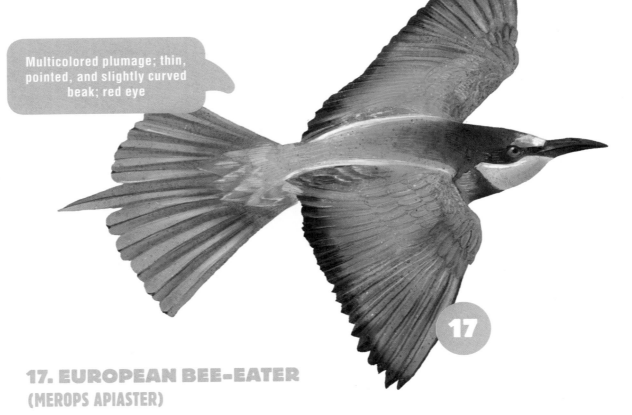

Multicolored plumage; thin, pointed, and slightly curved beak; red eye

17

17. EUROPEAN BEE-EATER
(MEROPS APIASTER)

Bee-eaters are birds with colorful plumage, and are widespread with many species in Africa and Asia. *Merops apiaster* is the only European bee-eater, and it, too, flaunts eye-catching coloring: The head, back, and wing coverts are chestnut brown, with yellow scapulars and a yellow throat, while the underparts and primary feathers are blue-green like the tail, of which the two central feathers are longer and more pointed. It specializes in hunting for large flying insects, including bees and wasps (hence the name). These birds live in colonies on cliffs or little vertical rock walls, nesting at the ends of long tunnels that they dig with their beaks. At the end of the summer they migrate to Africa.

LENGTH: 10–11 inches (25–29 cm)

WEIGHT: 1.5–2.5 ounces (45–70 g)

18. SARDINIAN WARBLER
(SYLVIA MELANOCEPHALA)

The Sardinian warbler is a small bird that frequents the Mediterranean maquis, areas of brush, scrub, and dense undergrowth. Restless and constantly on the move, these birds can often be glimpsed out in the open but only for brief moments, as they are always ready to dive back into the thick of the vegetation. The male can be recognized by its black head, against which the eyes stand out surrounded by a bright red ring; the throat is white, while the rest of the body is gray and darker on the upper parts. The female's head is gray rather than black, with a browner back and buff underparts, and the red eye-ring is less noticeable.

LENGTH: 5.5 inches (14 cm)

WEIGHT: 0.3–0.5 ounce (7.5–15 g)

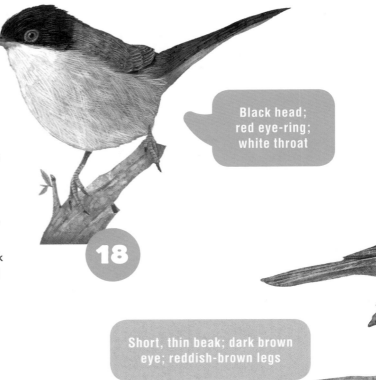

Black head; red eye-ring; white throat

18

Short, thin beak; dark brown eye; reddish-brown legs

19. DARTFORD WARBLER
(SYLVIA UNDATA)

The Dartford warbler is a typical bird of the Mediterranean maquis that nests in thick bushes and rarely shows itself in the open. The male makes an exception in the breeding season, when it can be seen singing on the top of a bush. It is a small long-tailed bird with a brownish back and wings, a gray head and tail, and purplish-red underparts. It has small whitish spots on the throat, and the crown of the head can be raised in a little crest. The eye is reddish brown and surrounded by a red ring. The female is darker brown on the upper parts and the underparts are a duller red.

LENGTH: 5 inches (12.5 cm)
WEIGHT: 0.2–0.4 ounce (6.5–11.5 g)

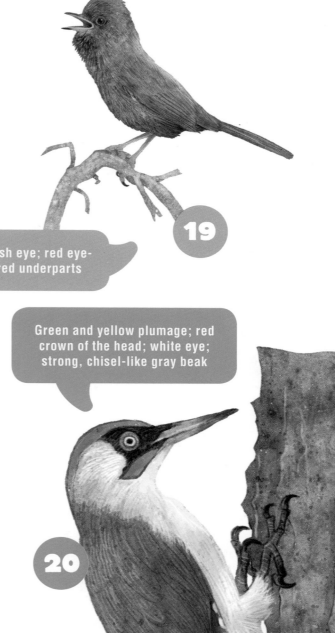

Gray head; reddish eye; red eye-ring; purplish-red underparts

Green and yellow plumage; red crown of the head; white eye; strong, chisel-like gray beak

20. EUROPEAN GREEN WOODPECKER
(PICUS VIRIDIS)

The European green woodpecker is about the size of a pigeon but slimmer. The plumage is green on the upper parts, with a yellow rump, and grayish on the underparts; the primaries and the tail feathers have white and dark bars. The head is very colorful, with a red crown, a black area around the white eye, a black "mustache" in the female, and a black one with a red center in the male (this feature is what tells them apart). They have a distinctive undulating flight pattern and a ringing call that sounds like loud cackling laughter. They feed mainly on insects, especially on ants that they capture by sticking their long sticky tongues into the tunnels of anthills.

LENGTH: 12–13 inches (30–34 cm)
WEIGHT: 5.5–7 ounces (160–200 g)

21. NIGHTINGALE
(LUSCINIA MEGARHYNCHOS)

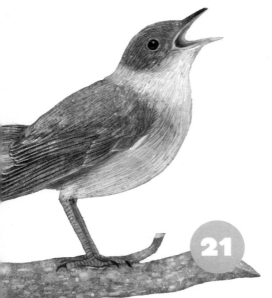

The nightingale is an inconspicuous bird about the size of a sparrow, rarely seen in the open, and is famous for its rich and melodious song that can be heard even at night in spring. Its plumage is tawny brownish on the upper parts and grayish on the underparts, with darker wings and a rust-red tail, often kept raised. It lives in hedges and dense undergrowth, where it builds a nest of stems, blades of grass, dry leaves, and rootlets, often on the ground among grasses or among the lower branches of shrubs and bushes. In September it leaves Europe and migrates to Africa.

LENGTH: 6.3–6.7 inches (16–17 cm)
WEIGHT: 0.8–1.1 ounces (21–32 g)

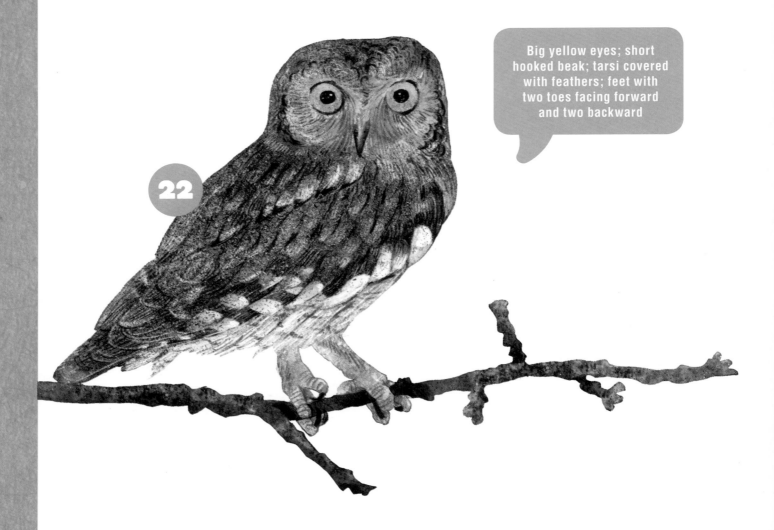

22

Big yellow eyes; short hooked beak; tarsi covered with feathers; feet with two toes facing forward and two backward

22. EURASIAN SCOPS OWL
(OTUS SCOPS)

The scops owl is the smallest European nocturnal bird of prey. Both sexes are similar in appearance, but the female is a little bigger. It has two varieties of coloring, one tending more toward gray and the other more reddish; both plumages are very well camouflaged, being densely striped and mottled with whitish and gray spots. By day, huddled close to a tree trunk with its eyes closed and keeping perfectly still, the scops owl looks like nothing so much as a dry branch in every way. It is active at night, when it hunts for large insects, earthworms, and, less commonly, small mammals; during the breeding season its territorial song is insistently repeated throughout the night—a high-pitched melancholy "tyoo" that can be heard up to one-third of a mile (536 m) away.

LENGTH: 7.5–8 inches (19–20 cm)

WEIGHT: 3–4 ounces (80–120 g)

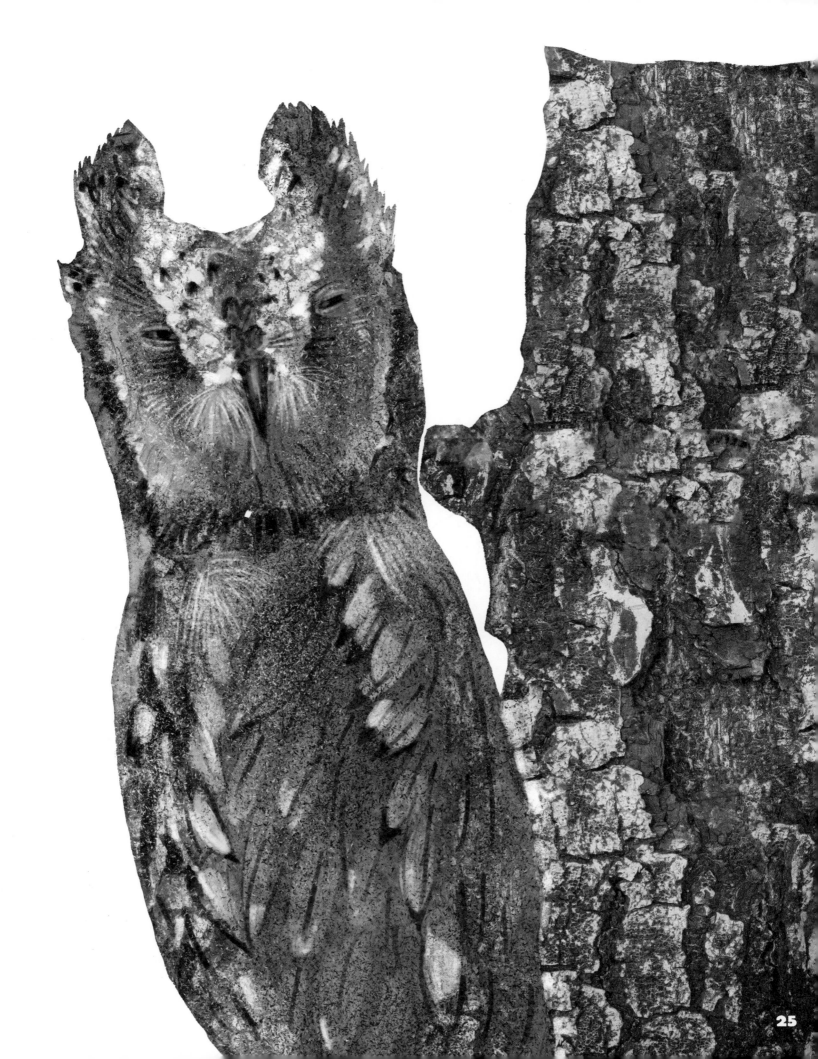

The Alps are Europe's main mountain range: an arc of mountains more than 745 miles (1,200 km) long and, at their widest point, more than 180 miles (290 km) wide. They have 82 "four-thousanders"—peaks over 4,000 meters (13,123 feet) high—culminating in the 15,774 feet (4,808 m) of Mont Blanc. The Alps offer a whole series of different environments, climbing from broadleaf forests to forests of fir, pine, and larch; from there to meadows above the tree line, on to stony ground, then rocky cliffs; and finally to peaks that are covered with snow all year round—not to mention the villages and mountain huts, whose stone walls offer good nesting places, or the rivers and streams that tumble foaming down the valleys. This great variety of environments offers abundant resources for many different species of birds, although the situation changes considerably over the seasons. The higher the altitude, the more difficult weather conditions become; as winter approaches, many birds no longer find sufficient resources. Some merely go down to lower altitudes, where they can still find insects, seeds, and fruits; many migrate to warmer regions on the coasts of the Mediterranean or in sub-Saharan Africa.

Only a few remain in the highest forests or even up on the scree now covered by snow. To survive the harsh alpine winters, these birds have had to develop special adaptations. The western capercaillie survives by eating the needles of the fir trees or the leaves of the few shrubs that emerge from the snow layer; the rock ptarmigan changes its gray and brown summer plumage and turns all white, the better to escape the eye of the GOLDEN EAGLE (in the drawing). This majestic bird of prey, in fact, remains in its mountain kingdom even in winter, hunting down partridges and hares or scouring the slopes in search of some large animal that has died of illness or old age or been engulfed by an avalanche, in order to eat its flesh. And when the carcass has been stripped, the majestic bearded vulture arrives to feed on the bones.

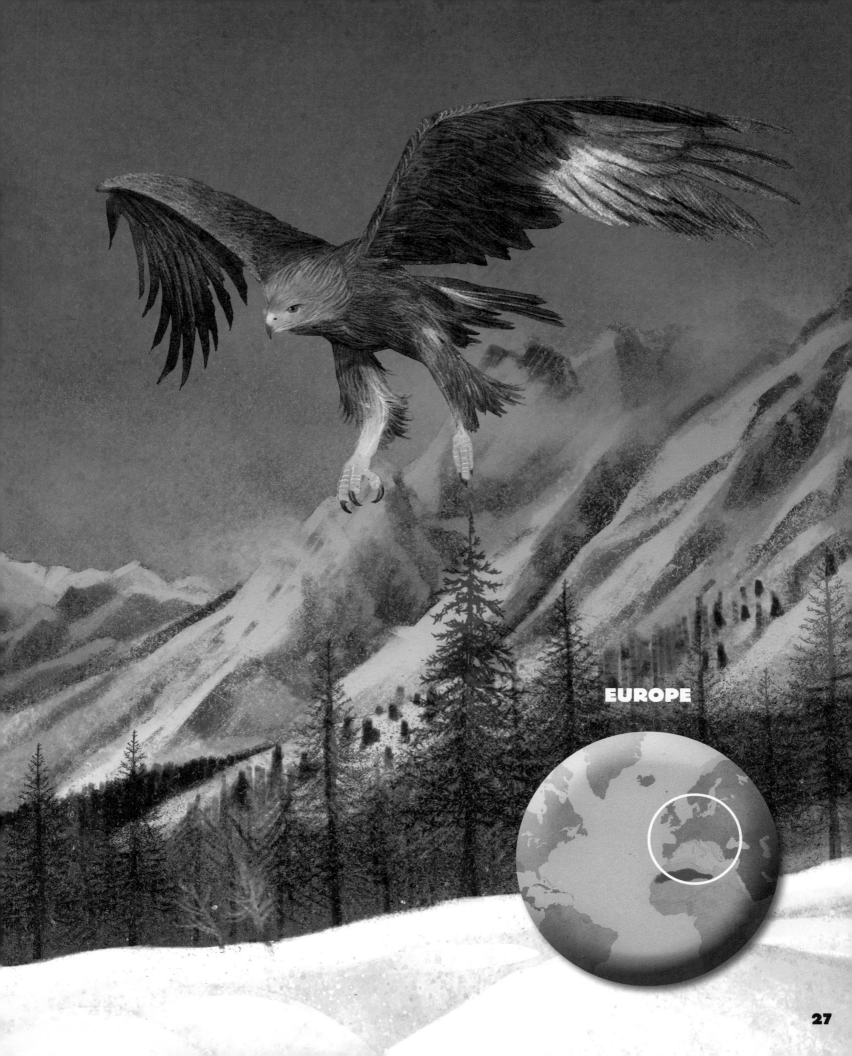

EUROPE

1. BEARDED VULTURE
(GYPAETUS BARBATUS)

The largest European vulture, this bird has long, narrow wings and a wingspan of up to nine feet (2.75 m). The upper parts are lead gray, with a whitish head and underparts that gradually acquire a cream or rust-red color due to bathing in reddish mud. A black stripe starting from the eye extends to form two mustache-like whiskers on either side of the beak. The vulture eats the remains of carrion and especially the bones; if these are too big, it will fly up and drop them onto the rocks to break them and then collect the pieces. Exterminated in the Alps in the last century, bearded vultures have since been reintroduced and several pairs can be seen today. They build huge nests of branches in caves or holes in the rocks in inaccessible places.

LENGTH: 41–49 inches (105–125 cm)

WEIGHT: 10–15 pounds (4.5–7 kg)

Thick, curved beak; yellowish eye; red eye-ring; black "whiskers" on the sides of the beak

1

2. ROCK PTARMIGAN
(LAGOPUS MUTA)

The rock ptarmigan lives at high altitude, on rocky grassland and scree, and remains there even in winter. Its nostrils, legs, and feet, including the toes, are covered with feathers to protect it from the cold, and it changes plumage to blend in better with the environment and escape predators. In summer its plumage is gray-brown speckled with white and black and blends in well among the rocks, while in winter, when the snow covers the ground, it turns white (with only the tail remaining black). In the spring and fall the plumage is mottled, because the feathers with the new color come in gradually and not all at once.

LENGTH: 13–16 inches (32–41 cm)

WEIGHT: 14–21 ounces (400–600 g)

Winter: all-white plumage, except the black tail; black lore (male); red caruncle becomes inconspicuous

2

Summer: gray-brown plumage; black tail; white wings, belly, and legs; red caruncle over the eye

3. ALPINE CHOUGH
(PYRRHOCORAX GRACULUS)

The Alpine chough is a member of the Corvidae, or crow family, and is closely linked to the mountains. It can be recognized by its black plumage, red tarsi, and yellow beak, and by its agile and acrobatic flight. Alpine choughs often form large groups that keep in touch with loud calls as they explore the slopes in search of food. They are omnivorous, mainly eating insects, spiders, and other invertebrates but also seeds, garbage, and the remains of dead animals; they can often be seen near mountain refuge huts or along the paths most frequented by hikers, on the lookout for any scraps.

LENGTH: 14–15 inches (36–39 cm)

WEIGHT: 6–9 ounces (165–255 g)

Iridescent black plumage; red tarsi; short, thin bright yellow beak

4. GOLDEN EAGLE
(AQUILA CHRYSAETOS)

Majestic and powerful in flight, the golden eagle is the greatest predatory bird in the European mountains. Both sexes are similar in appearance, but the female is the larger of the two, with a wingspan that can reach over 6.5 feet (2 m). They hunt marmots, hares, and large birds such as ptarmigans and rock partridges, but can also attack larger animals such as foxes, young chamois, or ibex. In the winter, when food is scarce, they also feed on carrion. Pairs stay together for life and use several nests. These are usually built on steep rock faces below the alpine meadows that are the golden eagle's main hunting area. Pairs normally raise a clutch of one to three eggs each season, and the chicks stay with the parents until the following spring and learn how to execute the golden eagle's difficult hunting techniques.

LENGTH: 30–35 inches (75–88 cm)

WEIGHT: male 6.5–9 pounds (3–4 kg); female 13–15 pounds (6–7 kg)

Powerful curved beak; brown plumage with golden tones on the neck and shoulders

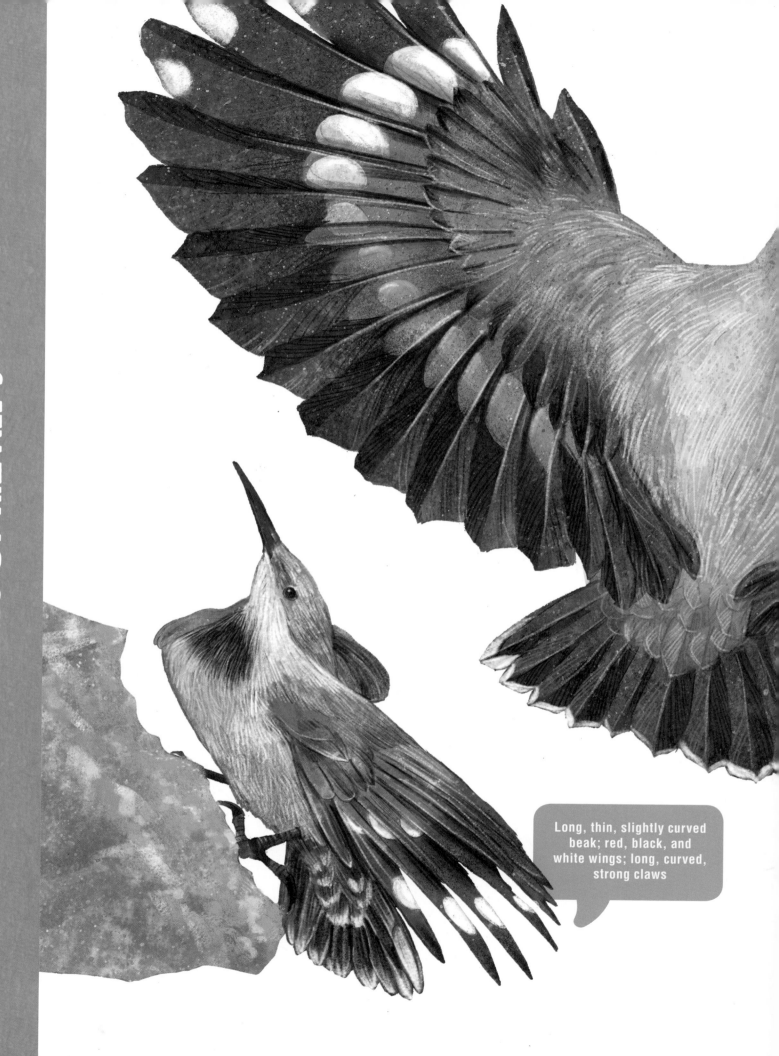

Long, thin, slightly curved beak; red, black, and white wings; long, curved, strong claws

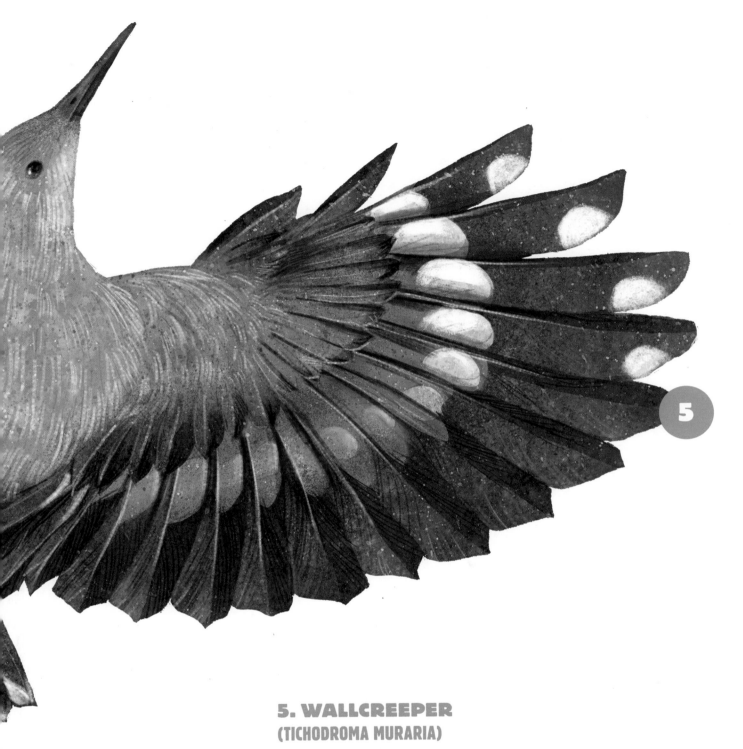

5. WALLCREEPER
(TICHODROMA MURARIA)

The wallcreeper does not belong to the woodpecker family, but like them it is an extraordinary climber, differing in that it "walks" on vertical and even overhanging rocks instead of on tree trunks. It has predominantly gray plumage, but when it moves it opens and closes its brightly colored wings. With its black and red primary flight feathers adorned with round white spots and red coverts, it looks like a giant butterfly flying among the rocks. Its long, thin beak is ideal for catching spiders and small insects in cracks in the rock. Both sexes are similar in appearance, but in spring and summer the male has a black chin and throat, while in the female they remain whitish.

LENGTH: 6.3–6.7 inches (16–17 cm)

WEIGHT: 0.5–1 ounce (15–22 g)

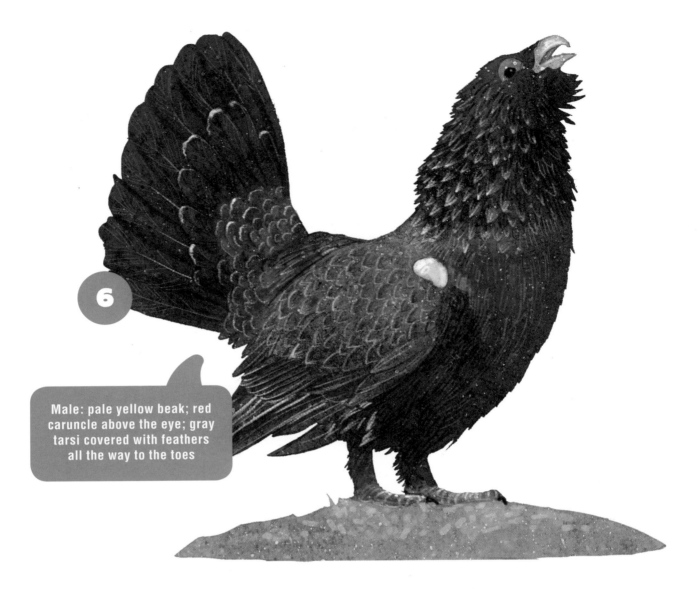

6

Male: pale yellow beak; red caruncle above the eye; gray tarsi covered with feathers all the way to the toes

6. WESTERN CAPERCAILLIE
(TETRAO UROGALLUS)

The capercaillie lives in mountain forests with clearings and thick undergrowth. The male is much larger than the female and has gray-black plumage with a blue shimmer and brown wings; the female is camouflaged, with gray-brown plumage spotted with black, white, and tawny on the breast. In spring, the male performs a spectacular display to attract females, spreading the tail like a fan and stretching up the neck while emitting a long series of dry, harsh sounds. After mating, the females alone brood and hatch the eggs (from three to twelve in each clutch) and lead the chicks in the search for food. The capercaillie remains in the mountains even in winter, mainly eating pine needles and leaves.

LENGTH: male 34–39 inches (86–98 cm); female 22–26 inches (56–65 cm)

WEIGHT: male 7.5–10 pounds (3.5–4.5 kg); female 3–5 pounds (1.5–2 kg)

Female: camouflaged plumage; brown beak; smaller red caruncle

7. COMMON REDPOLL
(ACANTHIS FLAMMEA)

The common redpoll is a small songbird found in the Alps living in sparse pinewoods with an understory of thick bush. The plumage is brown streaked with gray on the upper parts, and whitish with fairly dense brown streaks on the underparts. The dark wings display two narrow light bands, and it has a dark forked tail, a red forehead, and a black bib on its chin. The male differs in having a redder forehead and a deep pink or pink-tinted chest. Outside the breeding season redpolls form large groups that move around ceaselessly in search of food, uttering loud metallic calls.

LENGTH: 4.5 inches (12 cm)

WEIGHT: 0.4–0.6 ounce (10–17 g)

> Red forehead; pink chest; black bib; conical yellow beak, grayish on top

> Triangular crest; thin black beak; black lore and collar; black chin; gray-blue legs

8. EUROPEAN CRESTED TIT
(LOPHOPHANES CRISTATUS)

The crested tit is a small bird especially widespread in pine forests. The plumage is brown on the upper parts and whitish tinged with brown on the underparts. The head is white and black, with a triangular pointed crest of gray feathers bordered with white; it has a black bib, extending down to a black collar that ends at the nape. Lively and confident, crested tits are always on the move and their call is a silvery trill. They eat mainly insects, to which they add conifer seeds in winter, and they readily visit birdfeeders. They nest in holes in trees, which they often dig out themselves in rotten logs or tree trunks.

LENGTH: 4.5–5 inches (11.5–12.5 cm)

WEIGHT: 0.3–0.5 ounce (9–13 g)

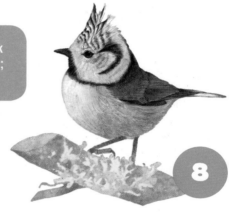

> Male: large head; sturdy bill with curved and crossed mandibles; brick-red plumage

9. RED CROSSBILL
(LOXIA CURVIROSTRA)

The crossbill is a bird whose habitat is confined to pinewoods; its distinctive beak with its crossed tips is an ideal tool for extracting the seeds from the pinecones on which it feeds. The male and female are easily distinguished by color: The male's head, underparts, and rump are brick red, varying in intensity, while the female has olive-gray coloring with a yellowish rump. In both sexes the wings are gray-brown, as is the tail, which looks forked due to the tail feathers growing progressively longer toward the outside.

LENGTH: 6.3–6.7 inches (16–17 cm)

WEIGHT: 1–2 ounces (33–53 g)

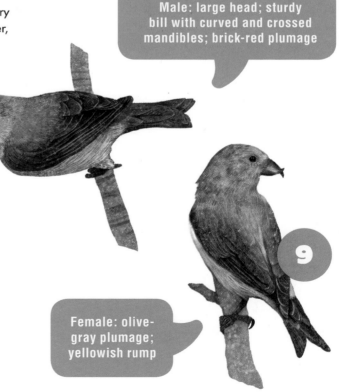

> Female: olive-gray plumage; yellowish rump

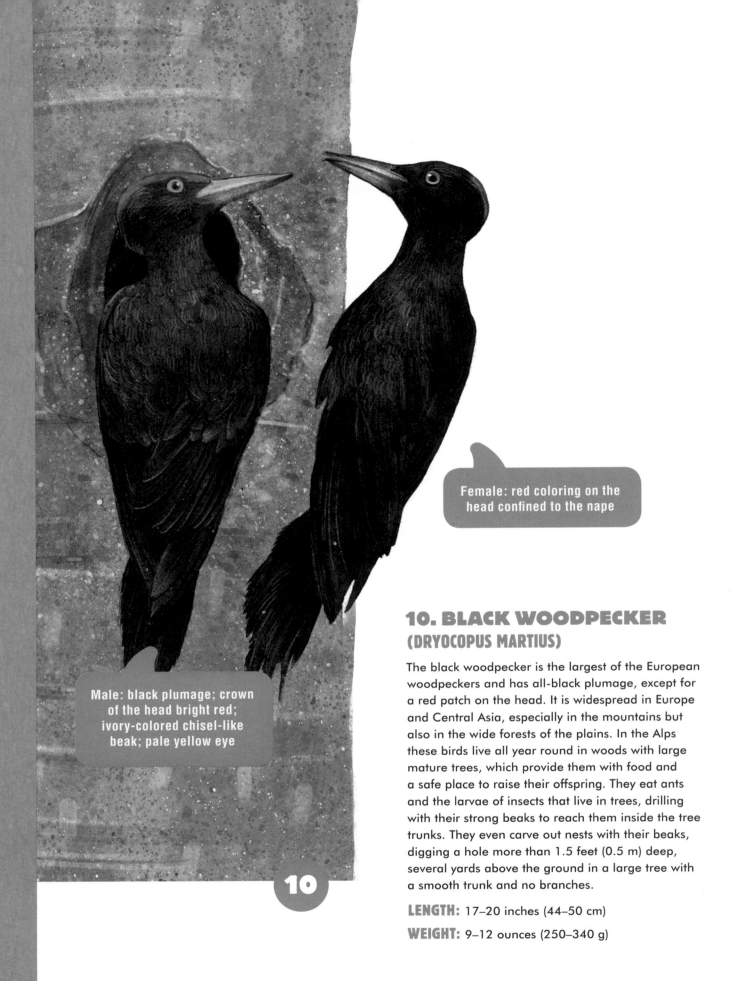

Female: red coloring on the head confined to the nape

Male: black plumage; crown of the head bright red; ivory-colored chisel-like beak; pale yellow eye

10

10. BLACK WOODPECKER (DRYOCOPUS MARTIUS)

The black woodpecker is the largest of the European woodpeckers and has all-black plumage, except for a red patch on the head. It is widespread in Europe and Central Asia, especially in the mountains but also in the wide forests of the plains. In the Alps these birds live all year round in woods with large mature trees, which provide them with food and a safe place to raise their offspring. They eat ants and the larvae of insects that live in trees, drilling with their strong beaks to reach them inside the tree trunks. They even carve out nests with their beaks, digging a hole more than 1.5 feet (0.5 m) deep, several yards above the ground in a large tree with a smooth trunk and no branches.

LENGTH: 17–20 inches (44–50 cm)

WEIGHT: 9–12 ounces (250–340 g)

11. NORTHERN GOSHAWK
(ACCIPITER GENTILIS)

The goshawk is a medium-sized bird of prey with gray-brown plumage on the back and white, thickly barred with brown, on the underparts. The white undertail is very noticeable in flight. The female is about one-third larger than the male. They live in large woods with trees of considerable size and are formidable hunters, catching mammals (squirrels, hares) and birds up to the size of a crow; the relatively short and rounded wings and the long tail enable the goshawk to fly with great agility between the trees and take its prey by surprise. The nest is a large structure of branches in a tall tree, often reused for several years in a row.

LENGTH: 19–24 inches (48–62 cm)

WEIGHT: male 1.5–2.5 pounds (600–1,100 g); female 2–5 pounds (820–2,200 g)

12. BOREAL OWL
(AEGOLIUS FUNEREUS)

The boreal owl is a small nocturnal bird of prey widespread in the forests of Europe and Northern Asia and localized in the Alps. It hunts small mammals, small birds, and large insects even in complete darkness, relying on its very sharp eyesight and hearing and its silent flight. It stays in the mountains even in winter, at most coming down to lower altitudes during the coldest periods. These owls are often found in the same territories as the black woodpecker because they use the woodpeckers' abandoned nests to make their own. When they are brooding, they may be seen guarding the nest with their eyes closed; this is thought to be a way of hiding it from predators by "blocking out" the very visible black opening with the pattern on their face.

LENGTH: 9.5–10 inches (24–26 cm)

WEIGHT: male 3.5–4.5 ounces (100–130 g); female 4.5–6.5 ounces (130–190 g)

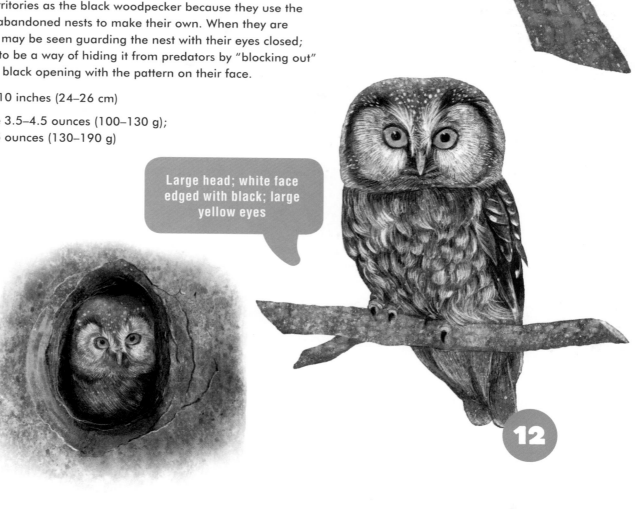

Short but very strong beak; long sharp talons; pale "eyebrow"; yellow-orange (female) or red-orange (male) eye

11

Large head; white face edged with black; large yellow eyes

12

13. BLACK REDSTART
(PHOENICURUS OCHRUROS)

The black redstart is a small, slender-looking songbird that frequents meadows with scattered boulders and scree, but also mountain villages, where it nests among the stones of the walls. The male and female are different in appearance, but both have a rust-colored tail that they twitch constantly. The male is dark gray, blackish on the throat and breast, and in the breeding season it has a white panel on the wing that may be more or less noticeable; the female is brownish gray, lighter on the belly. The black redstart usually perches in plain sight, twitching its tail and flitting constantly from one boulder to another.

LENGTH: 5.5–6.5 inches (14–16 cm)

WEIGHT: 0.5–0.7 ounce (13–20 g)

Thin, blackish beak; large dark brown eye; rust-colored tail

Red beak; black forehead, sides of the beak, lores, and collar; red eye-ring; red tarsi

14. ROCK PARTRIDGE
(ALECTORIS GRAECA)

The rock partridge has a compact, sturdy body with a small head and short legs. The plumage is mostly gray-brown with a light brown belly and undertail; the throat and face are white with black patterns, and on its flanks it displays a dozen alternating black and white vertical bars. It frequents steep and sunny slopes covered with rocks, low grasses, and sparse bushes; it remains in the mountains even in winter, on the steepest slopes that are the first to shed the snow, or at most descends to slightly lower altitudes. Outside the breeding season rock partridges often form small flocks that mainly graze in search of seeds and bits of plants; in spring they also eat insects and spiders.

LENGTH: 13–14 inches (32–36 cm)

WEIGHT: 1–2 pounds (500–820 g)

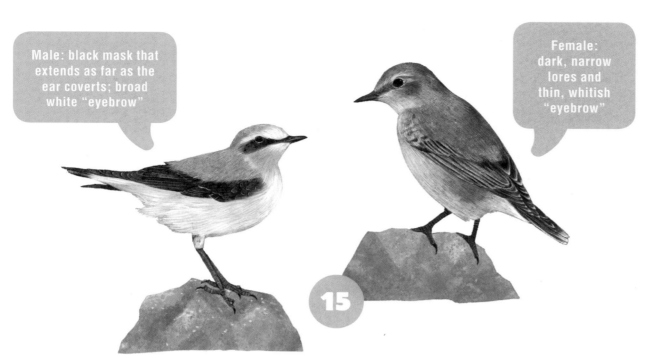

Male: black mask that extends as far as the ear coverts; broad white "eyebrow"

Female: dark, narrow lores and thin, whitish "eyebrow"

15

15. NORTHERN WHEATEAR (OENANTHE OENANTHE)

The northern wheatear is a small songbird living in the alpine meadows among the scattered rocks and boulders, on which it usually perches in plain sight. The male and female have different coloring: The male has gray-blue upper parts and white underparts with a light buff throat and black wings, while the female has a gray-brown back and blackish-brown wings. Both sexes can be recognized by their white rump and white tail, whose base and part of the central feathers are black in the form of an inverted T; the white area is very noticeable in flight. They feed mainly on insects, spiders, and other small invertebrates; at the end of the summer they migrate to Africa.

LENGTH: 5.5–6 inches (14–15 cm)

WEIGHT: 0.5–1 ounce (19–35 g)

16. COMMON OR RUFOUS-TAILED ROCK THRUSH (MONTICOLA SAXATILIS)

The common or rufous-tailed rock thrush is a little bigger than the northern wheatear and has a compact body with a short tail. In the Alps it frequents sunny, rocky slopes and meadows with boulders and rocks where it can hide its nest. The male and female are very different: The male is blue and orange, with a white patch on the back, while the female is brown with little white patches on the upper parts and light yellow-orange underparts with a wavy pattern of fine dark bars. In both sexes the wings are black and the tail is rust red. The rock thrush feeds on insects and other invertebrates, small lizards, and berries; when the breeding season ends, it migrates to Africa to winter.

LENGTH: 7–8 inches (18–20 cm)

WEIGHT: 1.5–2.5 ounces (40–65 g)

Male: blue-gray head, neck, and throat; orange breast and belly; blackish beak; dark brown eye

Female: brown head and back; throat and belly striped with black

16

Throughout the Northern Atlantic, from Norway to Scotland and from Iceland to the remote archipelagos of the Shetland Islands and the Hebrides, the coasts often tower over the sea in the form of great cliffs, vertical walls that can be many hundreds of feet high (several hundred meters). For many birds, these inaccessible rock walls are an ideal place to raise chicks. These are birds that spend most of the year on the high seas, feeding on fish, shellfish, and other marine animals, and return to land only at the beginning of spring, to lay their eggs on the narrow ledges or in the deep crevices of the rock and raise their offspring. These cliffs then become crowded vertical colonies, like high-rise apartment buildings, where thousands upon thousands of birds compete for the best places and come and go ceaselessly to fish in the waters below and return to the nest with food for the chicks. There are razorbills and murres, with black and white plumage that resembles that of a penguin; PUFFINS with their comic air and enormous brightly colored beaks (in the drawing); the noisy black-legged kittiwakes and the fulmars, great fliers that resemble gulls. These enormous concentrations of birds, together with their eggs and their chicks, also attract many predators, from the powerful gyrfalcon that even catches adult birds in flight to the great black-backed gull, a large seagull that preys mainly on eggs and chicks, and the Arctic skuas, veritable pirates that launch themselves in pursuit of birds returning to the nest with their beaks full of fish and hound them until they drop their booty.

As soon as the chicks are old enough to leave the nest, they follow their parents out to sea, where they learn to dive and chase down their prey underwater. Then, at the end of the summer, all these birds leave the cliffs and make for the open sea, where they will remain until the end of winter. The great rock walls, depopulated and silent, battered by waves and howling storms, await the spring, when the birds return to repopulate their noisy vertical cities.

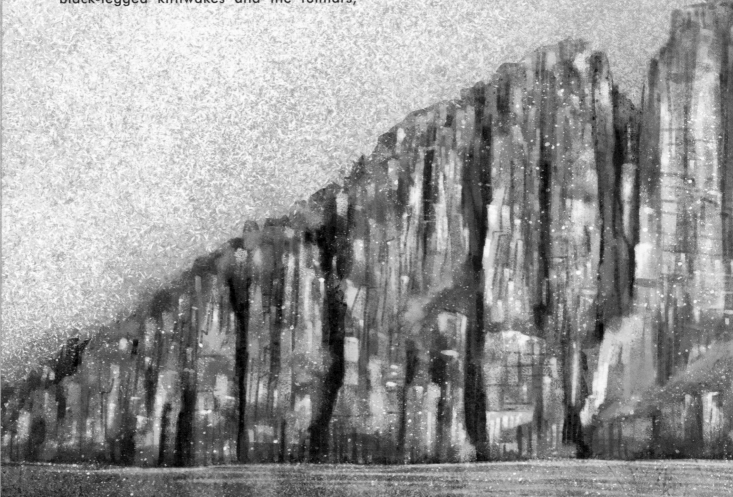

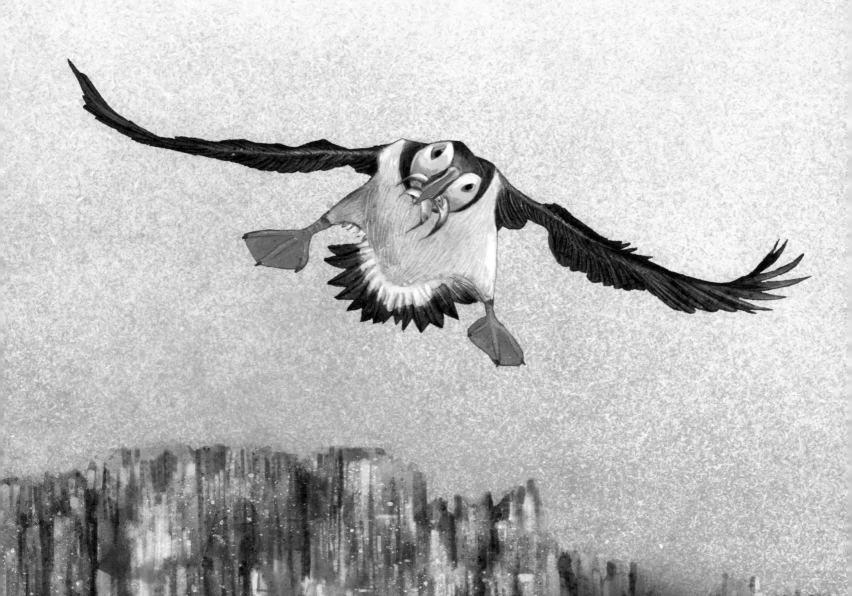

EUROPE

1. NORTHERN FULMAR
(FULMARUS GLACIALIS)

The northern fulmar is a medium-sized bird with a wingspan in excess of three feet (1 m). It spends most of its life in flight over the sea, coming ashore only to nest in very large colonies. Its plumage has different phases, with the lighter being ash gray above and white on the underparts, while the darker is all lead gray. The nostrils are tube-shaped and contain glands that remove excess salt. When they raise their chicks, the parents take turns to go and get food (fish and other small marine animals) and stay out at sea for as long as four or five days; the chicks get this regurgitated food, and to defend themselves from predators they can "spit" the stinking fish oil contained in their stomach.

LENGTH: 18–20 inches (45–50 cm)

WEIGHT: 1–2 pounds (450–1,000 g)

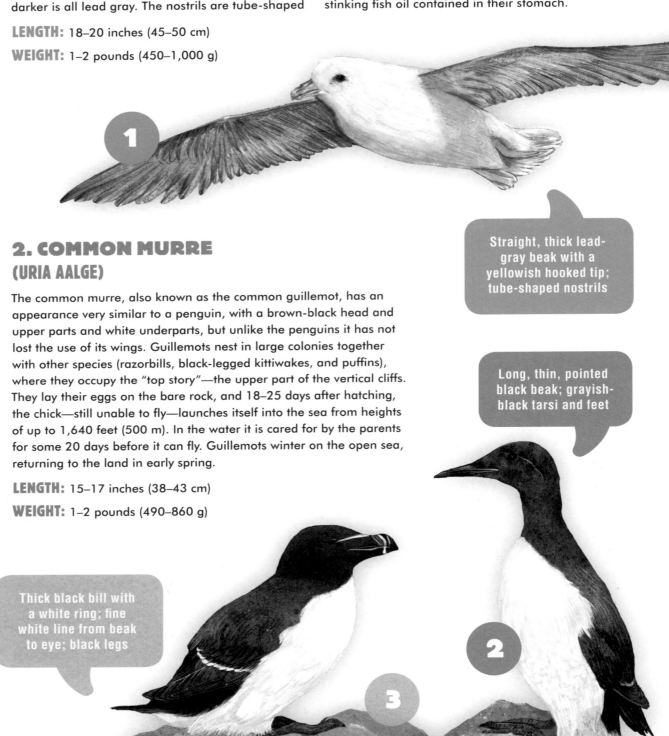

Straight, thick lead-gray beak with a yellowish hooked tip; tube-shaped nostrils

2. COMMON MURRE
(URIA AALGE)

The common murre, also known as the common guillemot, has an appearance very similar to a penguin, with a brown-black head and upper parts and white underparts, but unlike the penguins it has not lost the use of its wings. Guillemots nest in large colonies together with other species (razorbills, black-legged kittiwakes, and puffins), where they occupy the "top story"—the upper part of the vertical cliffs. They lay their eggs on the bare rock, and 18–25 days after hatching, the chick—still unable to fly—launches itself into the sea from heights of up to 1,640 feet (500 m). In the water it is cared for by the parents for some 20 days before it can fly. Guillemots winter on the open sea, returning to the land in early spring.

LENGTH: 15–17 inches (38–43 cm)

WEIGHT: 1–2 pounds (490–860 g)

Long, thin, pointed black beak; grayish-black tarsi and feet

Thick black bill with a white ring; fine white line from beak to eye; black legs

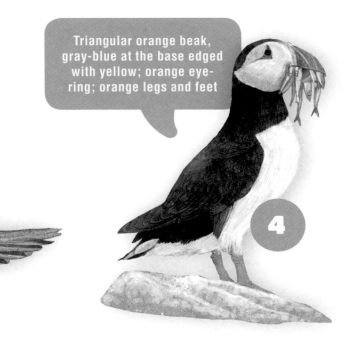

Triangular orange beak, gray-blue at the base edged with yellow; orange eye-ring; orange legs and feet

3. RAZORBILL
(ALCA TORDA)

The razorbill is a medium-sized bird, with black or chocolate-brown plumage on the head, throat, and upper parts and white on the underparts. It has a relatively long tail and usually sits back on its heels when at rest on the ground. Razorbills walk awkwardly, but are skillful swimmers that dive down to 130 feet (40 m) below the surface to hunt for fish, using their wings to advance through the water and their legs as a rudder. They breed in very large colonies on cliffs overlooking the sea on both sides of the North Atlantic, laying a single egg directly on the bare rock of a narrow ledge. After breeding, the razorbill heads out to the open sea, where it remains until the following spring.

LENGTH: 15–17 inches (38–43 cm)

WEIGHT: 1–1.5 pounds (500–700 g)

4. ATLANTIC PUFFIN
(FRATERCULA ARCTICA)

The puffin looks like a small penguin with a squat body, black on the upper parts and white on the underparts, and has a huge and conspicuously colored beak that gives it a comical clown-like air. It nests in colonies on grassy slopes at the tops of the cliffs, in a tunnel up to 3 feet (1 m) deep that is dug out by both members of the pair using their beaks and webbed feet. They feed on fish, which they catch by swimming underwater; when raising a chick, they return to the nest with a row of fish held crosswise in the beak. At the end of summer, the puffins leave the cliffs to winter on the high seas and do not begin to come near land again until March.

LENGTH: 11–14 inches (29–36 cm)

WEIGHT: 11–24 ounces (305–675 g)

5. GYRFALCON
(FALCO RUSTICOLUS)

The gyrfalcon is the largest of the European falcons, and in the Middle Ages—in the days of falconry—the right to own one was reserved for the monarch. These birds live on the coasts of northern regions all around the Arctic, nesting on cliffs or on mountain walls and hunting partridges and seabirds. The most common plumage is slate gray, varying in how dark it is, with black stripes on the breast and black bars on the flanks and crural feathers, but they can vary in appearance: In Greenland, North America, and East Asia it is possible to see very light-colored gyrfalcons, almost white, alongside other individuals that are very dark, almost black. The male and female have similar plumage, but the female is markedly larger.

LENGTH: 20–26 inches (50–65 cm)

WEIGHT: male 2–3 pounds (1–1.5 kg);
female 3–4.5 pounds (1.5–2 kg)

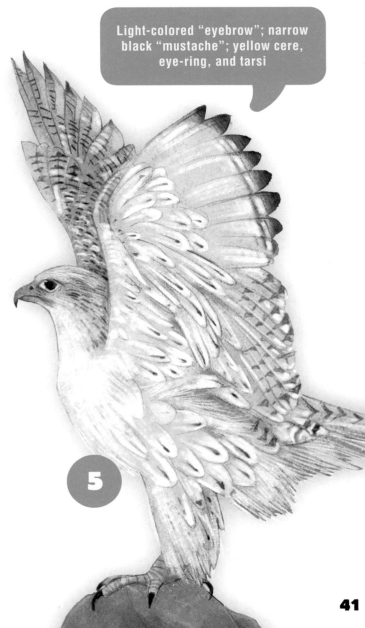

Light-colored "eyebrow"; narrow black "mustache"; yellow cere, eye-ring, and tarsi

6. ARCTIC SKUA
(STERCORARIUS PARASITICUS)

The skua, also known as the parasitic jaeger, is a medium-sized seabird, agile and powerful in flight, that breeds on the tundra but is often seen in large seabird colonies, where it behaves like a pirate, stealing other birds' food. It has two varieties of coloring: a lighter one with brownish-gray upper parts and whitish underparts, and a darker one where the whole body is brown; there are also intermediate forms, and all have a light-colored area at the base of the primaries. The two central tail feathers are elongated and pointed; the beak is relatively thin but hooked and razor sharp, and the webbed feet have curved claws. The skua takes aim at seabirds (black-legged kittiwakes, terns, puffin, and razorbills) returning to the nest with fish in their beaks or with their crops full of food for their chicks. It pursues them in high-speed, acrobatic flight, attacking them relentlessly until the unlucky victim drops its fish or regurgitates its food, which the skua hastens to snatch on the wing before choosing a new target and resuming the attacks.

LENGTH: 16–18 inches (41–46 cm)

WEIGHT: 12–20 ounces (330–570 g)

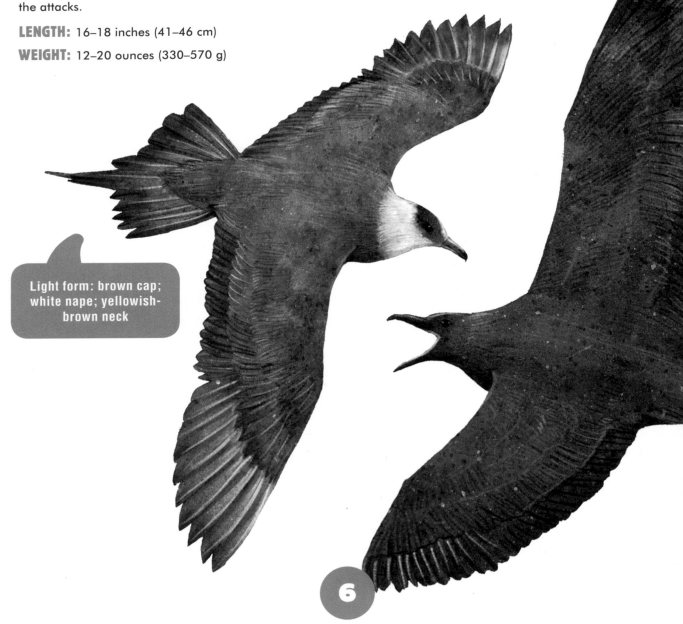

Light form: brown cap; white nape; yellowish-brown neck

6

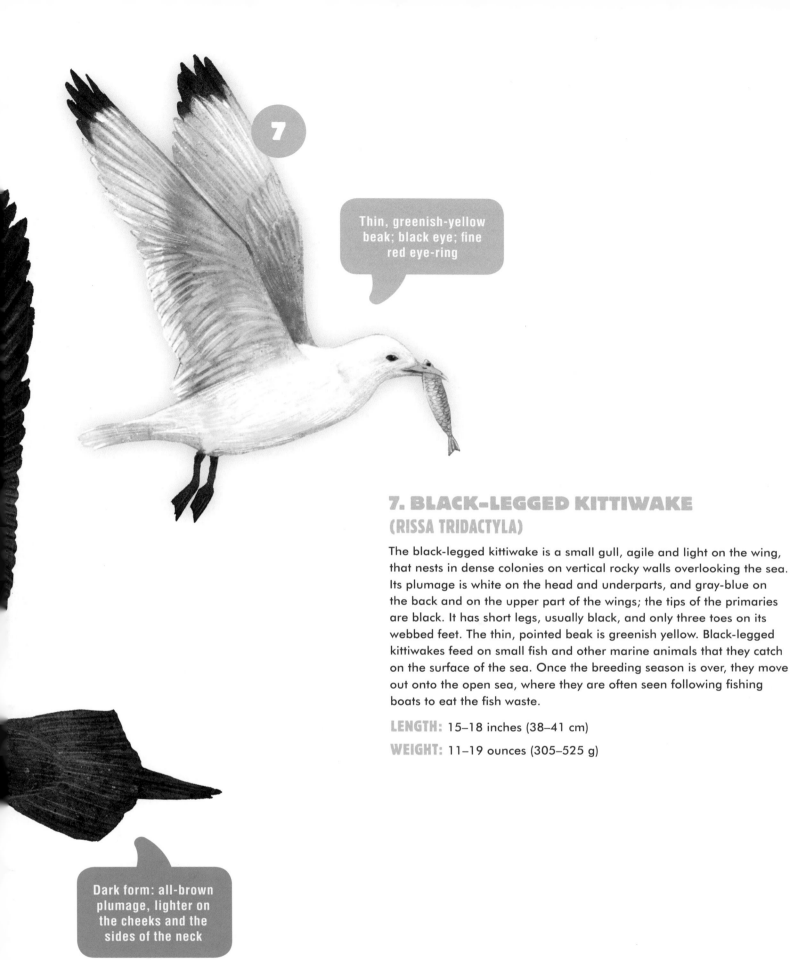

Thin, greenish-yellow beak; black eye; fine red eye-ring

7. BLACK-LEGGED KITTIWAKE
(RISSA TRIDACTYLA)

The black-legged kittiwake is a small gull, agile and light on the wing, that nests in dense colonies on vertical rocky walls overlooking the sea. Its plumage is white on the head and underparts, and gray-blue on the back and on the upper part of the wings; the tips of the primaries are black. It has short legs, usually black, and only three toes on its webbed feet. The thin, pointed beak is greenish yellow. Black-legged kittiwakes feed on small fish and other marine animals that they catch on the surface of the sea. Once the breeding season is over, they move out onto the open sea, where they are often seen following fishing boats to eat the fish waste.

LENGTH: 15–18 inches (38–41 cm)
WEIGHT: 11–19 ounces (305–525 g)

Dark form: all-brown plumage, lighter on the cheeks and the sides of the neck

8. GREAT BLACK-BACKED GULL
(LARUS MARINUS)

The great black-backed gull is a large gull with contrasting plumage: bright white on the head, the underparts, and the tail, and brown-black on the back; the wings are also black except for the tips of the primary and secondary remiges, which are white. It has a sturdy yellow beak with a red spot on the lower mandible. Like the other large gulls, the great black-backed gull is an opportunist that eats waste and carrion, but it is also an active predator that eats fish, eggs, and chicks, and can even catch adult birds up to the size of a duck. Because it doesn't have powerful claws, the great black-backed gull mainly uses its strong beak to injure its prey, or it pursues them in flight until they are exhausted.

LENGTH: 26–31 inches (65–78 cm)

WEIGHT: 3–5 pounds (1.5 –2.5 kg)

> Strong, heavy yellow beak with a red spot; yellow eye surrounded by a fine red ring; pink legs and feet

8

9. COMMON EIDER
(SOMATERIA MOLLISSIMA)

The eider duck is a large sea duck that lives in the Northern Hemisphere. The male and female have very different plumage: The male has black underparts and tail and flight feathers, while the coverts of the wings are white, as are the back, breast, and throat. The head is white with a black crown, and the back and sides of the neck are light green. The female is brown or reddish brown, with dark and light bars—coloring that blends in with the vegetation when it is sitting on the nest to brood. The nest is a hollow among the grasses, padded with soft down that the female plucks from its breast. Eider ducks eat mollusks, crustaceans, sea urchins, and starfish that they take with rapid dives.

LENGTH: 21–24 inches (53–60 cm)

WEIGHT: 2–7 pounds (850–3,025 g)

> Male: black and white plumage; large yellowish triangular bill; light green neck

> Female: barred brown plumage; gray-brown bill

9

10. BLACK GUILLEMOT
(CEPPHUS GRYLLE)

The black guillemot is a seabird the size of a pigeon, with a compact body; in the breeding season the plumage is all black except for two large white spots on the wings; the beak is black with a red interior; the tarsi and feet are also bright red. Outside the breeding season it lives on the open sea, even venturing as far as the edges of the polar ice. In spring it returns to the rocky coasts of the mainland or small islands, where it nests in the cracks of the rocks or between the boulders at the bases of rock walls, forming scattered colonies of a few dozen pairs. It feeds on fish that it catches underwater, with dives that can last up to two minutes and reach a depth of some 165 feet (50 m).

LENGTH: 12–14 inches (30–36 cm)
WEIGHT: 11–19 ounces (325–550 g)

Wedge-shaped black beak with red interior; black eye; bright red legs and feet

10

Dark beak with yellow base; tuft on the front of the crown; bright green eye

11

11. EUROPEAN SHAG
(PHALACROCORAX ARISTOTELIS)

The European shag is a large seabird with a long, thin neck and black plumage with a bright green shimmer. It has violet shimmers on the wings, and the black-edged feathers look like metallic scales. In the breeding season a small tuft develops on the top of the head. Shags feed on fish that they catch underwater, and nest in colonies on rocky coasts and islets. The nest is a voluminous structure of twigs and seaweed, placed on a ledge or in a hole in the rock, in which the female lays on average three eggs; the chicks are naked when they hatch and stay in the nest for about eight weeks, fed and cared for by both parents.

LENGTH: 26–31 inches (65–80 cm)
WEIGHT: 3–4 pounds (1.5–2 kg)

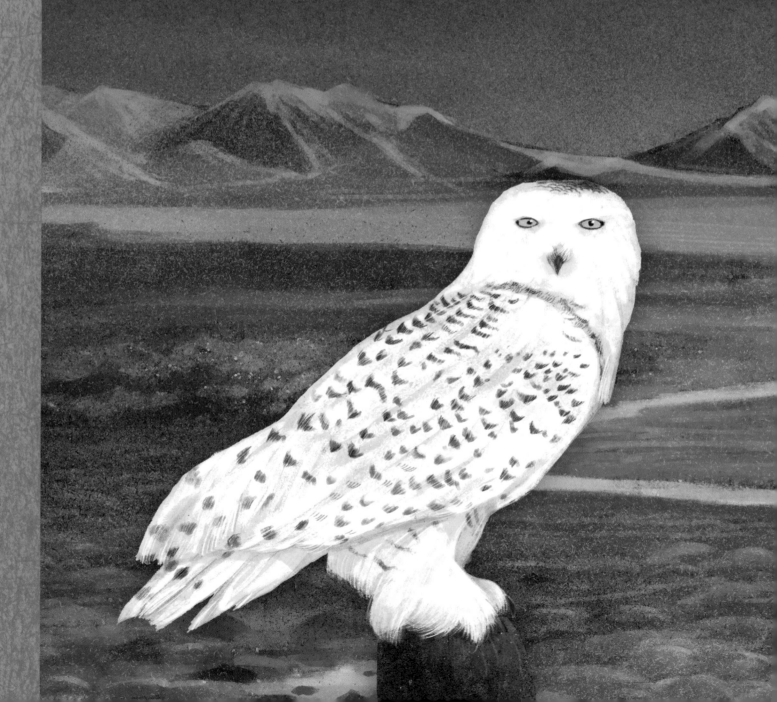

Across the northern end of the American continent, from Alaska to northern Canada, lies the tundra. This name defines an ecosystem typical of regions where the average annual temperature is below freezing. Beneath a thin surface layer, which thaws in the short summer, the ground is frozen to depths of many hundreds of feet, and in these conditions only grasses, mosses, lichens, and some low shrubs manage to take root and grow. For long months the tundra is covered with snow; with the arrival of summer, when the temperature can reach 40–50 degrees Fahrenheit (5–10 degrees Celsius), the grass reappears, and the surface thaw causes the formation of many thousands of lakes and ponds. The eggs and larvae of insects—flies and other dipterous (two-winged) insects, small butterflies, and, above all, billions upon billions of mosquitoes—that have spent the very long winter buried in the ground and protected by the snow now hatch out in a veritable explosion of life, which in turn attracts legions of birds.

Summer lasts a couple of months at most, and all the animals must hurry to complete their breeding cycle before the chill of the frost closes in on the tundra once again. It is a

hectic time, intensified by the fact that the sun never sets and there are 24 hours of daylight. Geese, swans, and ducks graze the grasses and vegetation of the marshes; others devour insects or the seeds of plants; cranes eat seeds and roots and are glad enough of the chance to feed on insects, amphibians, and small rodents. At the top of the food chain are predators such as the peregrine falcon and the SNOWY OWL with its white plumage (in the drawing).

As soon as the young are able to fly, all these birds rush to abandon the tundra; a delay could mean death, owing to the cold and the lack of food. Alone, in small groups, or in large flocks, they fly to warmer climes where they will find food and milder temperatures. The tundra sleeps beneath the snow, ready to wake again for its next brief, frenetic summer.

NORTH AMERICA

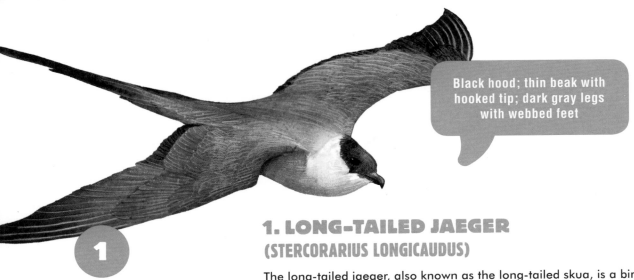

Black hood; thin beak with hooked tip; dark gray legs with webbed feet

1. LONG-TAILED JAEGER
(STERCORARIUS LONGICAUDUS)

The long-tailed jaeger, also known as the long-tailed skua, is a bird of the Stercorariidae family with a slender body and long, narrow wings. The very long and flexible central tail feathers make it seem larger than it really is. The plumage is gray-brown on the upper parts and whitish on the underparts; the head is black and contrasts with the white neck. These birds breed in all regions of the far north, from Alaska to Canada to Siberia. They nest on the ground and feed mainly on lemmings and other small rodents, but on occasion they do not hesitate to steal the prey of other seabirds. They spend the winter on the open sea, feeding on fish and shellfish.

LENGTH: 19–21 inches (48–53 cm) including the tail

WEIGHT: 8–12 ounces (230–350 g)

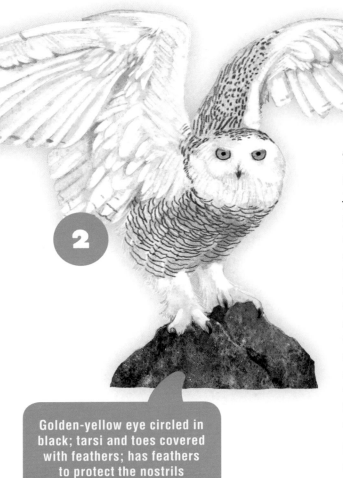

2. SNOWY OWL
(BUBO SCANDIACUS)

The snowy owl is a large bird of prey that nests in the far north, from Alaska to Siberia, with a distribution that can change from year to year depending on the availability of prey. The plumage is predominantly white, especially in males, which can even be almost completely white. The females, which are larger, have plumage barred to a greater or lesser extent with blackish brown; this means that they are less visible when sitting motionless on their eggs, which they lay in a dip in the ground. Unlike other species in the order Strigiformes—the owls— which have mainly nocturnal habits, the snowy owl is also active during the day, hunting down rodents and birds.

LENGTH: 21–26 inches (53–66 cm)

WEIGHT: male 1.5–5.5 pounds (710–2,500 g); female 1.5–6.5 pounds (780–2,950 g)

Golden-yellow eye circled in black; tarsi and toes covered with feathers; has feathers to protect the nostrils

3. PEREGRINE FALCON
(FALCO PEREGRINUS)

The peregrine falcon is a formidable predator, widespread almost throughout the world. Its fast, powerful flight enables it to catch birds as big as itself, such as ducks and pigeons, which it attacks mainly in flight. When it dives, it can reach speeds of almost 190 miles (300 km) an hour, which makes it the fastest animal in the world. The sexes are similar in appearance, but the female is markedly larger. The plumage is dark gray or brown on the upper parts and light on the underparts, with dark spots and bars. The head is black, with a striking "mustache" that contrasts with the light-colored cheeks and throat. Peregrine falcons generally avoid humans, but will sometimes nest even in large cities, on towers or skyscrapers.

LENGTH: 14–20 inches (35–51 cm)

WEIGHT: male 1–2 pounds (410–1,060 g); female 1.5–3.5 pounds (595–1,600 g)

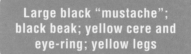

Large black "mustache"; black beak; yellow cere and eye-ring; yellow legs

4. BAR-TAILED GODWIT
(LIMOSA LAPPONICA)

The bar-tailed godwit is a limicolous, or mud-dwelling, bird; that is to say, it usually frequents the muddy areas alongside lakes, rivers, or the coast, where it probes the soft ground with its long beak in search of insects, mollusks, and marine worms. Its summer plumage is striking, with rust-red underparts and brown upper parts speckled with black and white; the winter plumage is grayish with dark bars. It nests in the tundra in the regions around the Arctic, and at the end of the summer it migrates to the Southern Hemisphere. Birds that have nested in Alaska fly to New Zealand, a journey of more than 6,800 miles (11,000 km) that they complete in about eight days without ever setting down on land or eating—the longest nonstop flight made by any migrating bird!

LENGTH: 15–16 inches (37–41 cm)

WEIGHT: male 6.5–14 ounces (190–400 g); female 9–22 ounces (262–630 g)

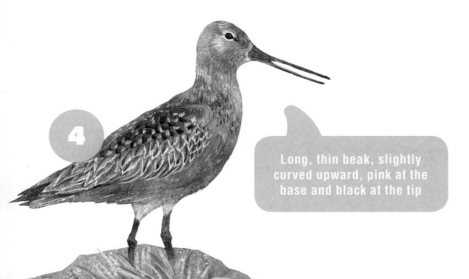

Long, thin beak, slightly curved upward, pink at the base and black at the tip

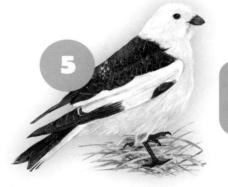

Black and white plumage; black eye, beak, and legs

5. SNOW BUNTING
(PLECTROPHENAX NIVALIS)

The snow bunting is a small songbird with a robust body and a short, heavily built beak. It lives in the mountains and on the rocky coasts of the far north and winters in Central Europe. The male is unmistakable in its summer plumage, which is white all over except for the back, the primaries, and the central tail feathers, which are black, as is the beak. In winter, the back and head and the sides of the breast turn yellowish brown and the beak is also yellowish. The female is grayish brown on the back and head. The snow bunting mainly eats seeds, but it feeds its chicks on caterpillars and other insects.

LENGTH: 5.5–7 inches (14–18 cm)

WEIGHT: 1.1–1.6 ounces (31–46 g)

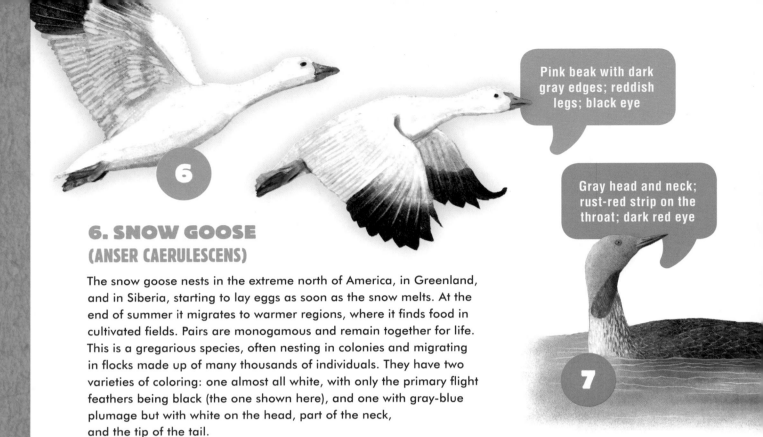

Pink beak with dark gray edges; reddish legs; black eye

Gray head and neck; rust-red strip on the throat; dark red eye

6. SNOW GOOSE
(ANSER CAERULESCENS)

The snow goose nests in the extreme north of America, in Greenland, and in Siberia, starting to lay eggs as soon as the snow melts. At the end of summer it migrates to warmer regions, where it finds food in cultivated fields. Pairs are monogamous and remain together for life. This is a gregarious species, often nesting in colonies and migrating in flocks made up of many thousands of individuals. They have two varieties of coloring: one almost all white, with only the primary flight feathers being black (the one shown here), and one with gray-blue plumage but with white on the head, part of the neck, and the tip of the tail.

LENGTH: 26–33 inches (66–84 cm)
WEIGHT: 3.5–6.5 pounds (1.5–3 kg)

7. RED-THROATED LOON
(GAVIA STELLATA)

The red-throated loon is the smallest and lightest member of its family. It nests on the tundra, on lakes, and even on small ponds, generally not far from the sea where it usually flies to catch fish, diving as far as 30 feet (9 m) deep. The summer plumage is distinguished by the uniformly gray-brown upper parts; the head is gray, the neck is gray with fine black and white vertical lines on the back and a strip of rust on the throat; the underparts are whitish. In winter, when the red-throated loon migrates farther south to winter at sea, the throat turns white and the back is covered with the little white patches that give rise to its specific name, *stellata*—flecked with stars.

LENGTH: 21–27 inches (53–69 cm)
WEIGHT: 2–5.5 pounds (1–2.5 kg)

8. RED PHALAROPE
(PHALAROPUS FULICARIUS)

In many species of birds the female is much less colorful than the male, but there are exceptions where the opposite is the case, and the red phalarope is one of these. In the breeding season, the female has much brighter and more vivid coloring. Roles in raising the offspring are also reversed: After laying the eggs, the female leaves the male to the task of brooding, feeding, and protecting the chicks until they become independent. In winter, both sexes change their plumage to light gray on the upper parts and white on the rest of the body, with just a few black spots on the head.

LENGTH: 8–8.5 inches (20–22 cm)
WEIGHT: 1.5–2.5 ounces (37–77 g)

Female: black crown with white cheeks; brick-red neck and underparts; yellow beak with black tip

Male: duller coloring, gray-brown crown

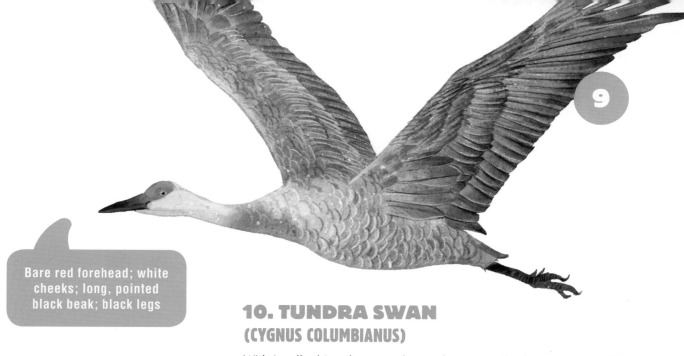

Bare red forehead; white cheeks; long, pointed black beak; black legs

10. TUNDRA SWAN
(CYGNUS COLUMBIANUS)

With its all-white plumage, the tundra swan, also known as Bewick's swan, is very similar to the other swans of the Northern Hemisphere save that it is a little smaller and has a shorter neck in proportion. The main difference is in the color of the beak, which is almost completely black with a small yellow area at the base. The tundra swan breeds in the Arctic tundra, on the shores of lakes, ponds, or marshes. The nest is a large mound of grasses, where the female lays five to seven eggs. Only the female broods, while the male guards against possible predators. The chicks are covered with a gray down, and only grow their all-white plumage in their second year of life.

LENGTH: 47–59 inches (120–150 cm)

WEIGHT: male 8.5–23 pounds (4–10.5 kg); female 9–20 pounds (4–9 kg)

9. SANDHILL CRANE
(ANTIGONE CANADENSIS)

The sandhill crane is a large bird with a long, thin neck and long legs. Both sexes are similar in appearance: They have gray plumage with tinges of ocher all over the body, white cheeks, and a featherless red forehead; the tertial wing coverts, which are very elongated, fall so as to cover the tail. Pairs mate for life. The nest is a mound of plant material built on the ground, preferably in a pond or a swamp. Both members of the pair brood and feed the chicks; the young stay with their parents until the following year. At the end of summer, family groups gather in large flocks that migrate together to warmer climes.

LENGTH: 34–48 inches (86–122 cm)

WEIGHT: 7.5–8 pounds (3.4–3.8 kg)

Black beak with a small yellow spot near the eye; black webbed feet

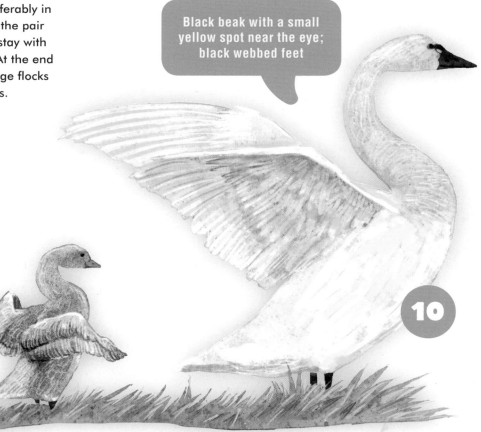

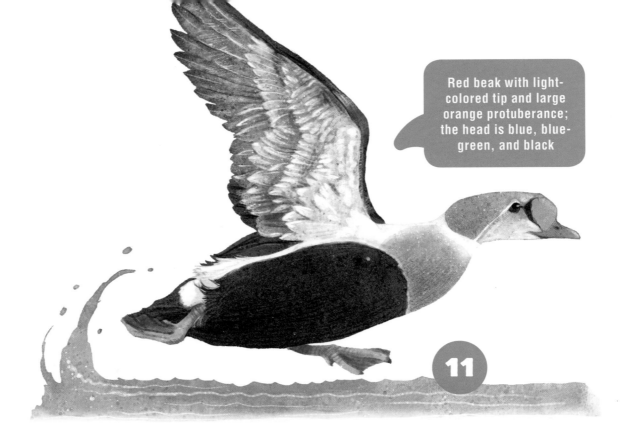

Red beak with light-colored tip and large orange protuberance; the head is blue, blue-green, and black

11. KING EIDER
(SOMATERIA SPECTABILIS)

The king eider is a sea-dwelling duck that lives in the islands around the North Pole; only in winter does it come farther south, into ice-free waters. The male is one of the most colorful ducks in the world: The body is black and white with a salmon-pink breast, the head is violet-blue on the nape and the crown and blue-green on the cheeks, while the beak is coral red with a large orange protuberance edged in black on the forehead. The female, as is often the case in ducks, is brown barred with black. The king eider is a diving duck that catches mainly shellfish, crustaceans, sea urchins, and starfish.

LENGTH: 19–25 inches (47–63 cm)

WEIGHT: 2.5–4.5 pounds (1–2 kg)

Ivory-white plumage all over; dark beak with yellowish tip; black webbed feet

12. IVORY GULL
(PAGOPHILA EBURNEA)

The ivory gull is a small seagull with a compact body, short legs, and a narrow beak. The plumage is completely white, with black legs and a dark gray beak with a yellowish tip. It lives on the Arctic seas, nesting on islets and cliffs around the frozen pack ice. It feeds on small fish and marine invertebrates, which it catches on the surface of the water or with shallow dives, and it follows fishing boats to take advantage of the fish waste. However, ivory gulls also often look for food on the pack ice itself, taking advantage of the occasional dead whale or the carcasses of seals killed by polar bears. Even in winter, they always stay on the shores of these frozen seas.

LENGTH: 17–19 inches (44–48 cm)

WEIGHT: 1–1.5 pounds (520–700 g)

13. HORNED GREBE
(PODICEPS AURITUS)

The grebes are skillful swimmers that catch fish by chasing them down underwater. In the breeding season the horned grebe has unmistakable plumage: The neck, breast, and underparts are all reddish, while the back is gray-brown and the head is black with two broad side tufts that make it look larger than it is; it also has two tufts of golden-yellow feathers that begin at the eyes and extend to the top of the head. In winter its plumage changes radically, turning black on the head, the back of the neck, and the back, and white on the front of the neck and the underparts. Even the distinctive golden tufts disappear.

LENGTH: 12–15 inches (31–38 cm)

WEIGHT: 11–16 ounces (300–470 g)

Black head with conspicuous side tufts; golden-yellow tufts over the eyes; red eye with yellow-edged pupil

Black and white head; gray area around the eye; black and pink beak; long, thin tail

14. LONG-TAILED DUCK
(CLANGULA HYEMALIS)

As its name suggests, the male long-tailed duck is unmistakable for its long, thin central tail feathers that can be as much as a third of its body length. Its summer plumage is very different from its winter look: In summer it is brown on the back and predominantly black on the head and neck; in winter it is white on the neck and most of the head, black on the back, and gray on the sides. The female's plumage is similar overall to the male's summer coloring but much less bright, and the female does not have the elongated tail. The long-tailed duck nests on the ponds and lakes of the tundra and winters in large flocks along the seacoast.

LENGTH: 15–19 inches (37–47 cm)
plus 4–6 inches (10–15 cm) of tail in the male

WEIGHT: 1–2 pounds (550–900 g)

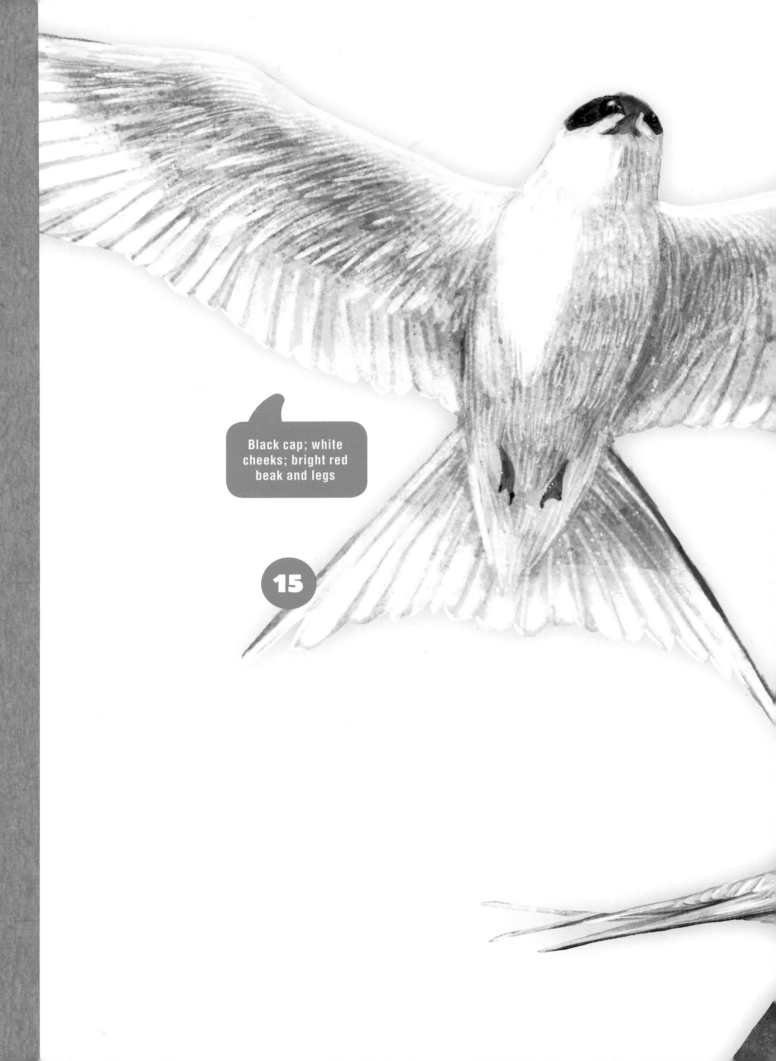

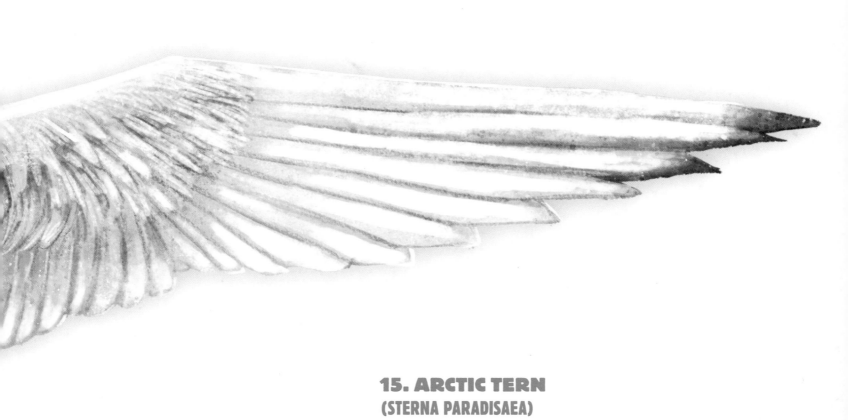

15. ARCTIC TERN
(STERNA PARADISAEA)

The Arctic tern is a bird with a thin body, long wings, and a light, fluttering flight, distinguished from other terns by its particularly elongated outer tail feathers, which are especially noticeable in flight. The plumage is predominantly white, with light gray on the back and the upper side of the wings. It feeds on fish, which it catches by diving from a height. It nests on the coasts of the North Atlantic, and at the end of the summer it migrates to reach land in the Antarctic at the other end of the Earth. In its annual migration this species can travel as far as 56,000 miles (90,000 km), the longest distance of any migration, and it has been calculated that in its average lifespan of 30 years a long-tailed tern can travel almost 1.6 million miles, more than six times the distance between Earth and the moon! What is more, since Arctic terns nest in the far north, where the sun never sets in the summer season, and then migrate to the opposite pole of Antarctica, where the sun never sets in the winter season, they are able to enjoy more sunlight than any other bird.

LENGTH: 13–14 inches (33–36 cm)

WEIGHT: 3–4.5 ounces (86–127 g)

The Rocky Mountains stretch over 3,000 miles (4,800 km) from British Columbia in Canada to New Mexico in the southwestern United States. They form a complex mountain chain that is divided into numerous groups and furrowed by deep valleys, with its highest point being the 14,440-foot (4,401 m) summit of Mount Elbert, and contains dozens of "fourteeners" (peaks over 4,000 meters or 13,123 feet).

At the heart of this magnificent mountain range is Yellowstone National Park, the first national park established in the United States, in 1872. Thanks to its national-park protection, which has lasted for the last century and a half, this vast area of land has been able to preserve a whole series of environments that still survive intact, from swaths of pine forests to prairies dotted with low shrubs, and from swirling rivers to lakes both large and small. Moreover, the central plateau, created by lava deposits from enormous eruptions, is still the scene of numerous volcanic phenomena today; incandescent lava lies only two and a half to three miles (4–5 km) deep, and the heat causes spectacles on the surface—

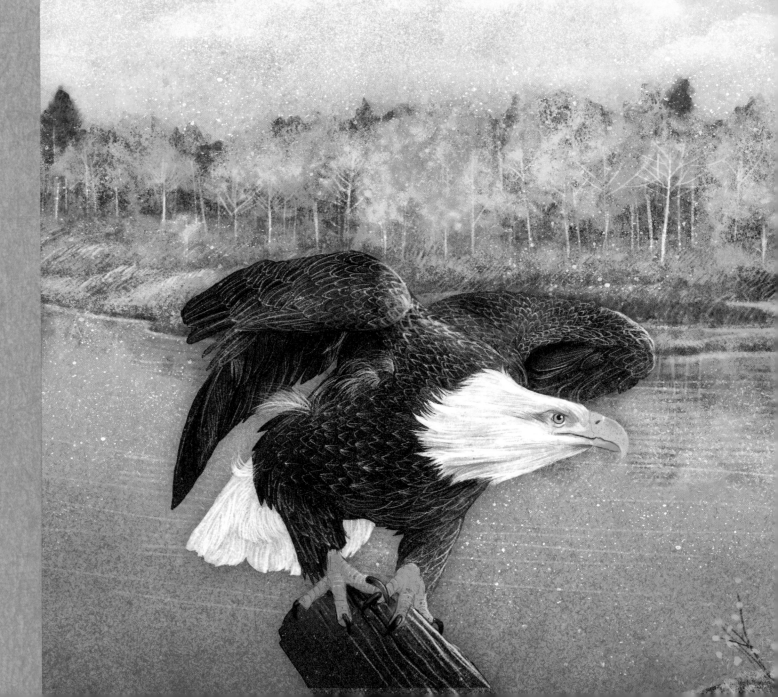

most notably geysers, which are jets of hot water that shoot up at intervals out of the ground. There are over 10,000 of these geysers within the confines of the park.

Yellowstone National Park is also famous for the mammals that live there, from the bison to the elk, from the fearsome grizzly bear to the black bear, and from the wolf to the beaver. But its wealth of bird life is also worthy of respect; no fewer than 298 different species have been counted within the park, some of which are present throughout the entire year, while others appear only in the nesting season or during their migration in the winter. In the forests of Yellowstone you can watch the spectacular displays of the grouse and the wild turkey, or come across the great gray owl or dozens of colorful small songbirds. The lakes are home to loons, mergansers, and the osprey who catch fish with spectacular dives. Outstanding among the diurnal (which means active during the day, as opposed to nocturnal) birds of prey is the majestic BALD EAGLE (in the drawing), the great predator that the United States chose as its national symbol.

NORTH AMERICA

1. RUFFED GROUSE
(BONASA UMBELLUS)

The ruffed grouse is a medium-sized bird with a compact body. It lives in broadleaf forests throughout the year, feeding on berries, fruits, and insects in the summer and on buds, twigs, and other plant material in the winter. The male performs spectacular courtship displays, fanning out its dark gray–bordered tail, fluffing up its neck feathers to form a large black collar, and beating its wings together to produce a loud drumming sound. The female is a little smaller, has brown plumage mottled with black and speckled with white, and broods the eggs and raises the chicks on its own.

LENGTH: 17–19 inches (43–48 cm)

WEIGHT: male 1.5–2 pounds (600–840 g);
female 1–1.5 pounds (495–585 g)

2. DUSKY GROUSE
(DENDRAGAPUS OBSCURUS)

The dusky grouse looks similar to the ruffed grouse but lives in pine forests, surviving in winter by eating mainly the needles of pines and firs. In this species, too, the male performs a spectacular courting display, but instead of drumming with its wings it emits deep, booming sounds by inflating and deflating two pockets of red skin located on the sides of the neck and surrounded by a ring of white feathers. The yellow or orange caruncles over the eyes also become particularly noticeable. The female is slightly smaller and has much less gaudy plumage.

LENGTH: 18–22 inches (45–57 cm)

WEIGHT: 2–3 pounds (900–1,350 g)

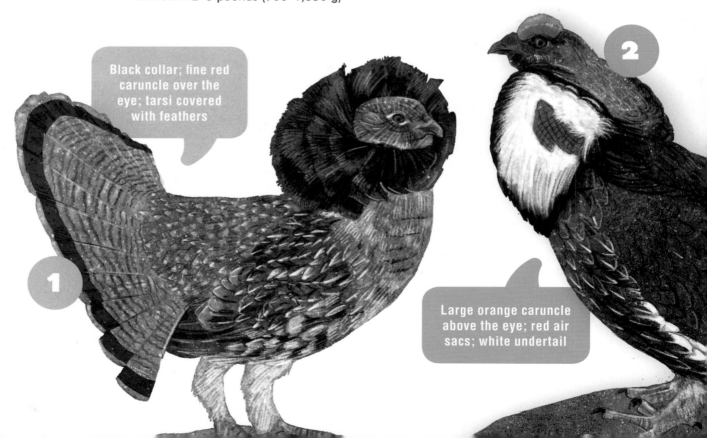

Black collar; fine red caruncle over the eye; tarsi covered with feathers

Large orange caruncle above the eye; red air sacs; white undertail

3. WILD TURKEY
(MELEAGRIS GALLOPAVO)

The wild turkey is similar to the domestic turkey in appearance, but it has more flamboyant plumage, with a metallic shimmer. The head and neck are without feathers, and it has wattles and bulges on the bare skin. The male is considerably larger than the female and exhibits itself in complex courtship displays, fluffing up its feathers and opening its tail like a fan; the growths located on the neck and above the beak swell and become bright red. The wild turkey lives in woods interspersed with clearings, where it spends most of its time on the ground. Despite its weight, however, it is able to fly, and in the evening will take refuge to sleep in a tall tree or other high point, safely away from predators.

LENGTH: male 43–47 inches (110–120 cm);
female 30–37 inches (76–95 cm)

WEIGHT: male 11–24 pounds (5–11 kg);
female 5.5–12 pounds (2.5–5.5 kg)

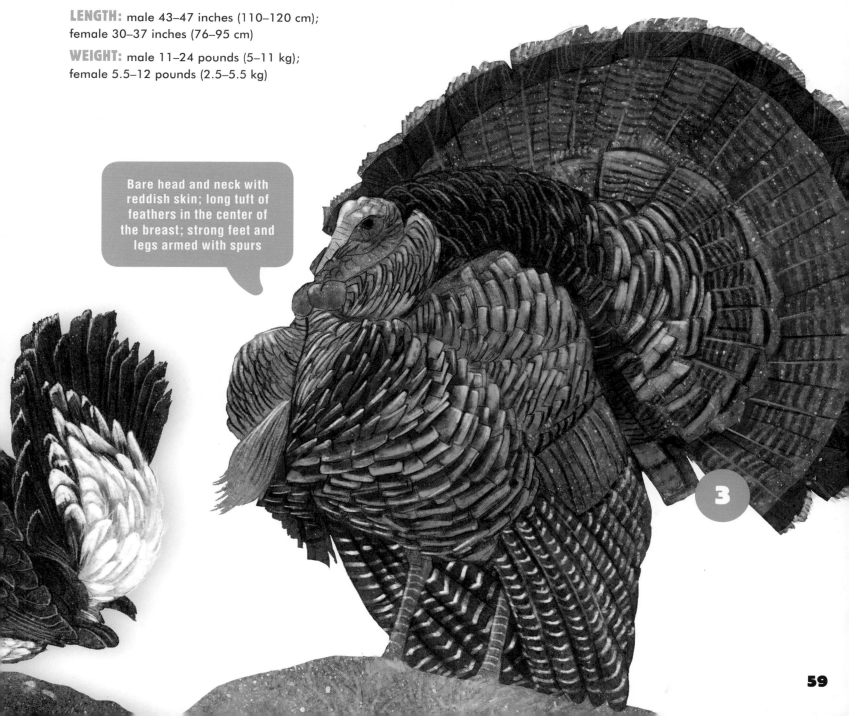

Bare head and neck with reddish skin; long tuft of feathers in the center of the breast; strong feet and legs armed with spurs

3

Brown-green head; short black beak; long wings and short tail

4. VIOLET-GREEN SWALLOW
(TACHYCINETA THALASSINA)

The violet-green swallow is a small bird that specializes in catching insects in flight. Its wings are long and triangular, and its tail is short and slightly forked. Its back is a shiny dark green; the underparts are white and there are two large white areas that divide the green of the back from the violet purple of the rump. Violet-green swallows nest in holes in trees, whether naturally occurring or carved out by other birds, or in cracks in rock walls where they can form numerous colonies. These birds often hunt in groups, catching flies, beetles, and other insects as well as small spiders carried by the wind.

LENGTH: 5–5.5 inches (13–14 cm)

WEIGHT: 0.5–0.6 ounce (14–16 g)

One of the few birds capable of walking upside down on tree trunks and along branches

5. WHITE-BREASTED NUTHATCH
(SITTA CAROLINENSIS)

The white-breasted nuthatch lives in pine forests and oak woods, where it remains even in winter thanks to the food supplies it prepares in the fall, when it hides away pine nuts, acorns, and other seeds in cracks in the bark. Its upper parts are gray-blue, with black on the nape and the top of the head; its face and underparts are white, with a reddish area on the belly. It is a very active and acrobatic bird, moving ceaselessly around the branches and trunks—often even walking upside down—stopping from time to time to catch spiders, caterpillars, and small insects in the fissures of the bark.

LENGTH: 5–6 inches (13–15 cm)

WEIGHT: 0.7–0.8 ounce (20–23 g)

6. STELLER'S JAY
(CYANOCITTA STELLERI)

Steller's jay is a corvid (a bird of the crow family, like jays, ravens, and magpies) with cobalt-blue plumage, black on the head, neck, and upper back, and a large triangular crest on its head. The coverts of the wings and the tail display a fine black bar. Both sexes are similar in appearance. Steller's jay prefers to live in dense pine forests, where it feeds mainly on pine nuts, but it also frequents deciduous forests where it finds acorns and hazelnuts. It also eats small insects, and often approaches campsites and picnic areas in search of scraps. Steller's jays are very gregarious, and in winter they form numerous flocks that move around together in search of food.

LENGTH: 12–13 inches (30–34 cm)

WEIGHT: 3.5–5 ounces (100–140 g)

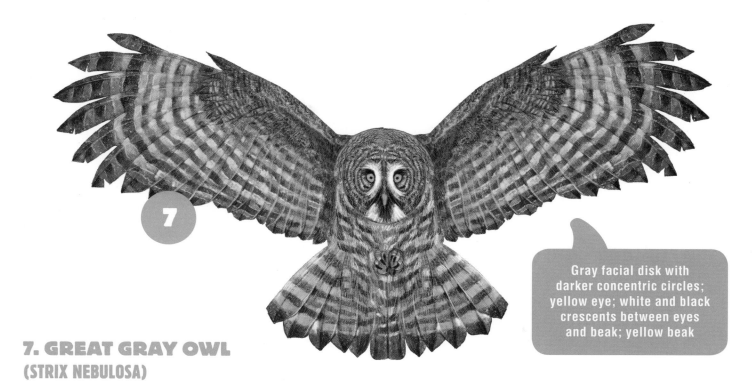

Gray facial disk with darker concentric circles; yellow eye; white and black crescents between eyes and beak; yellow beak

7. GREAT GRAY OWL
(STRIX NEBULOSA)

The great gray owl is a nocturnal bird of prey with a slender, elongated body. The female is larger but the plumage is similar in both sexes: light gray-brown on the back, and whitish with gray-brown vertical stripes on the underparts. The head is large and round, without ear tufts and with a large facial disk marked by fine gray concentric circles. It lives in forests with plenty of grassy clearings where it hunts, especially at dusk. Despite its size, the great gray owl is not a strong predator and mainly catches small rodents, such as voles and mice.

LENGTH: 24–33 inches (61–84 cm)

WEIGHT: male 1–2.5 pounds (570–1,100 g); female 2–4 pounds (980–1,900 g)

8. CEDAR WAXWING
(BOMBYCILLA CEDRORUM)

The cedar waxwing is a songbird of medium–small size, distinguished by its soft, silky plumage. The back is gray-brown while the rump, wings, and tail are gray, the latter ending with a yellow band. The head is a more intense tawny color, as is the soft backward-facing crest, and it has a black mask that extends from the beak to the nape. The belly is pale yellow and the undertail is white. The secondary flight feathers end in a small waxy formation, like a bright red droplet. The cedar waxwing eats mainly berries, fruits, and pine nuts, as well as insects in spring and summer.

LENGTH: 6–7 inches (16–18 cm)

WEIGHT: 1–1.3 ounces (31–35.5 g)

Sturdy, conical black beak; black eye; dense triangular crest

Tawny crest; black mask edged with white; short black beak; red "droplets" on the secondaries

9. AMERICAN KESTREL
(FALCO SPARVERIUS)

The American kestrel is the smallest of the North American diurnal birds of prey. They are easily seen—often perching at the top of a tree or a pole, or while seemingly suspended in the air as they hover, ready to dive on a large insect or a small rodent. The male has very contrasted plumage, tawny on the back and tail and gray-blue on the head and wings. The tail ends with a black band and a white border. The female, which is slightly larger, is darker on the back and wings. On the nape there are two small black spots, which a predator looking down from above might mistake for a pair of eyes, prompting it to abandon its attack.

LENGTH: 8–12 inches (21–31 cm)

WEIGHT: male 3–5 ounces (80–143 g); female 3–6 ounces (84–165 g)

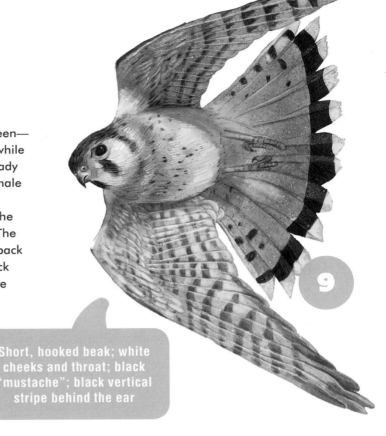

Short, hooked beak; white cheeks and throat; black "mustache"; black vertical stripe behind the ear

10. MOUNTAIN BLUEBIRD
(SIALIA CURRUCOIDES)

As its name implies, this bird is distinguished in the case of the male by its deep blue plumage on the upper parts, with a paler breast and belly and a white undertail; the female is grayish with blue tones on the wings, rump, and tail. Its habitat consists of mountain meadows with scattered conifer groves. It feeds on insects, which it catches on the ground or in flight by launching from an exposed perch. In winter these birds generally undertake a partial migration by moving a little farther south and to lower altitudes.

LENGTH: 6.5–8 inches (17–20 cm)

WEIGHT: 1–1.2 ounces (27–33 g)

11. LAZULI BUNTING
(PASSERINA AMOENA)

The lazuli bunting is a small bird common in bushy areas and at the edges of glades in broadleaf forests. The male is very colorful, with a bright blue head, neck, and throat, a blue back and tail, a white belly, and a cinnamon-colored band on the breast. The wings are dark with two whitish bars. The female's coloring is less bright, with a light-brown back and blue tones on the wings, rump, and tail. The male marks out its territory by moving around its "frontiers" and stopping to perch on a number of high spots—protruding branches, the tops of bushes, telephone poles, and so on—from which to voice its melodious song.

LENGTH: 5–5.5 inches (13–14 cm)

WEIGHT: 0.5–0.7 ounce (13–19.5 g)

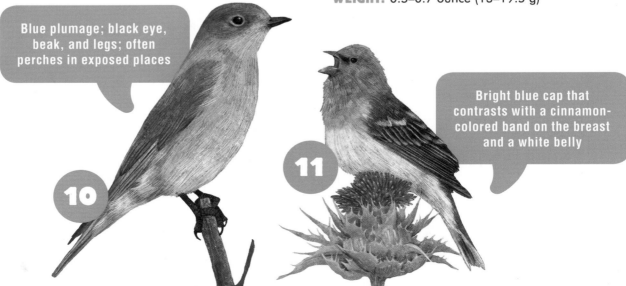

Blue plumage; black eye, beak, and legs; often perches in exposed places

Bright blue cap that contrasts with a cinnamon-colored band on the breast and a white belly

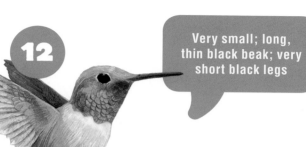

Very small; long, thin black beak; very short black legs

Like all woodpeckers, it has two toes pointing forward and two backward to give a better grip on tree trunks

12. RUFOUS HUMMINGBIRD
(SELASPHORUS RUFUS)

Hummingbirds are typical of tropical forests, and the rufous hummingbird is the only species that ventures north to the Rocky Mountains and beyond. The male is reddish brown on the upper parts and sides, with a white breast and an iridescent orange-red bib on the throat. The female has more subdued colors and green upper parts. Like all hummingbirds, the rufous hummingbird feeds almost exclusively on the nectar of many flowers, with the addition of a few small insects; when one finds a flowering bush rich in nectar, it remains beside it even after feeding, ready to chase away any other hummingbird that approaches.

LENGTH: 3–4 inches (8–10 cm)

WEIGHT: 0.10–0.15 ounce (2.9–3.9 g)

13. NORTHERN FLICKER
(COLAPTES AURATUS)

The northern flicker is a medium-sized woodpecker with very colorful plumage. There are three different populations, with slight differences in plumage: The one in the Rocky Mountains has a gray-brown back striped with black; the breast and flanks are light cinnamon scattered with round black spots; the cap and head are gray, with the forehead and the area around the eye being cinnamon-colored and the male sporting a red "mustache"; and there is a black crescent separating the gray of the throat from the breast. The rump and the undertail are white with patches of black, while the underside of the tail and wings and the edges of the primary feathers are salmon pink.

LENGTH: 13–14 inches (32–36 cm)

WEIGHT: 3.5–6 ounces (106–164 g)

14. AMERICAN ROBIN
(TURDUS MIGRATORIUS)

The American robin is the best-known bird in North America, widespread in most habitats from mountain forests to city parks. The male's plumage is very contrasted, with brick-red underparts, dark gray upper parts, and a black head. The female is similar in appearance but has slightly more subdued overall coloring. The American robin lives up to its specific name of *migratorius*—migratory—and in winter it migrates south; when it returns to its breeding territory at the beginning of spring, the male's long, melodious song is considered a sign that the seasons have turned and the warm weather has arrived.

LENGTH: 9–11 inches (23–28 cm)

WEIGHT: 2–3.5 ounces (59–94 g)

Yellow beak with gray tip; brown eye; white patch around the eye

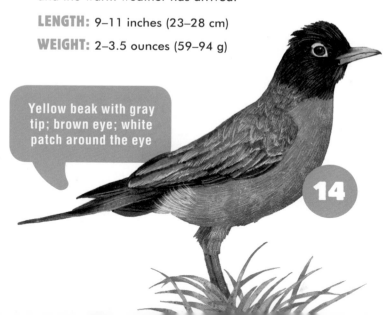

Male: black eye; red webbed feet; bright red beak with black tip

15

15. COMMON MERGANSER
(MERGUS MERGANSER)

The common merganser, also known as a goosander, is the largest of the mergansers, and like all the members of this family it is distinguished by a long, thin beak with a hooked tip and serrated edges that is ideal for holding on to the slippery bodies of the fish on which it feeds. The male is white and black, with a dark green head with a metallic shimmer and a crest on the nape that forms a sort of bulge. The female is gray, with a brown head that contrasts with the white throat and breast and a tousled reddish crest. The chicks are able to swim as soon as they hatch out of the egg, but the mother often carries them on her back to give them a rest.

LENGTH: 23–28 inches (58–72 cm)

WEIGHT: male 3–4.5 pounds (1.3–2.1 kg); female 2–3.5 pounds (900–1,700 g)

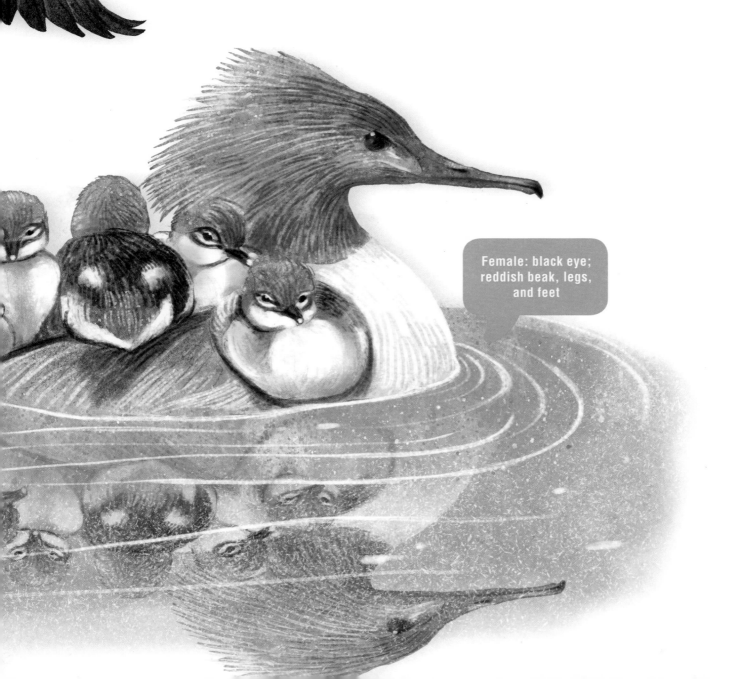

Female: black eye; reddish beak, legs, and feet

> Yellow eye; short black beak; grayish legs and feet; long, curved black claws

16. OSPREY
(PANDION HALIAETUS)

The osprey is a medium-sized bird of prey with long wings, light and agile in flight. Its plumage is brown on the upper parts and white on the underparts; it has a brown band across the eyes extending from the beak to the nape; the throat has some vertical brown stripes, and the underside of the tail is barred in white and brown. The osprey feeds exclusively on fish, which it catches by flying over the surface of the water and diving with outstretched claws; its claws are long and curved, and the toes are covered on the underside with little spines, or spicules, that help it keep a grip on slippery prey like fish.

LENGTH: 22–23 inches (55–58 cm)

WEIGHT: male 2–4 pounds (990–1,800 g); female 2.5–4.5 pounds (1.2–2.05 kg)

17. COMMON LOON OR GREAT NORTHERN DIVER
(GAVIA IMMER)

Common loons are diving birds that frequent lakes whose banks are rich in vegetation where they can hide their nests; they prefer to winter along seacoasts. They dive effortlessly, reaching depths of as much as 200 feet (60 m) and remaining underwater for two or three minutes. Their spring and summer plumage is black on the back, with regular rows of white spots; the head and neck are dark metallic green. Their winter livery is gray-brown on the upper parts and white on the underparts. In the breeding season they utter a distinctive call: a long, tremulous, and melancholy song, which can be heard mainly at dusk and at night.

LENGTH: 27–36 inches (69–91 cm)

WEIGHT: 6–10 pounds (3–4.5 kg)

> Red eye; sturdy, conical black beak; collar with black and white stripes on the sides of the neck and on the throat

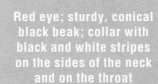

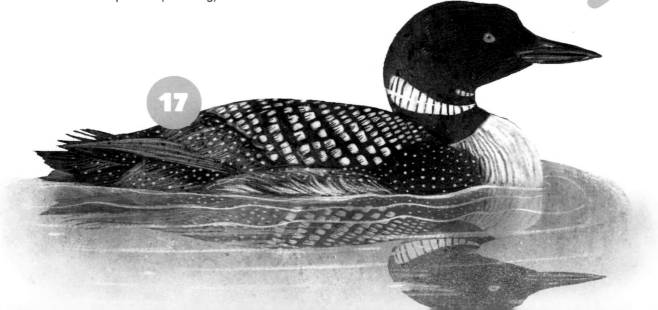

18. BALD EAGLE
(HALIAEETUS LEUCOCEPHALUS)

The bald eagle is a large sea eagle with long, square wings and a wingspan of over 6.5 feet (2 m). The dark brown plumage of the body contrasts with its white head and tail. These eagles are widespread near large lakes and rivers or along the seacoast, and in winter they are concentrated mainly on the coast or on large rivers where salmon come to spawn. Their nest is a mound of branches placed in a large tree, which they build up year after year until it reaches a considerable size. Despite its majestic and powerful appearance, the bald eagle feeds mainly on fish and small mammals. Since 1782 it has been the symbol of the United States of America.

LENGTH: 29–36 inches (74–92 cm)

WEIGHT: male 7–12 pounds (3–5.5 kg); female 8–15 pounds (3.5–7 kg)

19. HOODED MERGANSER
(LOPHODYTES CUCULLATUS)

The hooded merganser is a diving duck that has a long, thin beak with serrated edges. The male is unmistakable thanks to a tuft that extends from the forehead to the nape; this is often kept flattened, but it can be raised to form a white crescent fringed with black. The plumage is black and white, with cinnamon-colored flanks. The female is gray-brown with a reddish crest. The hooded merganser nests by small freshwater ponds surrounded by woods and feeds on aquatic insects, fry (young fish), and small frogs.

LENGTH: 17–20 inches (42–50 cm)

WEIGHT: 1–2 pounds (453–910 g)

Large white crest fringed with black; golden-yellow eye; black beak with serrated edges

Long, curved, sharply pointed bright yellow beak; yellow feet with long, curved talons

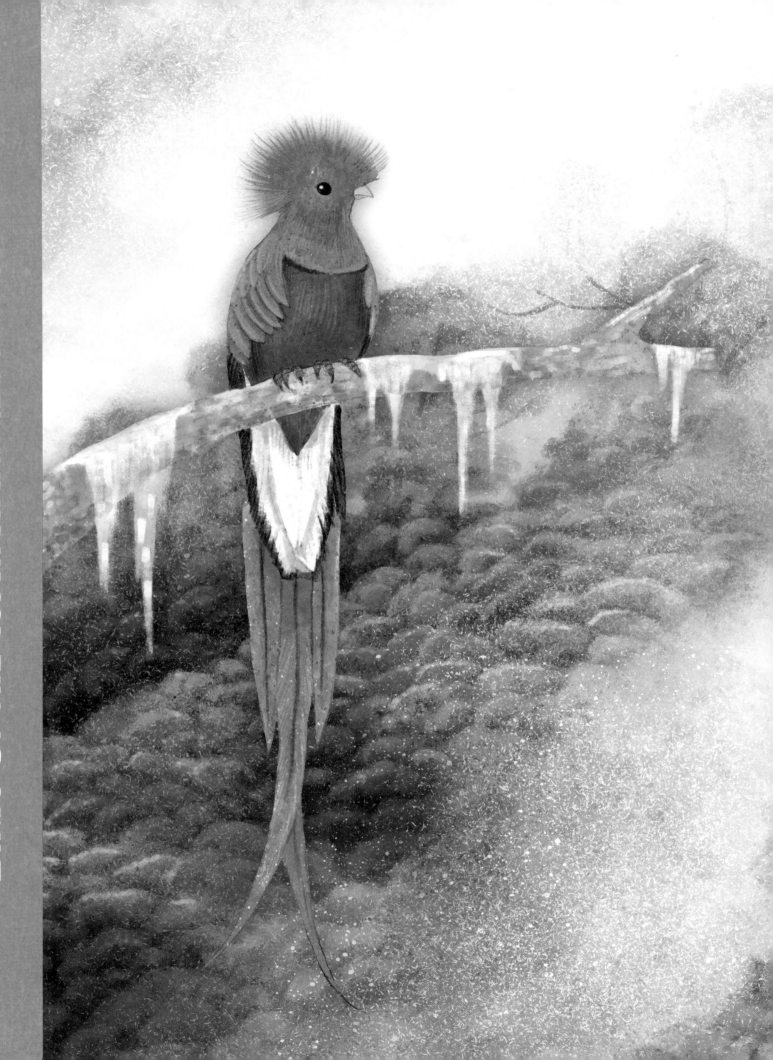

BIRDS OF THE COSTA RICAN CLOUD FOREST

osta Rica is a small country located on the narrow strip of land that connects North America to South America. Despite its small size, it is home to almost 900 different species of birds—more than the United States and Canada combined and almost 10 percent of all bird species present on Earth today—of which more than 600 live in Costa Rica throughout the year. The land is harsh, with mountains over 5,000 feet (1,500 m) high and dozens of volcanoes—many of which are still active—and its geographical location between the Caribbean Sea and the Pacific Ocean, with the presence of widely differing habitats, favors an extraordinary biodiversity. Costa Rica has beaches, savannas, tropical forests, dry broadleaf (or "tropical dry") forests, and rain forests; overall, forests cover more than a quarter of the country. Twenty-five percent of the territory of Costa Rica is preserved in the form of national parks and other protected areas, and this also contributes to preserving its exceptionally rich biodiversity.

In the following pages, we have chosen to show mainly the birds of one of Costa Rica's most distinctive and unique natural environments: the cloud forest. This is a forest permanently shrouded in unmoving mists lying wreathed about the upper part of the mountains; the high level of humidity favors the growth of mosses, lichens, epiphytes (plants that grow on the trunks of other plants), and ferns. Among the typical birds of these ecosystems, the place of honor belongs to the RESPLENDENT QUETZAL (in the drawing) with bright green and red plumage and a very long tail: a bird whose appearance is so fascinating that it is known as "the most beautiful bird in the world." But there are many other spectacular birds present here, too, from the majestic harpy eagle to the king vulture, from toucans to colorful tanagers—not forgetting the dozens of hummingbirds that can hover motionless in the air as they dip their beaks into the corollas of flowers to feed on sugary nectar.

CENTRAL AMERICA

1. HARPY EAGLE
(HARPIA HARPYJA)

The harpy is one of the largest eagles in the world and the largest forest-dwelling bird of prey. Despite its bulk, it hunts among the trunks and branches with ease, catching mainly mammals that live in trees, like coati, young sloths, monkeys, and, more rarely, birds. The upper parts are slate gray, the underparts white with a black band on the breast, and the flanks and crural feathers striped with black; the head is light gray. The black tail has three gray bands on the upper side and three white bands on the underside. The harpy eagle is the national bird of Panama and is depicted on that nation's coat of arms. It is very rare and threatened with extinction due to the destruction of the forests where it lives.

LENGTH: 35–41 inches (89–105 cm)

WEIGHT: male 9–17.5 pounds (4–8 kg); female 13–20 pounds (6–9 kg)

Long forked tail; thin, hooked black beak; black eyes

2. SWALLOW-TAILED KITE
(ELANOIDES FORFICATUS)

The swallow-tailed kite, so called because of its very elongated outer tail feathers, is a bird of prey with gray, white, and black plumage, long and pointed wings, and a deep-forked tail. Seen from below, it is unmistakable, all white except for its black flight feathers and tail feathers; the upper parts are iron gray, with darker, blackish shoulders, and the head is white. It has a light, agile flight and spends a lot of time hovering above the treetops and especially above clearings and open spaces, ready to swoop on its prey: insects, especially termites and flying ants; lizards; and small snakes that it usually catches with its feet and often eats in flight.

LENGTH: 20–26 inches (52–66 cm)

WEIGHT: 11–22 ounces (325–612 g)

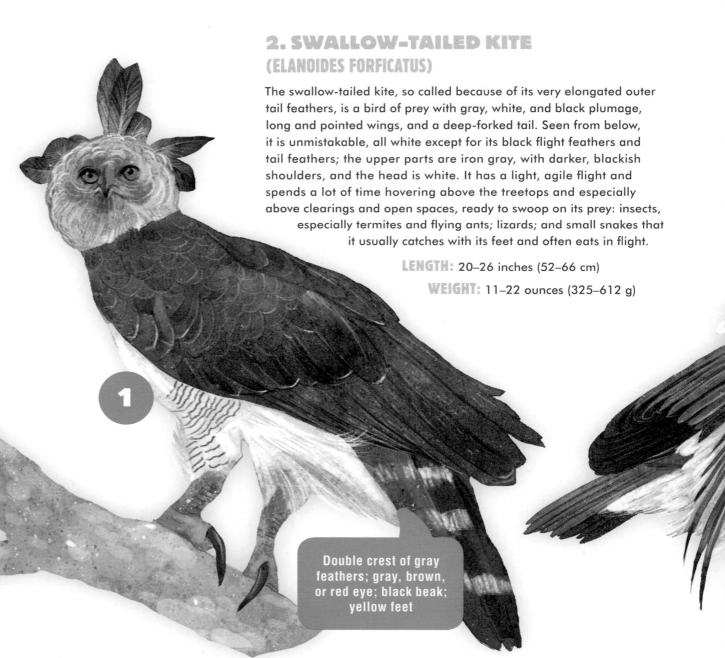

Double crest of gray feathers; gray, brown, or red eye; black beak; yellow feet

3. SQUIRREL CUCKOO
(PIAYA CAYANA)

The squirrel cuckoo is so named because of its habit of running along the branches and jumping from one to another, just like squirrels do. The head and upper parts are tawny, with a paler throat, a gray chest, and a black belly. The tail is very long and tapered, its tawny feathers with black-and-white tips getting longer and longer toward the center. Squirrel cuckoos catch large insects, such as grasshoppers and cicadas, and caterpillars, including those covered with stinging hairs; they have often been seen to follow alongside columns of army ants on the march, so as to catch the insects that flee in panic ahead of the ants' dense ranks.

LENGTH: 16–20 inches (40.5–50 cm)

WEIGHT: 2.5–5 ounces (73–137 g)

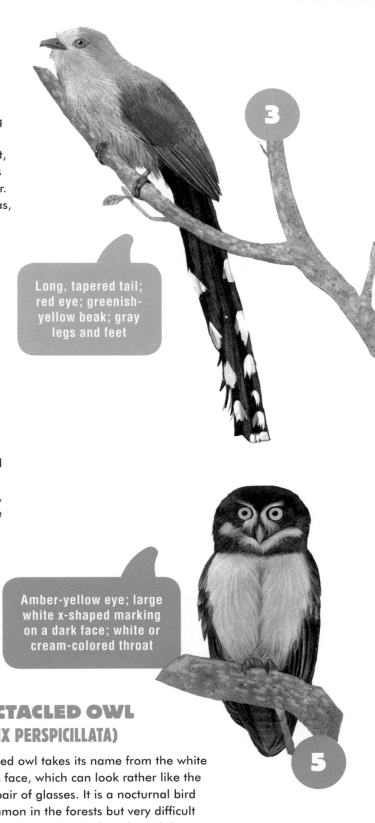

Long, tapered tail; red eye; greenish-yellow beak; gray legs and feet

4. KING VULTURE
(SARCORAMPHUS PAPA)

The king vulture has broad, square wings and a short, wide tail. The plumage is creamy white on the whole body, in contrast with the black flight feathers and tail feathers. A thick collar of gray feathers surrounds the base of the neck; the neck itself is bare of feathers and colored red, with yellow on the throat. The head is also bare, but partly covered by a sparse, bristly blackish down; it has large orange, yellow, gray, and black caruncles on the sides of the head and on the forehead. The king vulture feeds on dead animals that it seeks out by flying over the woods and clearings for hours, most likely using its sense of smell as well as sight to find them.

LENGTH: 28–32 inches (71–81 cm)

WEIGHT: 6.5–8 pounds (3–4 kg)

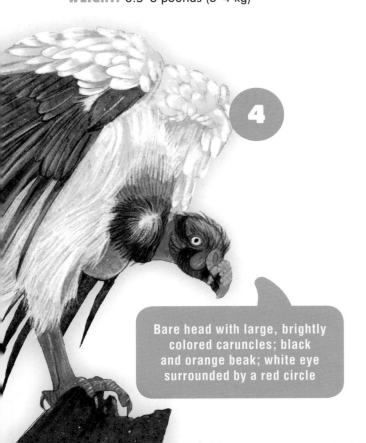

Bare head with large, brightly colored caruncles; black and orange beak; white eye surrounded by a red circle

Amber-yellow eye; large white x-shaped marking on a dark face; white or cream-colored throat

5. SPECTACLED OWL
(PULSATRIX PERSPICILLATA)

The spectacled owl takes its name from the white marks on its face, which can look rather like the frame of a pair of glasses. It is a nocturnal bird of prey, common in the forests but very difficult to see because it remains sheltered amid dense foliage during the day. The head, the breast, and the upper parts are coffee-colored; the lower parts are pale, a whitish or creamy color of varying intensity; the face and throat are smudged with white. Spectacled owls hunt at night, catching large insects, small mammals, lizards, and small birds.

LENGTH: 17–20 inches (43–52 cm)

WEIGHT: 1–2 pounds (550–980 g)

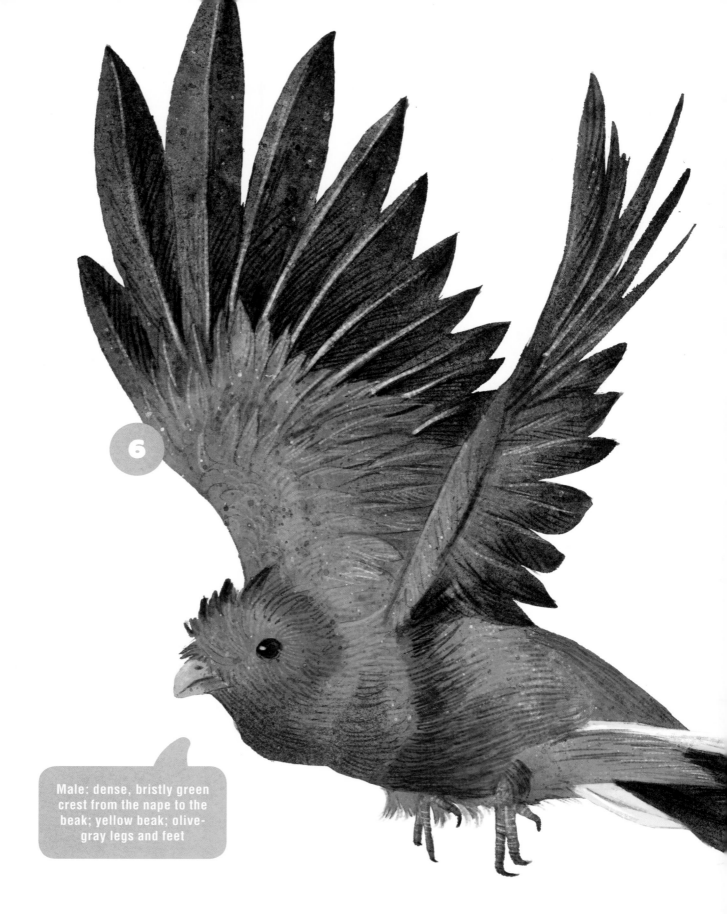

6

Male: dense, bristly green crest from the nape to the beak; yellow beak; olive-gray legs and feet

6. RESPLENDENT QUETZAL
(PHAROMACHRUS MOCINNO)

The male resplendent quetzal is one of the most spectacular birds in the world, with metallic green plumage on the upper parts, the head, the throat, and the upper breast, and carmine red on the lower breast and belly. The coverts of the wings extend to cover the flanks, while the four tail coverts, very elongated and flexible, form a long train. The tail itself is white with black central tail feathers. The resplendent quetzal was a sacred bird to the Maya and the Aztecs, and its feathers adorned the headdresses of the emperors. Today it is the national symbol of Guatemala and also lends its name to that country's currency.

LENGTH: male 14–16 inches (36–40 cm) plus up to 26 inches (65 cm) of elongated tail coverts; female 14–15 inches (36–40 cm) in total—they do not have a long tail train

WEIGHT: 6.5–9 ounces (180–250 g)

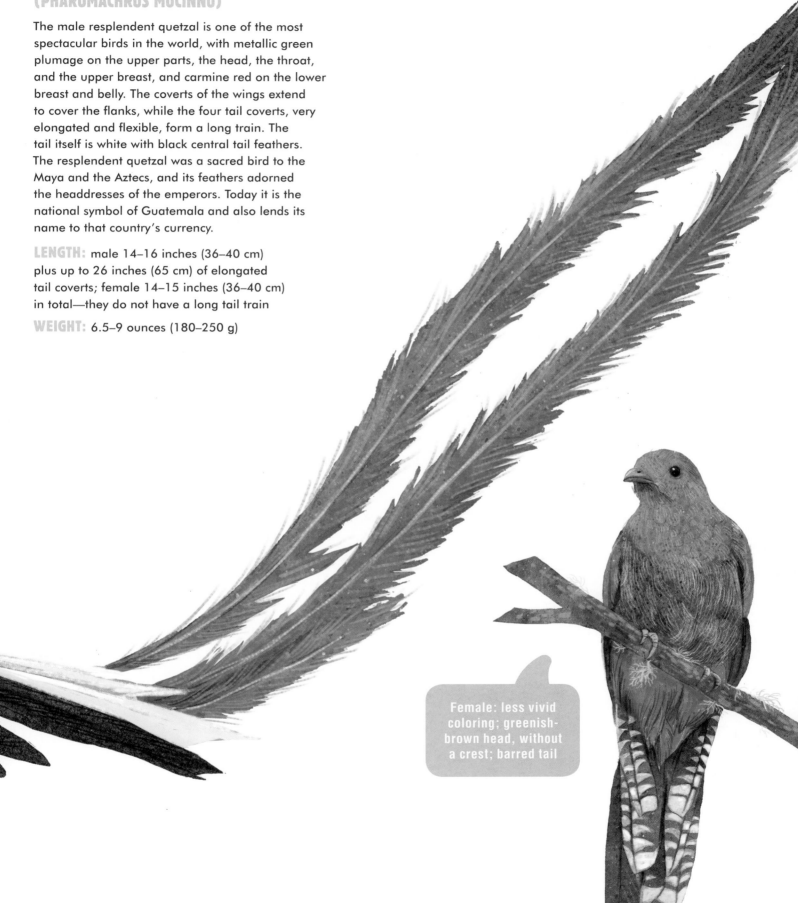

Female: less vivid coloring; greenish-brown head, without a crest; barred tail

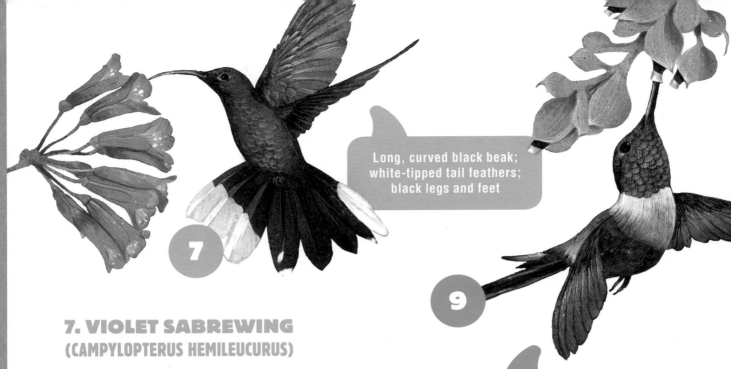

Long, curved black beak; white-tipped tail feathers; black legs and feet

Long, thin black beak; black legs and feet; forked tail

7. VIOLET SABREWING
(CAMPYLOPTERUS HEMILEUCURUS)

The violet sabrewing is a relatively large hummingbird, with a long, slightly down-curved beak. The male has mainly dark violet plumage, with the shoulders and back in metallic dark green. The tail is blackish, but the three outermost tail feathers are half-white. The female is dark green on the upper parts and gray on the underparts, with a violet throat; the tail is half-white, like that of the male. Like all hummingbirds, violet sabrewings feed on the nectar of flowers; this species especially prefers the flowers of the banana tree and the red inflorescences of heliconias. Despite their size, they are not very aggressive toward other hummingbirds and rarely defend flowering bushes.

LENGTH: 5–6 inches (13–15 cm)

WEIGHT: male 0.4 ounce (11.8 g); female 0.3 ounce (9.5 g)

8. MAGNIFICENT OR
RIVOLI'S HUMMINGBIRD
(EUGENES FULGENS)

Long, straight black beak; white spot behind the eye; black legs and feet

The magnificent or Rivoli's hummingbird is among the largest hummingbirds in the high-altitude forests. The male has dark bronze-green upper parts and breast, a black head with a violet crown, a bright green throat, and a white spot behind the eye. The female has bronze-green coloring on the upper parts, including the crown of the head, and grayish underparts; the throat is speckled with fawn. The beak is long, straight, and thin. In the breeding season the males defend the flowers of giant thistles, and both sexes feed on the nectar of epiphytes and many flowers, including those of the passionflower and fuchsia.

LENGTH: 4.5–5 inches (11–13) cm

WEIGHT: 0.2–0.3 ounce (7–7.5 g)

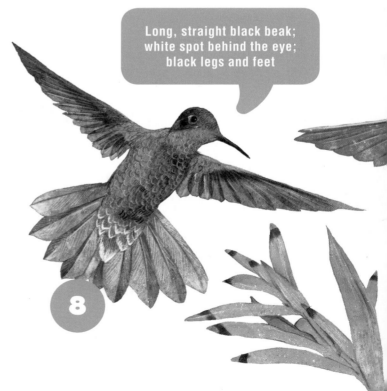

9. MAGENTA-THROATED WOODSTAR
(CALLIPHLOX BRYANTAE)

The magenta-throated woodstar is a hummingbird of rather small size, distinguished by a forked tail with elongated outer tail feathers. The plumage of the male is bronze-green on the upper parts, with two creamy-white spots at the base of the back; the underparts are greenish on the breast and reddish on the belly, and there is an eye-catching white collar that separates the breast from the throat, which is purple with a metallic shimmer. The female has similar but less bright plumage, a cream-colored throat, and a short tail with fawn-colored lateral tail feathers. This hummingbird feeds on the nectar of the flowers of various trees, bushes, and even grasses, which it defends fiercely during their flowering period.

LENGTH: 3–3.5 inches (7.5–9 cm)

WEIGHT: 0.1 ounce (3.5 g)

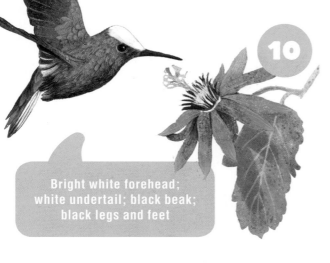

Bright white forehead; white undertail; black beak; black legs and feet

10. SNOWCAP
(MICROCHERA ALBOCORONATA)

The snowcap is a small hummingbird with a relatively short beak and a short, rounded tail. The male is unmistakable, with predominantly wine-red plumage and a brilliant white forehead. The tail is bronze-colored, with whitish lateral tail feathers with a blurred dark brown band at the end. The female is green on the upper parts and white on the underparts. The snowcap hummingbird feeds mainly on nectar from different trees that have small flowers, where its rather short beak can still reach the nectar at the base of the calyx (a flower bud's protective layer). Males often defend a feeding area, but are easily chased away by larger hummingbirds.

LENGTH: 2.4–2.6 inches (6–6.5 cm)

WEIGHT: 0.1 ounce (2.5 g)

11. FIERY-THROATED HUMMINGBIRD
(PANTERPE INSIGNIS)

The fiery-throated hummingbird has very colorful, bright plumage that is especially dazzling in particular light conditions. The general coloring is green, brighter on the shoulders and underparts; the head is blackish with a brilliant blue crown and a white spot behind the eye; the throat is bright orange-red, and there is a bright violet-blue spot at the center of the breast; the tail is violet-blue. The male and female are similar in appearance. They feed mainly on nectar from the flowers of epiphytes that grow on tree trunks; they are very aggressive and often defend clusters of nectar-rich flowers.

LENGTH: 4.1–4.3 inches (10.5–11 cm)

WEIGHT: male 0.21–0.22 ounce (5.9–6.2 g); female 0.17–0.18 ounce (4.9–5.2 g)

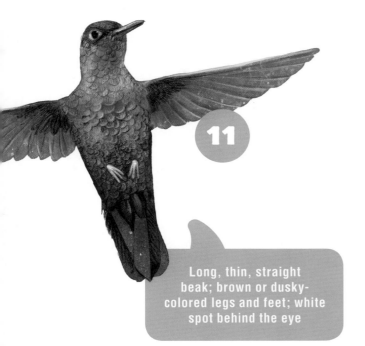

Long, thin, straight beak; brown or dusky-colored legs and feet; white spot behind the eye

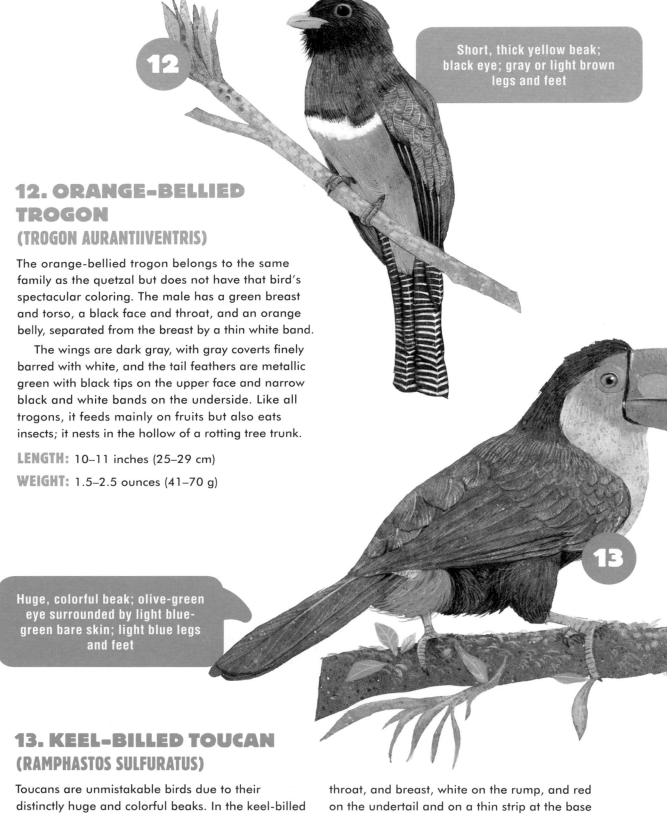

12

Short, thick yellow beak; black eye; gray or light brown legs and feet

12. ORANGE-BELLIED TROGON
(TROGON AURANTIIVENTRIS)

The orange-bellied trogon belongs to the same family as the quetzal but does not have that bird's spectacular coloring. The male has a green breast and torso, a black face and throat, and an orange belly, separated from the breast by a thin white band.

The wings are dark gray, with gray coverts finely barred with white, and the tail feathers are metallic green with black tips on the upper face and narrow black and white bands on the underside. Like all trogons, it feeds mainly on fruits but also eats insects; it nests in the hollow of a rotting tree trunk.

LENGTH: 10–11 inches (25–29 cm)

WEIGHT: 1.5–2.5 ounces (41–70 g)

Huge, colorful beak; olive-green eye surrounded by light blue-green bare skin; light blue legs and feet

13

13. KEEL-BILLED TOUCAN
(RAMPHASTOS SULFURATUS)

Toucans are unmistakable birds due to their distinctly huge and colorful beaks. In the keel-billed toucan the beak is green, blue, and orange, with a dark red tip and a black line all around the base. The plumage is also colorful: black on most of the body, with hints of dark brown on the shoulders and the back of the neck, bright yellow on the face, throat, and breast, white on the rump, and red on the undertail and on a thin strip at the base of the breast. The keel-billed toucan feeds on seeds, berries, and fruits, which it grips with the end of its beak and then swallows by tipping its head back.

LENGTH: 18–20 inches (46–51 cm)

WEIGHT: male 9.5–19 ounces (275–550 g); female 9–18 ounces (250–500 g)

14. THREE-WATTLED BELLBIRD
(PROCNIAS TRICARUNCULATUS)

The name *bellbird* refers to the song of the male, whose deep metallic notes can be heard as far as 1,500 feet (450 m) away; the three wattles, for their part, refer to three fleshy growths that look like black worms, located on either side of the beak and above it. The two sexes of the three-wattled bellbird are very different in appearance: the male's body is tawny all over with a white head, neck, throat, and upper breast, while the female is olive green on the upper parts and yellow flecked with green on the underparts. In the breeding season, the male sings for a long time from the top of a tall tree, opening its mouth wide to reveal a black interior.

LENGTH: male 12 inches (30 cm); female 10 inches (25 cm)

WEIGHT: male 7.5 ounces (210 g); female 5 ounces (145 g)

Male: black beak; wide mouth with black interior; bare gray skin between the beak and the eye

Female: green and yellow plumage; black beak; dark gray legs and feet

14

15. SULPHUR-WINGED PARAKEET
(PYRRHURA HOFFMANNI)

The sulphur-winged parakeet, also known as Hoffmann's conure, is a medium-sized parrot. It has a light horn-colored beak, a green head and neck, a green breast with a yellow shimmer, and a crimson ear patch; the wings have light blue primary flight feathers and bright yellow secondary feathers, and the tail has a reddish tinge. These birds are gregarious in their behavior, moving from tree to tree in search of food in groups that can number as many as a dozen. They mainly eat fruits and seeds, which they crack with a sturdily built beak, and they nest in natural holes in trees or in the abandoned nests of woodpeckers.

LENGTH: 9–9.5 inches (23–24 cm)

WEIGHT: 3 ounces (82 g)

Brown-gray eye with whitish eye-ring; light horn-colored beak; gray legs and feet

15

Black eye; short, thick black beak; gray legs and feet

16. EMERALD TANAGER
(TANGARA FLORIDA)

The emerald tanager has mainly green and black plumage. The face, throat, breast, and belly are brilliant emerald green; the nape and back have yellowish shades; the rump is bright yellow, and the lower belly is a duller yellow. It has black coloring all around the base of the beak, on the region around the ears, and in long stripes on the shoulders and back. The wings have black primary flight feathers and black secondaries with green edges; the tail feathers are also black with green edges. The female has similar but less bright coloring. Emerald tanagers often join with other small birds in search of insects, spiders, and small fruits.

LENGTH: 4.5 inches (12 cm)

WEIGHT: 0.6–0.7 ounce (16.5–20.5 g)

Black eye; short, conical black beak; dark brown legs and feet

17. GOLDEN-HOODED TANAGER
(TANGARA LARVATA)

This tanager has colorful plumage and a mask around the eyes; the mask itself is black and contrasts with the ocher-colored crown of the head, throat, and neck, and it has a light violet-blue forehead and cheeks. The breast and upper parts are black, but the rump and tertial coverts are light blue, as is the belly, while the lower belly is white. The tail feathers and the flight feathers are black with green edges, while the secondary coverts are black with light blue edges. It feeds mainly on fruits and seeds, but also eats the insects it catches on leaves or while on the wing.

LENGTH: 4.5 inches (12 cm)

WEIGHT: 0.5–1 ounce (17.1–23.9 g)

Bright red eye; thin black beak; black legs and feet

18. SCARLET-THIGHED DACNIS
(DACNIS VENUSTA)

The scarlet-thighed dacnis is also a member of the tanager family of small birds with colorful plumage. The male dacnis is black and turquoise, with the exception of the feathers that cover the upper legs; these are scarlet, as referenced in the species' name in several languages. The face, throat, breast, belly, wings, and tail are a brilliant glossy black, while the head and upper parts are turquoise blue. The female's coloring is much less bright than the male's, with greenish upper parts and light gray-brown underparts. They often join together with other tanagers in search of fruits and seeds with a fleshy covering.

LENGTH: 4.5 inches (12 cm)

WEIGHT: 0.5–0.6 ounce (15–17 g)

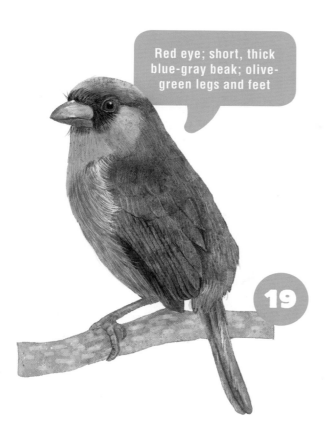

Red eye; short, thick blue-gray beak; olive-green legs and feet

19. PRONG-BILLED BARBET
(SEMNORNIS FRANTZII)

The prong-billed barbet is a bird with a compact, sturdily built body, short wings and tail, very powerful legs, and a big, strong beak that it uses to dig out its nest in tree trunks like a woodpecker. The plumage is mainly olive green on the upper parts, wings, and tail, with ocher yellow, of lesser or greater intensity, on the forehead, cheeks, throat, and breast, and light olive on the belly. There is a gray spot on either side of the breast, and a blackish mask around the beak and eyes. The prong-billed barbet is very territorial in the breeding season, and pairs work together to raise their offspring. For the rest of the year they live in small bands, and at night a dozen or more individuals may cluster together to sleep in the same hole.

LENGTH: 7 inches (18 cm)

WEIGHT: 2–2.5 ounces (54.5–72 g)

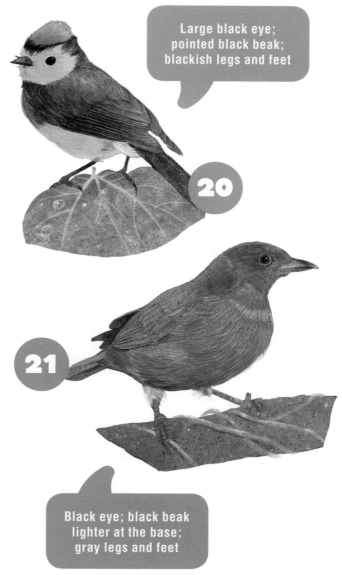

Large black eye; pointed black beak; blackish legs and feet

20. COLLARED WHITESTART
(MYIOBORUS TORQUATUS)

A small black and yellow bird, the collared whitestart has a showy orange-red crest that can be raised in alarm or excitement. The face, throat, and belly are bright yellow, while the forehead, nape, upper parts, and a band across the breast are black. The wings and tail are also black, while the lower belly is white. The male and female are similar in appearance, and the pair stay together all year. They live in mountain forests with dense undergrowth and feed on insects, sometimes by catching them on leaves or on bark, but usually by launching quick little flights to snatch them out of the air.

LENGTH: 5 inches (13 cm)

WEIGHT: 0.5 ounce (10.5 g)

21. BAY-HEADED TANAGER
(TANGARA GYROLA)

The bay-headed tanager has predominantly green and blue plumage, against which the color of its bright chestnut head stands out. The back, the wing coverts, and the rump are emerald green, with a fine golden band at the base of the neck and a golden-yellow patch on the wrist joint of the wing. The breast and belly are turquoise blue, while the lower belly is green and the crural feathers are reddish. The female has similar but lighter coloring. They usually move around in pairs or family groups and often join together with other tanagers and small birds. They eat mainly seeds, small fruits, and insects.

LENGTH: 4.5 inches (12 cm)

WEIGHT: 0.5–1 ounce (17.5–26.5 g)

Black eye; black beak lighter at the base; gray legs and feet

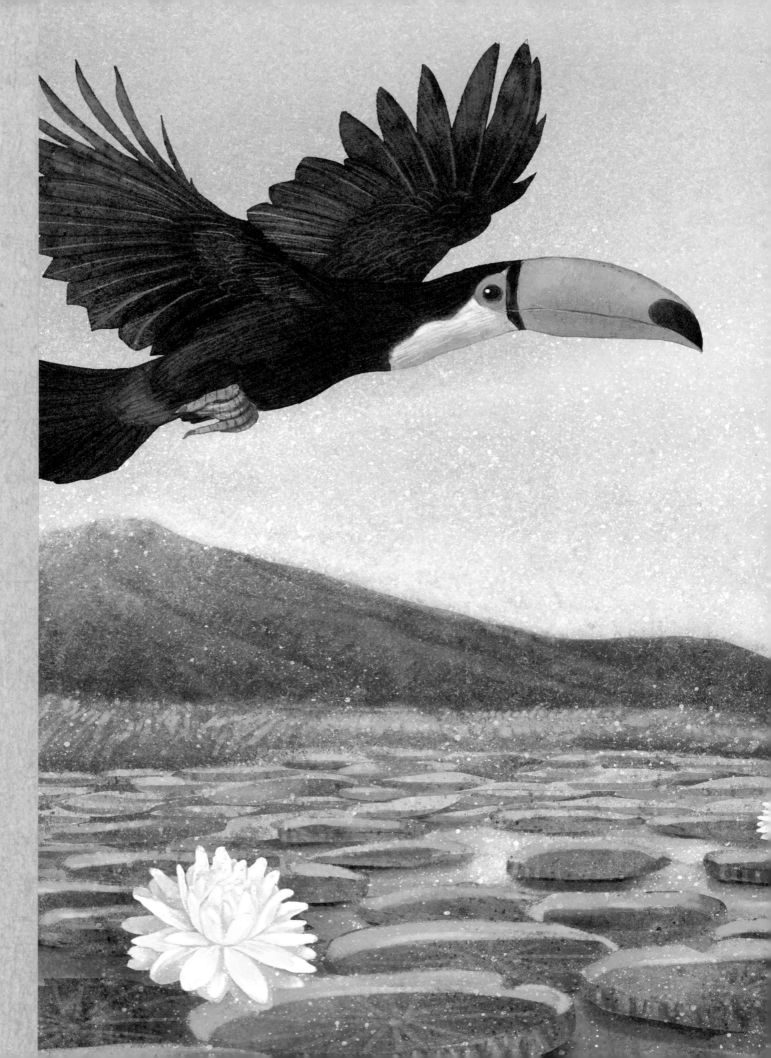

The Pantanal (the name derives from the Portuguese *pântano*, or marsh) is an immense plain subject to regular flooding, where the borders of Brazil, Paraguay, and Bolivia meet. It covers about 58,000 square miles (150,000 km^2)—roughly the size of Illinois. For many months a year, starting in October, when the long rainy season begins, this land is gradually flooded by the waters that pour down from the surrounding highlands and then slowly make their way toward the Paraguay River. At the height of the flood more than 80 percent of the region is covered with water and the great plain becomes an endless mosaic of marshes, channels, and pools separated by brief patches of higher, dry land where bushes and trees grow. It is the largest wetland on the planet, an ecosystem that hosts the greatest number of plants and animals in the world: About 3,500 different plant species have been counted here, together with around 230 species of mammals, 650 species of birds (including both those resident throughout the year and migratory visitors), 80 species of reptiles, and 325 species of fish, not to mention the thousands upon thousands of insects and other invertebrates. Outstanding among the mammals are the giant anteater, the tapir, the capybara, the giant otter, and the jaguar, which can be found in woods along the riverbanks. Among the reptiles, in addition to the caiman (a 1996 census counted as many as ten million individuals!), we might mention the huge yellow anaconda, a snake that can exceed 13 feet (4 m) in length, and the green iguana.

As for the birds, the lion's share is made up of typical wetlands species that find abundant food among the fish, amphibians, and reptiles living in the shallow waters: the jabiru, the other storks, the roseate spoonbill, the herons, the kingfishers. But the water-free meadows and groves are also home to species of great interest, such as the TOCO TOUCAN, with its enormous beak (in the drawing). And, above all, the hyacinth macaw, a marvelous parrot with all-blue plumage, is now seriously threatened by poachers, who catch them to sell on the caged-bird market.

SOUTH
AMERICA

1. ROSEATE SPOONBILL
(PLATALEA AJAJA)

The spoonbills take their name from the unusual shape of their beaks, which are long, flat, and wider at the tip, and which they use to filter muddy water to sieve out crustaceans, aquatic insects, tadpoles, and small fish. In the roseate spoonbill the plumage is pink—more or less intense in color depending on age and season—on the wings and tail; it is white on the neck, back, and underparts, except for a tuft of pink feathers in the center of the breast. The head is bare of feathers, with greenish or yellowish skin. The roseate spoonbill is a gregarious species, and birds often feed together in large groups, advancing through the water with beaks immersed, moving them side to side in a steady rhythm.

LENGTH: 27–34 inches (68–86 cm)

WEIGHT: 2.5–3 pounds (1–1.5 kg)

2. JABIRU
(JABIRU MYCTERIA)

The jabiru, or jabiru stork, is a common presence in the Pantanal. Its large size and all-white plumage, against which its black neck stands out sharply, make it an unmistakable figure as it walks slowly through the shallow water of the marshes, ready to stab eels and other fish with its big sharp beak. In the language family of Tupi-Guarani, the word *jabiru* means "swollen neck" and that is precisely this large stork's most distinctive feature: The neck is extremely thick and has no feathers, its bare black skin having a red ring at the base. Jabirus frequent pools and marshes but build an enormous nest of branches in an isolated tall tree or inside a grove or brushwood.

LENGTH: 48–57 inches (122–144 cm)

WEIGHT: male 13–18 pounds (6–8 kg);
female 9.5–14 pounds (4.5–6.5 kg)

3. WATTLED JACANA
(JACANA JACANA)

The wattled jacana has black plumage on the underparts, the neck, and the head, and chestnut on the back and wing coverts. The tail feathers are greenish yellow, but only show when it is flying. The beak is yellow, with a red frontal shield (sometimes called a head shield) and two caruncles on the sides. Its feet have very long toes, giving it a wide base of support that enables it to walk with ease on the floating leaves of water lilies. The female, which is bigger, has a dominant role in mating and fights with other females to conquer more males. It is the males that then brood the eggs and feed the chicks while the female defends the territory.

LENGTH: 8–10 inches (21–25 cm)

WEIGHT: male 3–4 ounces (81–118 g); female 4.5–5.5 ounces (129–151 g)

Gray beak; pink legs and feet; bare skin on the head; orange eye

Bare black neck with red at the base; large black beak, slightly curved upward; black legs and feet

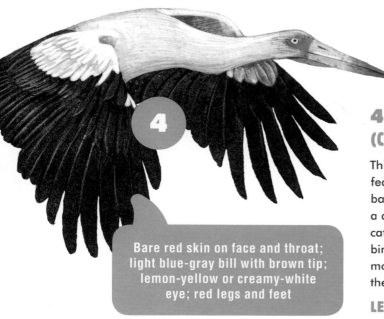

4. MAGUARI STORK
(CICONIA MAGUARI)

This large stork has white plumage with black flight feathers and tail feathers. The tail is very short and forked. The face and throat are bare, with red skin, and the large, pointed beak is light-colored with a dark tip. The maguari stork frequents swamps with shallow water, catching mainly fish, amphibians, and snakes but also rats and small birds. Unlike other storks, it does not nest in trees but builds a large mound of reeds and grasses in the dense vegetation on the shore of the marshes; several pairs will often nest near each other.

LENGTH: 38–43 inches (97–110 cm)

WEIGHT: 8.5–9 pounds (3.8–4.2 kg)

Bare red skin on face and throat; light blue-gray bill with brown tip; lemon-yellow or creamy-white eye; red legs and feet

5. RINGED KINGFISHER
(MEGACERYLE TORQUATA)

The biggest kingfisher on the American continent, the ringed kingfisher has a very large and heavily built beak and a tousled crest that runs from the base of the beak to the neck. The upper parts are light grayish blue and the underparts are rust-colored. The female has a light gray-blue band across the breast, and both sexes have a striking white collar. The ringed kingfisher lives near rivers, lakes, and other bodies of water, feeding on fish that it catches by diving from a perch. It makes its nest at the end of a tunnel dug into the steep bank of a river or stream.

LENGTH: 15–17 inches (38–42 cm)

WEIGHT: 9–11 ounces (255–300 g)

Gray beak with a yellowish base; brown eye; short legs and yellowish toes

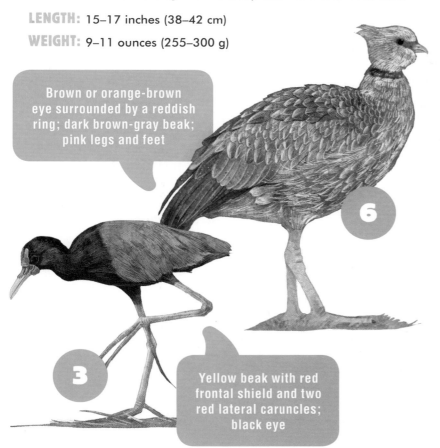

Brown or orange-brown eye surrounded by a reddish ring; dark brown-gray beak; pink legs and feet

Yellow beak with red frontal shield and two red lateral caruncles; black eye

6. SOUTHERN SCREAMER
(CHAUNA TORQUATA)

The southern screamer is related to geese and ducks, although it looks quite different. It is a large bird with mainly gray plumage and dark brownish wings. Its head is small in relation to its body, with a short, pointed beak. It has a short, tousled crest on the nape; at the base of the neck are two rings of feathers—one black, one white. It has two large sharp spurs on its wings that it uses as defensive weapons. It has very strong legs and partially webbed feet. The southern screamer has a loud cry that sounds like a double trumpet blast and can be heard up to 2 miles (3 km) away.

LENGTH: 31–37 inches (80–95 cm)

WEIGHT: 6–9.5 pounds (2.5–4.5 kg)

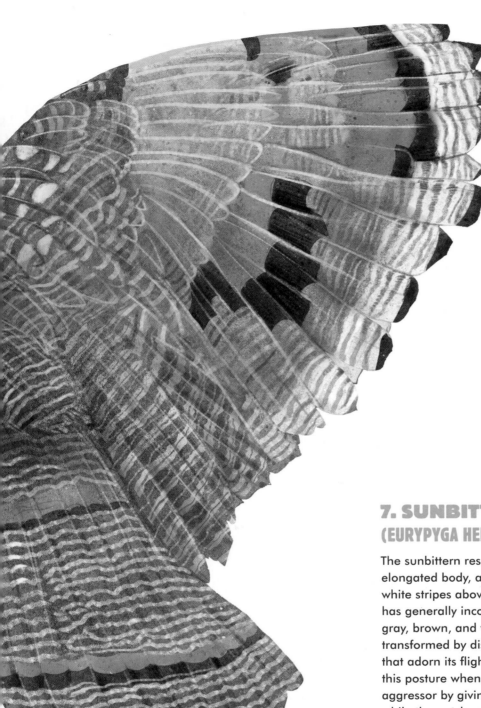

7. SUNBITTERN
(EURYPYGA HELIAS)

The sunbittern resembles a small heron, with shorter legs and a more elongated body, a long, thin neck, a small head with two striking white stripes above and below the eye, and a long, narrow beak. It has generally inconspicuous plumage, mottled and flecked with gray, brown, and white, but when it opens its wings and its tail it is transformed by displaying the large tawny, black, and yellow patches that adorn its flight feathers and tail feathers. The sunbittern adopts this posture when threatened, and probably aims to frighten the aggressor by giving the impression of being much larger than it is, while the patches on the wings may look like two big eyes.

LENGTH: 17–19 inches (43–48 cm)
WEIGHT: 6.5–10 ounces (188–295 g)

8. RUFOUS-TAILED JACAMAR
(GALBULA RUFICAUDA)

The rufous-tailed jacamar is a relatively small bird with a long, tapered tail and a long, thin beak. The plumage is golden-green with a metallic shimmer on the upper parts, breast, and central portion of the tail; the rest of the tail and the underparts are rust red, the chin and throat are white, and there is a dark mask surrounding the eye. The rufous-tailed jacamar frequents clearings and the edges of woods, and feeds on flying insects (butterflies, dragonflies, wasps) that it catches on the wing, launching itself from an exposed branch to which it returns to kill them by beating them vigorously against the branch. Before swallowing its prey, it removes their wings.

LENGTH: 7.5–10 inches (19–25 cm)

WEIGHT: 0.5–1 ounce (18–28 g)

Long, thin black beak; dark brown eye; dark yellow tarsi and dark grayish-brown toes

8

9. RED-LEGGED SERIEMA
(CARIAMA CRISTATA)

The red-legged seriema is a large bird with a slender body, long legs, a long tail, and a long, thin neck. The plumage is dark brown, lighter on the head, neck, and breast, and white on the belly; the tail has a black bar and a white tip. The head is distinguished by a tuft of soft feathers between the beak and the forehead. The crested seriema lives in grasslands near water, either solitary or in small family groups, hunting for insects, lizards, snakes, and small rodents. It kills larger prey by banging it violently against the ground or a hard surface; the second toe has a much larger claw, which is probably also used to dismember prey.

LENGTH: 30–35 inches (75–90 cm)

WEIGHT: 3.5–5 pounds (1.5–2 kg)

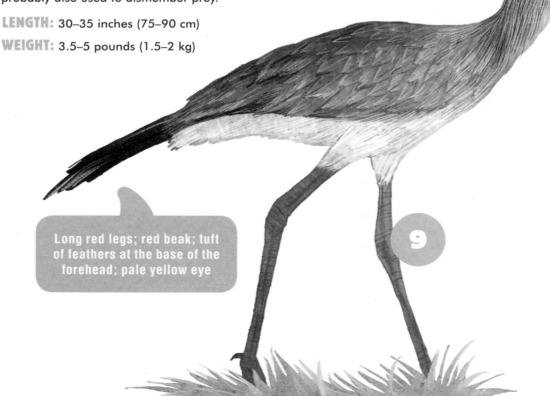

Long red legs; red beak; tuft of feathers at the base of the forehead; pale yellow eye

9

10. SOUTHERN CRESTED CARACARA
(CARACARA PLANCUS)

The southern crested caracara is a bird of prey of the falcon family, but it is not so much an active predator as an opportunist that prefers to feed on carrion, visit landfills, and loot nests by seizing eggs and chicks, and which does not choose to catch insects. The crown of the head, belly, crural feathers, wings, and tip of the tail are a dark brown-black; the breast, back, and upper part of the tail are whitish barred with black, and there is a light-colored area on the primary flight feathers. The throat and cheeks are white, and the black plumage on the head extends into a crest that is often kept lowered.

LENGTH: 20–25 inches (50–64 cm)

WEIGHT: 2.5–3.5 pounds (1–1.5 kg)

> Deep yellow or orange cere and bare skin of the face; gray beak; yellow tarsi

11. PLUSH-CRESTED JAY
(CYANOCORAX CHRYSOPS)

The plush-crested jay is a member of the Corvidae, or crow family, with strikingly colored black, violet-blue, and yellow plumage and a bright yellow eye. The head, neck, and upper part of the breast are black; there are patches of dark blue varying in intensity around the eye and on the nape, and the top of the head has a short, bristly, brush-like crest. The back and wings are dark violet-blue, as is the tail, which ends in a broad pale yellow band; the lower part of the breast and the belly are creamy yellow. The plush-crested jay is a gregarious bird that often looks for food in groups of as many as 10 individuals and feeds mainly on insects and fruits.

LENGTH: 13–14 inches (32–35 cm)

WEIGHT: 4.5–6 ounces (127–170 g)

> Bright yellow eye; dark gray beak; black legs and feet; short, bristly crest running from the forehead to the nape

12. GUIRA CUCKOO
(GUIRA GUIRA)

The guira cuckoo is a medium-sized bird with a long tail and an eye-catching tousled crest that begins on the forehead. Its plumage is dark brown mottled with white on the upper parts, and a light buff on the underparts and rump; the crest is fawn. The guira cuckoo frequents pastures and marshy areas with scattered trees or small woods where it builds its nest; unlike most other cuckoos, it does not lay eggs in the nests of other birds but hatches them itself and raises its own chicks. These birds often move around in noisy groups, hunting for insects, spiders, frogs, mice, and nestlings, which they catch on the ground or in the trees.

LENGTH: 14–17 inches (36–42 cm)

WEIGHT: 3.5–6 ounces (103–168 g)

> Orange-yellow eye and beak; tawny crest; dark gray legs and feet

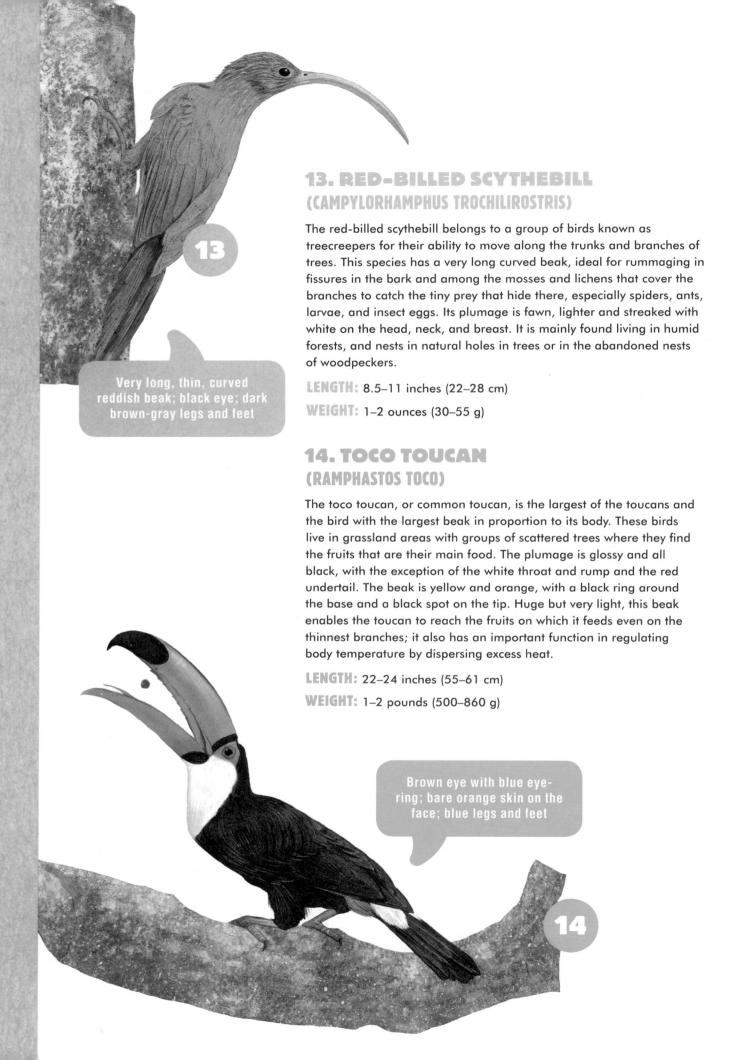

13. RED-BILLED SCYTHEBILL
(CAMPYLORHAMPHUS TROCHILIROSTRIS)

The red-billed scythebill belongs to a group of birds known as treecreepers for their ability to move along the trunks and branches of trees. This species has a very long curved beak, ideal for rummaging in fissures in the bark and among the mosses and lichens that cover the branches to catch the tiny prey that hide there, especially spiders, ants, larvae, and insect eggs. Its plumage is fawn, lighter and streaked with white on the head, neck, and breast. It is mainly found living in humid forests, and nests in natural holes in trees or in the abandoned nests of woodpeckers.

LENGTH: 8.5–11 inches (22–28 cm)

WEIGHT: 1–2 ounces (30–55 g)

> **Very long, thin, curved reddish beak; black eye; dark brown-gray legs and feet**

14. TOCO TOUCAN
(RAMPHASTOS TOCO)

The toco toucan, or common toucan, is the largest of the toucans and the bird with the largest beak in proportion to its body. These birds live in grassland areas with groups of scattered trees where they find the fruits that are their main food. The plumage is glossy and all black, with the exception of the white throat and rump and the red undertail. The beak is yellow and orange, with a black ring around the base and a black spot on the tip. Huge but very light, this beak enables the toucan to reach the fruits on which it feeds even on the thinnest branches; it also has an important function in regulating body temperature by dispersing excess heat.

LENGTH: 22–24 inches (55–61 cm)

WEIGHT: 1–2 pounds (500–860 g)

> **Brown eye with blue eye-ring; bare orange skin on the face; blue legs and feet**

15. CRIMSON-CRESTED WOODPECKER
(CAMPEPHILUS MELANOLEUCOS)

The specific name *melanoleucos* means "black and white," but the distinctive feature of this large woodpecker is actually its bright red head adorned with a crest of feathers of the same color. The plumage of the body is predominantly black, with two white stripes on the sides of the neck that extend over the back; its flanks, lower breast, and belly are a light buff, thickly barred with black. The head has a whitish area at the base of the beak and a small white spot under the cheeks. The female is distinguished by having black plumage on its forehead and the front part of the crest, and two broad white stripes that start from the beak and extend to join the stripes on the neck.

LENGTH: 13–15 inches (33–38 cm)

WEIGHT: 6.5–10 ounces (181–284 g)

Female: black forehead and forward part of crest; white stripe on the side of the face

Male: white or yellow eye; whitish or gray beak; dark brown-gray legs and feet

15

Thick, curved black beak; black eye; long, pointed tail

16

16. HYACINTH MACAW
(ANODORHYNCHUS HYACINTHINUS)

The hyacinth macaw is the largest parrot in the world. The plumage is blue over the whole body (only the undersides of the wings are black) with two areas of deep-yellow bare skin around the lower part of the beak and around the eye. The beak is very large and powerfully built, able to crack the hard shells of the nuts and palm tree fruits that represent the bird's main source of nourishment. Hyacinth macaws nest in holes in trees. Destruction of their habitat due to deforestation and trapping to meet commercial demand for aviary birds has brought them to the brink of extinction. Today, thanks to protection programs and the installation of artificial nests, the species is gradually recovering.

LENGTH: 39 inches (100 cm)

WEIGHT: 3–4 pounds (1.4–1.7 kg)

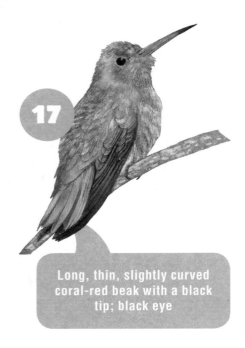

17. GILDED HUMMINGBIRD
(HYLOCHARIS CHRYSURA)

This small hummingbird is widespread in grassland areas with scattered bushes and trees. It has iridescent golden-green plumage over most of the body, with a whitish or dull buff-colored belly, dark flight feathers, and a golden-bronze tail. It has a reddish throat and a long, thin coral-red beak with a black tip. It feeds on the nectar of many flowers as well as on insects. The male is territorial and fiercely defends the flowers in its territory, driving away other males or any large insects that approach in order to suck the nectar.

LENGTH: 3–4 inches (8–10 cm)

WEIGHT: 0.14–0.18 ounce (4–5 g)

> Long, thin, slightly curved coral-red beak with a black tip; black eye

18. CHESTNUT-EARED ARAÇARI
(PTEROGLOSSUS CASTANOTIS)

The chestnut-eared araçari belongs to the same family as the toucans but is more slender and has a less imposing beak. It is a very colorful bird, with black plumage on the top of the head and throat, a dark chestnut face, greenish shoulders, wings, and tail, deep-chestnut back and crural feathers, and yellow underparts with a chestnut band running across them. The beak is black and yellowish, with a bright red spot at the base and a serrated edge revealing a checkered black and yellowish pattern. It lives in woods and marshes with patches of trees, and it feeds mainly on fruits, supplementing its diet with insects, flower nectar, and seeds.

LENGTH: 17–19 inches (43–47 cm)

WEIGHT: 8–11 ounces (220–310 g)

> White eye; bare gray-blue skin around the eye; dark gray legs and feet

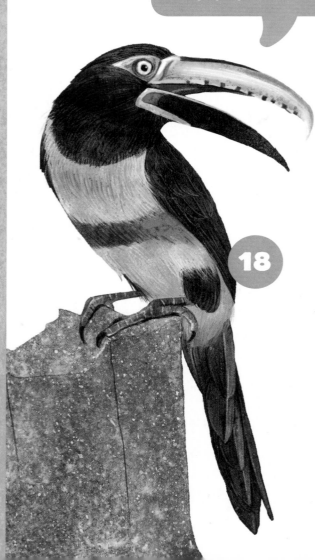

Male: crimson crest; black beak; reddish-brown eye; deep-pink legs and feet

Female: olive green; small frontal crest

19. BARE-FACED CURASSOW
(CRAX FASCIOLATA)

The bare-faced curassow is a large bird with a long, square tail; it generally resembles a pheasant. As the name suggests, it has an area of bare skin on the face, but its most noticeable feature is a crest of curly feathers extending from the forehead to the nape. The male is all black except for the white underbelly. The female has a black neck and chest, but the back, wings, and tail are black barred with white stripes, and the underparts are cinnamon-colored with sparse black bars; the crest is black and white. The bare-faced curassow lives in dense, humid forests where it feeds mainly on fallen fruits, seeds, and flowers.

LENGTH: 30–33 inches (75–85 cm)

WEIGHT: male 6–6.2 pounds (2.5–3 kg); female 6 pounds (2.5 kg)

20. HELMETED MANAKIN
(ANTILOPHIA GALEATA)

The helmeted manakin is a small bird that lives in humid forests and brush, especially near water. The male is all black with a crimson patch that runs from the back to the forehead and extends into a forward-pointing crest like a helmet visor, which explains the species' name. The female is very different, with olive-green coloring, but also has a small crest on the forehead. The helmeted manakin is a territorial species: The male defends its territory all year round, using its song as a periodic mark of possession.

LENGTH: 5.4–5.7 inches (13.9–14.5 cm)

WEIGHT: 0.5–1 ounce (18–26.5 g)

Female: black and white crest; grayish skin on the face

Male: brown-red eye; dark gray legs and feet; gray beak with yellow cere

91

When we think of the Sahara Desert, the first image that comes to mind is a world of sand and dunes scorched by the sun, where life is impossible. In reality, although it is an extreme environment, even the Sahara plays host to various forms of life. It is not all sand dunes as far as the eye can see; there are also rocky areas and stony expanses where sparse vegetation can grow, as well as some oases where there is water. Of course, in order to survive, species have to have developed very special skills and, above all, the ability to adapt to extreme living conditions. Many desert animals thus lead a mainly nocturnal life, sheltering from the sun underneath stones or underground and becoming active when the sun sets and the temperature falls. Birds, however, have not adapted to live an underground life and are therefore active during the day; to help them avoid being spotted by possible predators, they often have sand-colored plumage, like the CREAM-COLORED COURSER (in the drawing). Many feed on the seeds of the few plants that grow in the desert, while others catch insects, scorpions, or small reptiles such as lizards or little snakes. There are also some predators, such as the lanner falcon, which hunts other birds, or the pharaoh eagle-owl, which hunts at night and preys mainly on

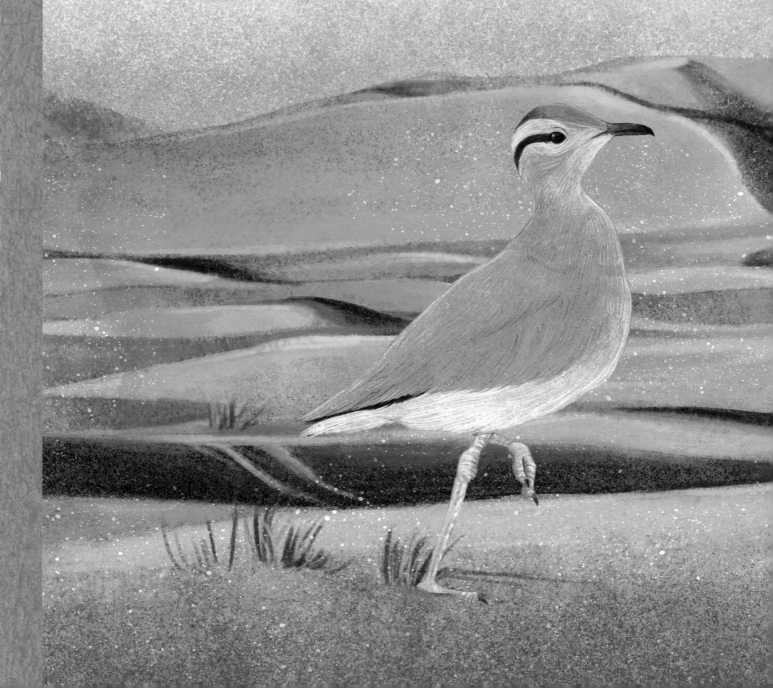

small rodents, such as gerbils or the lesser Egyptian jerboa, but also on birds, reptiles, and even large insects and scorpions.

The main problem that all of these species encounter is the need for water. Many manage to get it from the seeds they eat or liquids contained in the bodies of the animals they feed on. Others have to make long flights, over dozens of miles, to find a puddle of water to drink from. A special case is that of the pin-tailed sandgrouse, which, in addition to drinking, also soaks its feathers with water for its chicks to drink, or to cool the eggs during brooding.

AFRICA

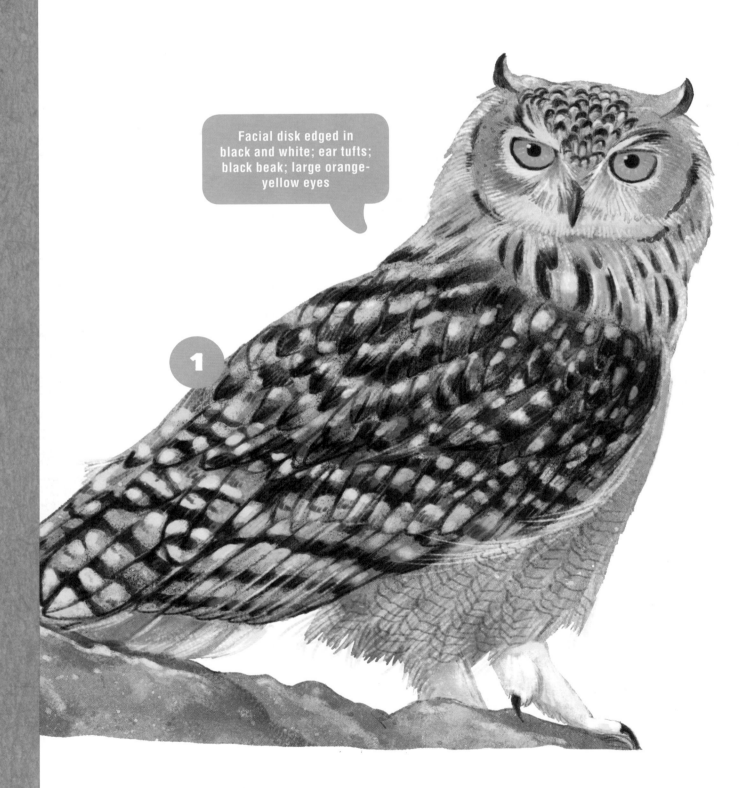

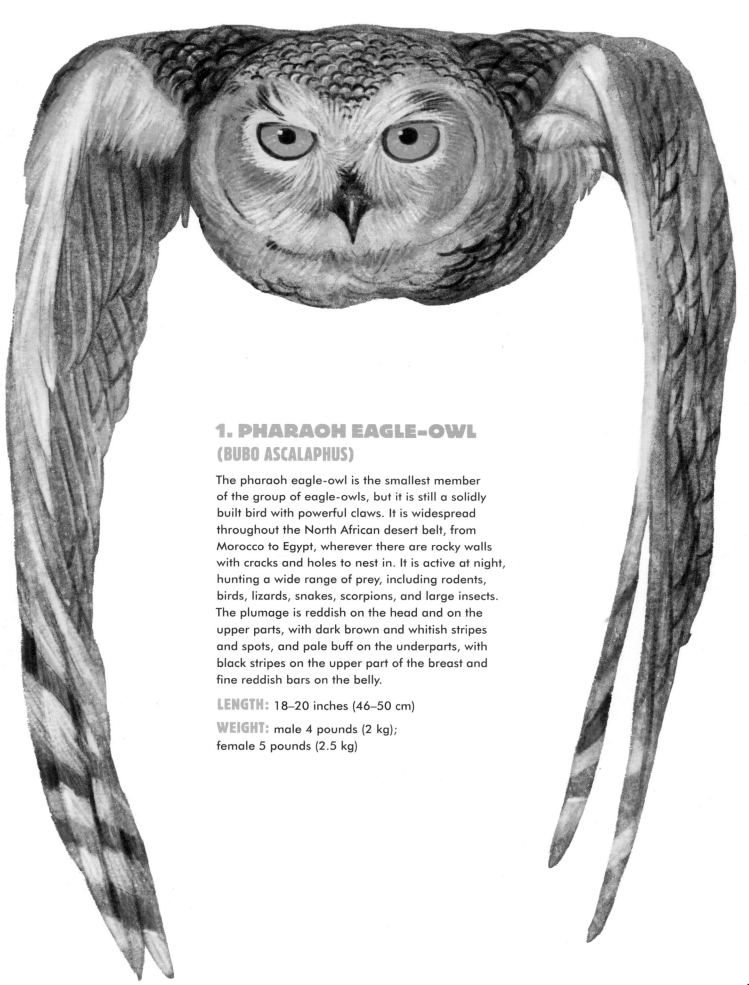

1. PHARAOH EAGLE-OWL
(BUBO ASCALAPHUS)

The pharaoh eagle-owl is the smallest member of the group of eagle-owls, but it is still a solidly built bird with powerful claws. It is widespread throughout the North African desert belt, from Morocco to Egypt, wherever there are rocky walls with cracks and holes to nest in. It is active at night, hunting a wide range of prey, including rodents, birds, lizards, snakes, scorpions, and large insects. The plumage is reddish on the head and on the upper parts, with dark brown and whitish stripes and spots, and pale buff on the underparts, with black stripes on the upper part of the breast and fine reddish bars on the belly.

LENGTH: 18–20 inches (46–50 cm)

WEIGHT: male 4 pounds (2 kg);
female 5 pounds (2.5 kg)

2. HOUBARA BUSTARD OR AFRICAN HOUBARA (CHLAMYDOTIS UNDULATA)

The houbara bustard is a large bird with a thin neck, an elongated body, a long tail, and strong legs. It has large wings and is powerful in flight, although in fact it rarely flies and spends most of its time on the ground, even walking for miles in search of seeds, large insects, lizards, and snakes. When it senses danger, it often crouches close to the ground, where it is able to blend in with the earth and sparse bushes thanks to its sand-colored camouflage, mottled and barred with dark plumage on the upper parts. Both sexes are similar in appearance, but the male is larger and has brighter colors; it has more white on the head and the black stripe on each side of the neck is more noticeable. In the breeding season, it performs spectacular courtship displays by raising and fluffing up the feathers of the neck and head.

LENGTH: 26–30 inches (65–75 cm)
WEIGHT: 2.5–7 pounds (1–3 kg)

3. LANNER FALCON (FALCO BIARMICUS)

The lanner is a medium-sized falcon found in arid and semidesert regions, where it makes its nest on rock walls. The upper parts are gray-brown with dark bars and the underparts are light-colored, sometimes with dark spots scattered over a varying area of the breast and fine black bars on the crural feathers; it has a grayish, barred tail. The head has a cream-colored or reddish crown, white cheeks, and a narrow black "mustache." Both sexes are similar in appearance. The lanner preys mainly on birds up to the size of a pigeon, which it usually captures in flight; often both members of a pair will work together to hunt.

LENGTH: 15–19 inches (39–48 cm)
WEIGHT: male 15–21 ounces (430–600 g); female 24–32 ounces (700–900 g)

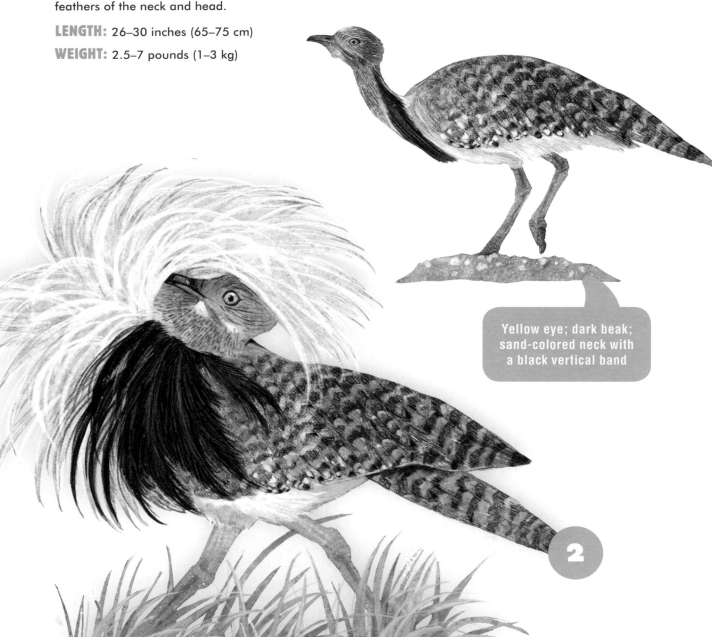

Yellow eye; dark beak; sand-colored neck with a black vertical band

2

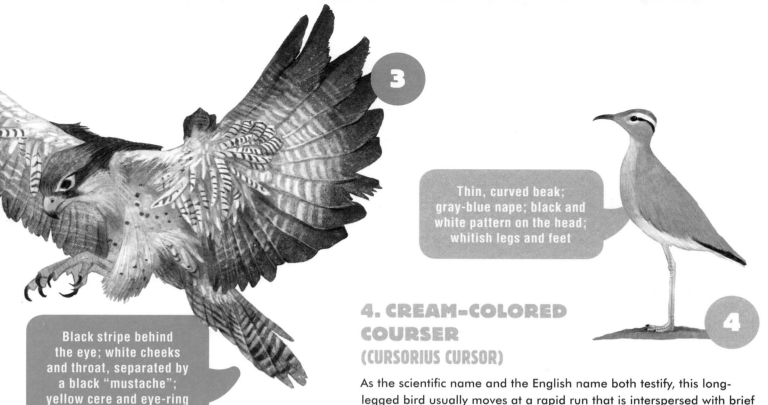

> Black stripe behind the eye; white cheeks and throat, separated by a black "mustache"; yellow cere and eye-ring

> Thin, curved beak; gray-blue nape; black and white pattern on the head; whitish legs and feet

4. CREAM-COLORED COURSER
(CURSORIUS CURSOR)

As the scientific name and the English name both testify, this long-legged bird usually moves at a rapid run that is interspersed with brief pauses as it hunts for insects and other invertebrates and small lizards. The plumage is a warm sandy color on the upper parts and lighter on the underparts; the nape is gray-blue, and it has a long white "eyebrow" and a black line beginning at the eye that come together on the neck to form a V. The black primaries and lower coverts of the wing are eye-catching in flight.

LENGTH: 8–10 inches (20–25 cm)

WEIGHT: 3.5–4 ounces (100–120 g)

5. WHITE-CROWNED WHEATEAR
(OENANTHE LEUCOPYGA)

The white-crowned wheatear is a small bird of lively behavior and eye-catching coloring. Both sexes are similar in appearance: The plumage is glossy black, with white on the top of the head and the nape, as well as the rump and the undertail. The tail is also white, with black central tail feathers. This bird is widespread in arid rocky deserts, where it often perches in plain sight on a boulder or low bush, ready to pounce on its prey. It feeds mainly on insects, which it catches on the ground or on the wing, as well as small reptiles and, to a lesser extent, seeds.

LENGTH: 6.5–7.5 inches (17–18.5 cm)

WEIGHT: 1–1.5 ounces (23–39 g)

6. TRUMPETER FINCH
(BUCANETES GITHAGINEUS)

The trumpeter finch, so called because of its loud, nasal song that somewhat resembles the sound of a trumpet, is a small bird that lives in arid and rocky areas. The thick and heavily built beak is ideal for crushing the seeds that are its main food. The male has gray plumage on the head and neck and brown on the back; the rump and the underparts are pink, and the edges of the wing feathers and the sides of the tail are also pink. The beak is pink, varying in intensity, and the legs and feet are orangish. The female has less bright plumage overall, tending more toward grayish brown with just a few hints of pink.

LENGTH: 4.5–5 inches (11.5–13 cm)

WEIGHT: 0.5–1 ounce (16–25 g)

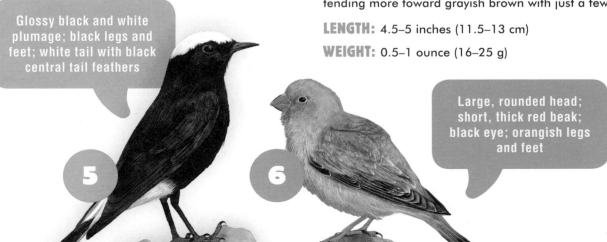

> Glossy black and white plumage; black legs and feet; white tail with black central tail feathers

> Large, rounded head; short, thick red beak; black eye; orangish legs and feet

7. PIN-TAILED SANDGROUSE
(PTEROCLES ALCHATA)

The pin-tailed sandgrouse is a medium-sized bird with a compact body, a small head, very colorful plumage, and long, pointed central tail feathers. Both sexes have a bright white belly and a tawny band on the breast, edged above and below in black. The upper parts are golden-green with yellowish spots in the male, more mottled with brown in the female; the pattern on the head and neck is slightly different in the two sexes. The pin-tailed sandgrouse lives in arid and semiarid regions without trees, feeds mainly on seeds, and obtains water by flying at dawn every day to one of the rare pools to be found.

The nest is a little hollow in the ground, and both sexes take turns brooding the eggs and raising the chicks. Only the male, however, provides them with water, and it has a very unusual system for doing so. Every day it flies to a pool, which can be several miles away, and plunges its belly into the water until the feathers are soaked like a sponge; then it returns to the nest, and the chicks suck the water from the feathers on its belly.

LENGTH: 12–16 inches (30–40 cm)

WEIGHT: 7.5–14.5 ounces (210–410 g)

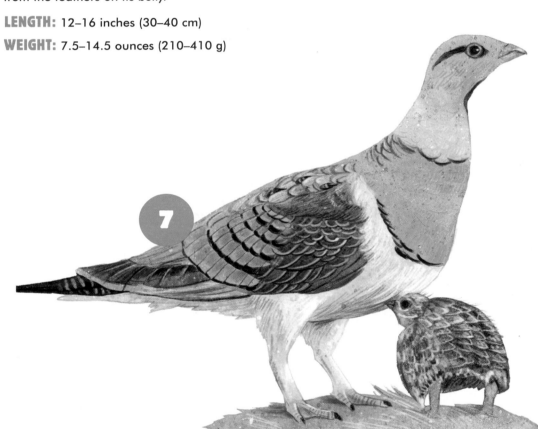
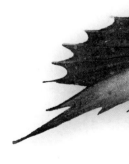

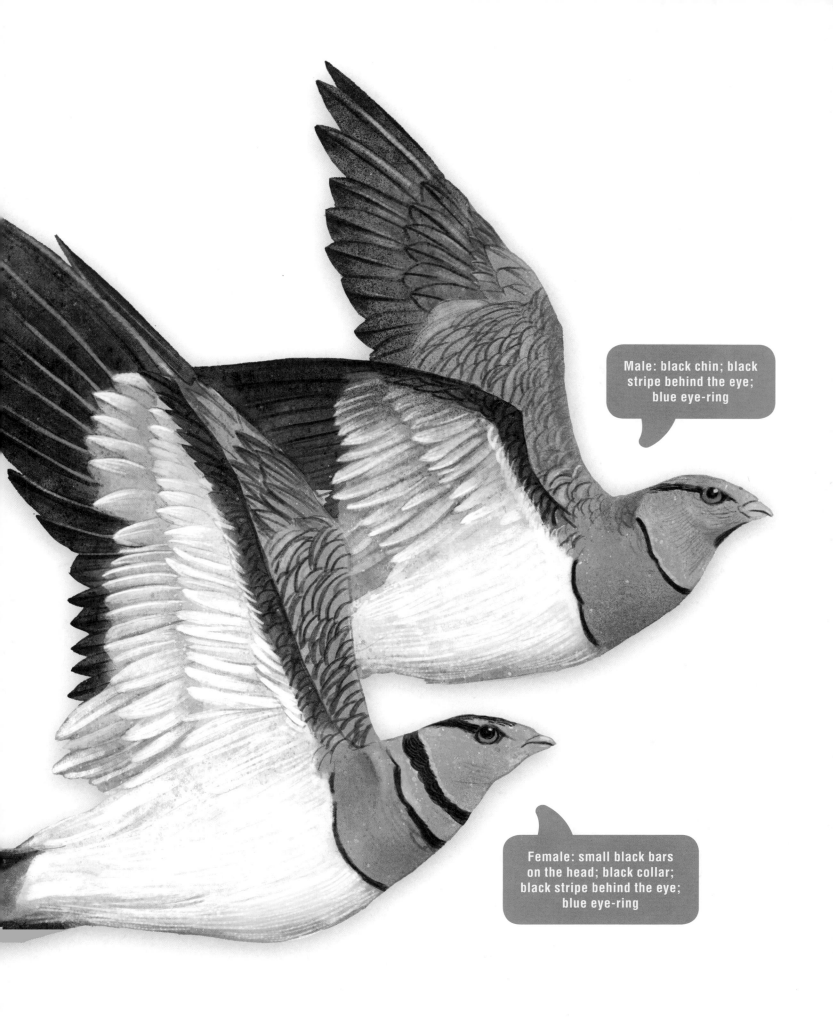

The savannas that stretch between Kenya and Tanzania in Eastern Africa, just south of the equator, are endless prairies dotted here and there with thorny bushes and isolated trees (especially *Vachellia tortilis*—the umbrella thorn acacia—and baobab trees); only on the banks of the few watercourses do trees find the necessary moisture to grow more lush and form narrow strips of woodland. The climate of this region is distinguished by a long rainy season and an equally long dry season, but temperatures never drop below 68°F (20°C), and seeds, insects, lizards, and small mammals are always present in abundance.

These savannas are famous for the large mammals that live there: lions and cheetahs, hyenas and buffalo, elephants and rhinoceroses, antelope and gazelles. But they are also an ideal place for a multitude of species of birds. Many look for food on the ground, among the tall grasses; others perch on top of a bush or on a protruding branch, ready to pounce on an insect or a lizard; others, such as the vulture or marabou stork, take advantage of large animals that have died from natural causes or been killed by predators and flock around their carcasses to fight for the leftovers.

In the following pages, we present some of the hundreds of species that populate the African savannas, chosen from among the most common, the most colorful, or those with the most spectacular behavior: the OSTRICH

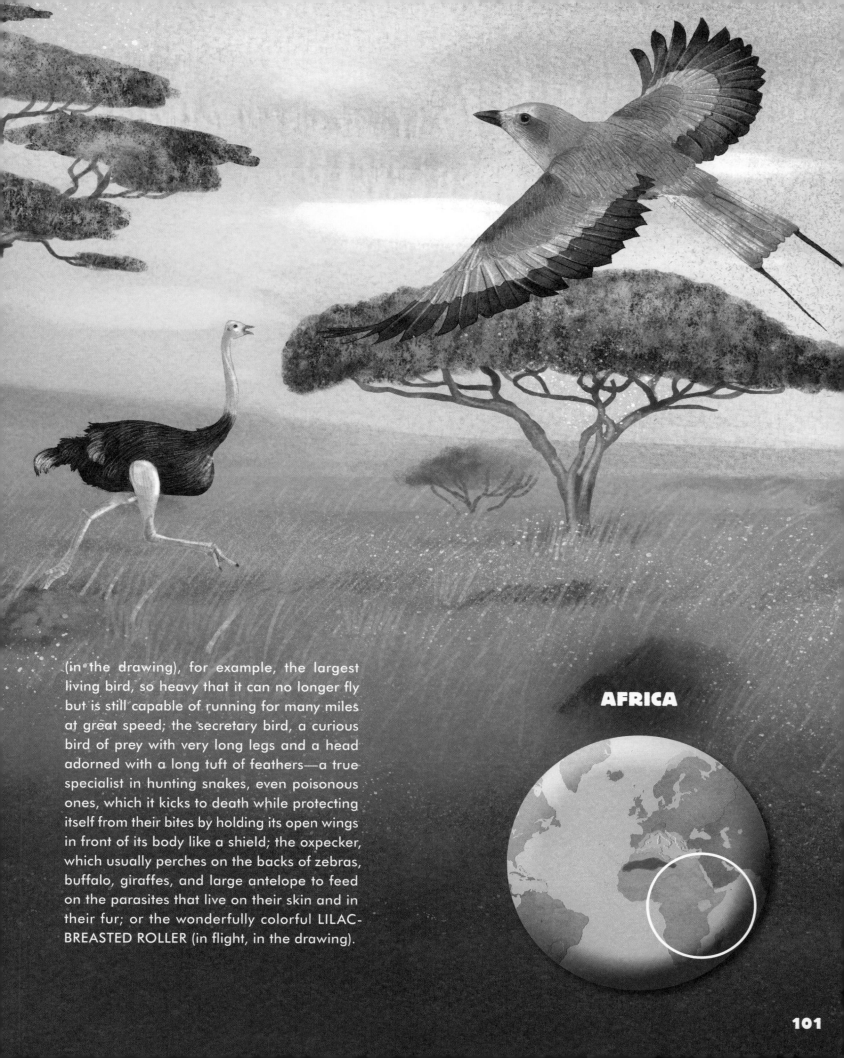

(in the drawing), for example, the largest living bird, so heavy that it can no longer fly but is still capable of running for many miles at great speed; the secretary bird, a curious bird of prey with very long legs and a head adorned with a long tuft of feathers—a true specialist in hunting snakes, even poisonous ones, which it kicks to death while protecting itself from their bites by holding its open wings in front of its body like a shield; the oxpecker, which usually perches on the backs of zebras, buffalo, giraffes, and large antelope to feed on the parasites that live on their skin and in their fur; or the wonderfully colorful LILAC-BREASTED ROLLER (in flight, in the drawing).

AFRICA

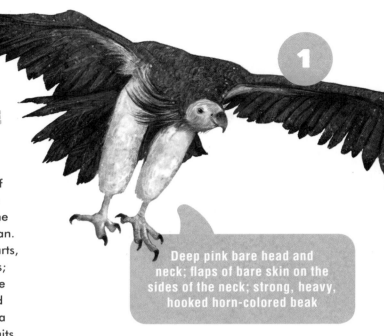

1. LAPPET-FACED VULTURE
(TORGOS TRACHELIOTOS)

The lappet-faced vulture is one of the largest vultures and is distinguished by two loose folds of bare skin on the sides of the head, which are the origin of its name. As with many other vultures the head is naked, which makes it easier to keep clean. The plumage is a uniform brown on the upper parts, and brown with whitish streaks on the underparts; the crural feathers are white, as is the edge of the wing, which is visible in flight. The mighty hooked beak is strong enough to cut through the skin of a large mammal; often the lappet-faced vulture waits for other vultures to abandon a half-eaten carcass so it can eat the skin, tendons, and the other hardest parts that are left.

LENGTH: 37–45 inches (95–115 cm)
WEIGHT: 12–21 pounds (5.5–9.5 kg)

> Deep pink bare head and neck; flaps of bare skin on the sides of the neck; strong, heavy, hooked horn-colored beak

2. MARABOU STORK
(LEPTOPTILOS CRUMENIFER)

The marabou is a large stork that draws the eye as it makes its way across the savanna with long strides. Its plumage is dark gray on the upper parts and white on the underparts, but the most striking feature of its appearance is the neck and head, which are bare of feathers, like with many birds that feed on carrion; the bare and wrinkled skin is reddish gray, and under the beak hangs a large reddish sac. Ungainly on the ground, the marabou is, however, elegant and light in flight, with a wingspan that can reach as much as 10 feet (3 m). It is a gregarious bird that nests in colonies. Marabou storks mainly eat garbage, which they even forage for in villages, and carrion; they join the vultures flocking around the remains of large mammals.

LENGTH: 59 inches (150 cm)
WEIGHT: 10–18 pounds (4.5–8 kg)

> Large wedge-shaped beak; head and neck bare of feathers; large sac of reddish skin at the base of the neck

3. COMMON OSTRICH
(STRUTHIO CAMELUS)

This is the largest living bird; an adult male can weigh as much as 344 pounds (156 kg). It is too heavy to fly, and its short wings have no rigid feathers; it is an extraordinary runner, on the other hand, with extremely strong legs. The foot has only two toes, equipped with strong claws that make it a very effective weapon. The male has black plumage, with white wings and tail; the female, which is a little smaller, is gray-brown. The legs are completely devoid of feathers, and the head and neck are only partially covered by a sparse down. Ostriches live in groups formed by a male and several females; they lay eggs (white and weighing as much as 3 pounds 5 ounces, or 1.5 kg) in a single communal nest that can contain as many as 40; only one bird, the dominant female, broods the eggs during the day, while the male takes over at night.

LENGTH: 69–108 inches (175–275 cm)
WEIGHT: male 220–344 pounds (100–156 kg); female 200–243 pounds (90–110 kg)

4. SOUTHERN GROUND HORNBILL
(BUCORVUS LEADBEATERI)

The southern ground hornbill is a bird about the size of a turkey, with glossy black plumage (the white tips of the primaries are visible only in flight). The skin around the eyes is bare and red, and the throat also displays an area of flaccid red skin that it can inflate to varying degrees. The female has a blue-violet patch in the middle of its throat. These birds live in savanna areas with low grass and large scattered trees, in groups of five to ten individuals that occupy a vast territory, keeping in touch by loud calls. They spend most of their time on the ground, hunting for lizards and small snakes, spiders, large insects, and small mammals. They nest in holes in old trees, and pairs are always helped by some juveniles in raising the single nestling.

LENGTH: 37–40 inches (95–102 cm)

WEIGHT: male 7.5–13.5 pounds (3.5–6 kg); female 5–10 pounds (2–4.5 kg)

5. SUPERB STARLING
(LAMPROTORNIS SUPERBUS)

The superb starling is justly named for its resplendent plumage, with brilliant colors and a metallic shimmer. The back, wings, and tail are electric blue with an iridescent shine; the throat and the upper breast are deep blue while the belly is orange-red. A fine white line separates these two colors, and the undertail is also white. The head is a velvety black, with a cream-colored eye. The black tips of the greater and median coverts form two lines of droplet-shaped spots. They are a social species, foraging together in a group for insects, seeds, and berries on the ground. Parents will even have the help of several assistants in the construction of the nest and in raising chicks.

LENGTH: 8 inches (20 cm)

WEIGHT: 2–3 ounces (60–80 g)

6. RED-BILLED OXPECKER
(BUPHAGUS ERYTHRORHYNCHUS)

The red-billed oxpecker is a bird with a slender body and olive-brown plumage on the head, back, and throat, with cream on the underparts. It has a short, pointed red beak, and its red eye is surrounded by a yellow ring of bare skin. The red-billed oxpecker is widespread wherever there are great concentrations of large herbivores (animals that feed on plants): zebras, giraffes, buffalo, antelope, and rhinoceroses. They spend the days clinging to the bodies of these animals, eating the ticks, flies, and parasite larvae that live in the hair and on the skin; an oxpecker can eat a hundred blood-swollen ticks and thousands of larvae in a day. Even its nest, which it makes in a hole in a tree, is lined with hairs plucked from the bodies of these hosts.

LENGTH: 8 inches (20 cm)

WEIGHT: 1.5–2 ounces (42–59 g)

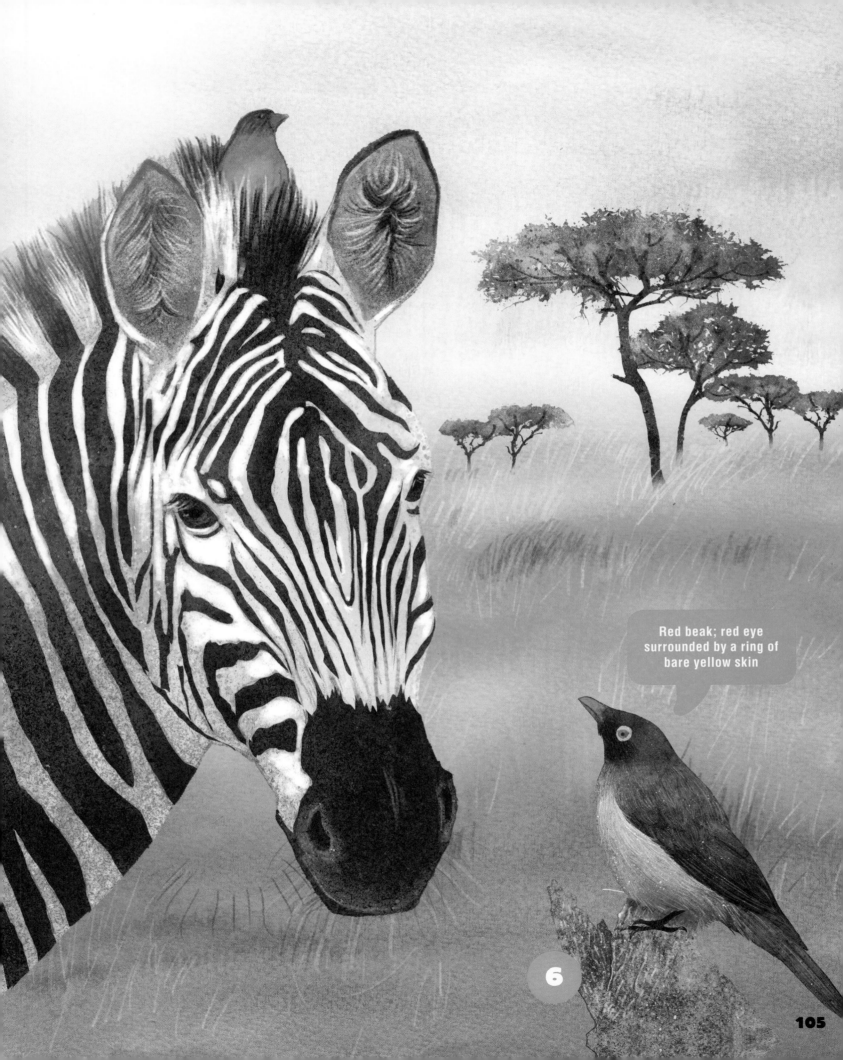

Red beak; red eye surrounded by a ring of bare yellow skin

6

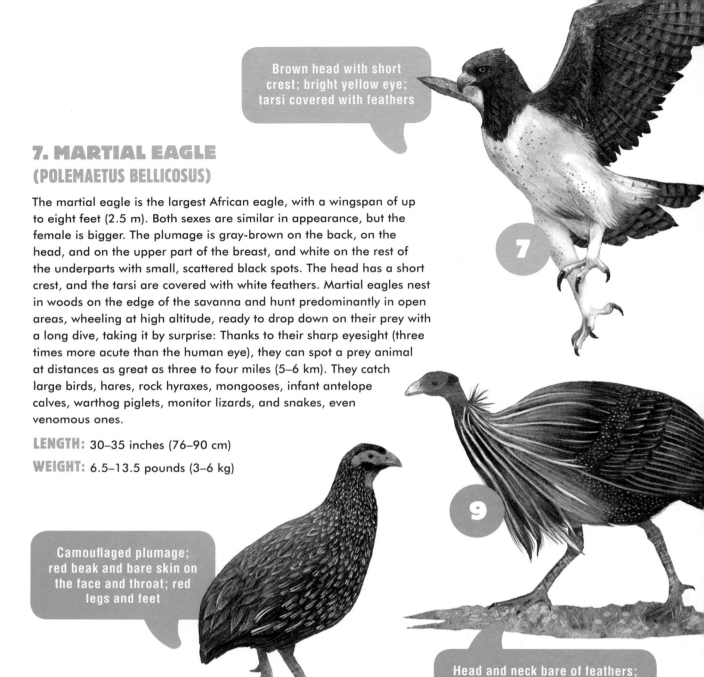

Brown head with short crest; bright yellow eye; tarsi covered with feathers

7

7. MARTIAL EAGLE
(POLEMAETUS BELLICOSUS)

The martial eagle is the largest African eagle, with a wingspan of up to eight feet (2.5 m). Both sexes are similar in appearance, but the female is bigger. The plumage is gray-brown on the back, on the head, and on the upper part of the breast, and white on the rest of the underparts with small, scattered black spots. The head has a short crest, and the tarsi are covered with white feathers. Martial eagles nest in woods on the edge of the savanna and hunt predominantly in open areas, wheeling at high altitude, ready to drop down on their prey with a long dive, taking it by surprise: Thanks to their sharp eyesight (three times more acute than the human eye), they can spot a prey animal at distances as great as three to four miles (5–6 km). They catch large birds, hares, rock hyraxes, mongooses, infant antelope calves, warthog piglets, monitor lizards, and snakes, even venomous ones.

LENGTH: 30–35 inches (76–90 cm)

WEIGHT: 6.5–13.5 pounds (3–6 kg)

9

Camouflaged plumage; red beak and bare skin on the face and throat; red legs and feet

8

Head and neck bare of feathers; chestnut-brown tuft on the nape; red eye; long blue and white feathers at the base of the neck

8. RED-NECKED SPURFOWL OR FRANCOLIN
(PTERNISTIS AFER)

The red-necked spurfowl, or red-necked francolin, has a compact body with brown plumage on the upper parts and gray mottled with black and white on the underparts. It has bare red skin around the eyes and on the throat, and the beak and tarsi are also red. Both sexes are similar in appearance, but the male has a spur on the back of the tarsus. Very shy and cautious, the red-necked spurfowl leaves the protection of the bushes only to forage for food: seeds, roots, and bulbs, which it supplements with ants, termites, and locusts. Pairs stay together for life. The female lays three to nine eggs in a simple dip in the ground under a bush and broods them for 23 days. Both parents accompany the chicks in search of food.

LENGTH: 14–16 inches (35–40 cm)

WEIGHT: male 17–35 ounces (480–1,000 g); female 13–24 ounces (370–690 g)

9. VULTURINE GUINEAFOWL
(ACRYLLIUM VULTURINUM)

The vulturine guineafowl is a large bird with a rounded body, a thin neck, a small head, and a long pointed tail. The plumage is black dotted with white, the chest is cobalt blue, and the neck and head are bare of feathers, with bluish-gray skin and a sort of little crown of chestnut-colored feathers on the nape. At the base of the neck is a sunburst of long, thin blue and white feathers covering the breast and the back. The beak is heavily built and curved, and the eye is red. These birds live almost entirely on the ground, flying only very rarely and for short stretches, though they do spend the night in the trees. They form family groups of 20 to 30 individuals that forage for food together and defend a common territory.

LENGTH: 28 inches (70 cm)

WEIGHT: 2–3.5 pounds (1–1.5 kg)

10. LILAC-BREASTED ROLLER
(CORACIAS CAUDATUS)

The lilac-breasted roller is unofficially considered the national bird of Kenya. It lives in savanna woodlands and sparse woods with wide clearings, where it is readily seen perched on a protruding branch or at the top of a bush, ready to dive onto a big insect, a lizard, a scorpion, or a small rodent. Both sexes are similar in appearance, with very colorful plumage: The breast goes from lilac to orange, streaked with white; the belly is turquoise; the back and wing coverts are chestnut-colored, while the flight feathers and tail feathers are blue with the two elongated outermost tail feathers being black. In the breeding season the male performs spectacular aerial displays, climbing to a great height and then dropping into a steep dive with sudden spins and sharp turns.

LENGTH: 13–14 inches (32–35 cm)

WEIGHT: 3–4.5 ounces (87–135 g)

White forehead; black eyes and beak; blue tail with long black outermost feathers

Very long legs; long black feathers on the nape; bare orange skin around the eye

11. SECRETARY BIRD
(SAGITTARIUS SERPENTARIUS)

The secretary bird is a bird of prey with a very distinctive appearance: It has very long legs, a long tail, a small head adorned on the nape with 20 long, fluttering black feathers, and a curved beak. Males and females are similar in appearance, with light-gray plumage, black primaries, and black and white tail feathers with the two central feathers being extremely long; the upper part of the legs' crural feathers are black. The secretary bird travels long distances, walking through the grass of the savanna hunting for lizards, large insects, rodents, and especially snakes, even venomous ones. It kicks them violently, protecting itself from bites by using its large wings spread open like a shield and thanks to the tough scales that cover its tarsi.

LENGTH: 49–59 inches (125–150 cm)

WEIGHT: 5–9.5 pounds (2.5–4 kg)

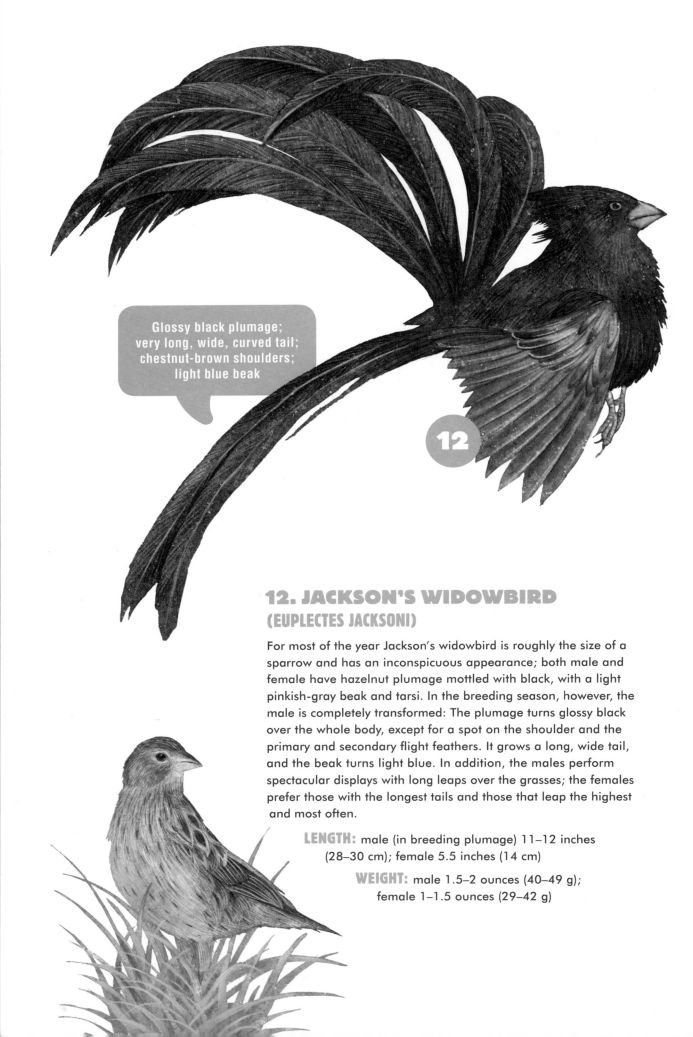

Glossy black plumage; very long, wide, curved tail; chestnut-brown shoulders; light blue beak

12

12. JACKSON'S WIDOWBIRD
(EUPLECTES JACKSONI)

For most of the year Jackson's widowbird is roughly the size of a sparrow and has an inconspicuous appearance; both male and female have hazelnut plumage mottled with black, with a light pinkish-gray beak and tarsi. In the breeding season, however, the male is completely transformed: The plumage turns glossy black over the whole body, except for a spot on the shoulder and the primary and secondary flight feathers. It grows a long, wide tail, and the beak turns light blue. In addition, the males perform spectacular displays with long leaps over the grasses; the females prefer those with the longest tails and those that leap the highest and most often.

LENGTH: male (in breeding plumage) 11–12 inches (28–30 cm); female 5.5 inches (14 cm)

WEIGHT: male 1.5–2 ounces (40–49 g); female 1–1.5 ounces (29–42 g)

13. KORI BUSTARD
(ARDEOTIS KORI)

The kori bustard is a large, long-legged bird that spends most of its time on the ground, but despite its size it is able to fly. It lives on grasslands and savannas with scattered trees throughout sub-Saharan Africa. These birds are omnivorous, eating insects, small rodents, and lizards, but also grasses, seeds, and fruits. They have camouflage coloring, with a gray-brown back and a neck mottled with white and black, while the underparts are white and black. The female is smaller and lighter, with thinner legs and neck. The male performs a spectacular courtship display to win the female's favor, fluffing up its neck feathers and stalking stiffly over the ground with its tail raised and wings lowered.

LENGTH: 39–59 inches (100–150 cm)

WEIGHT: male 24–42 pounds (11–19 kg);
female 11–15 pounds (5–7 kg)

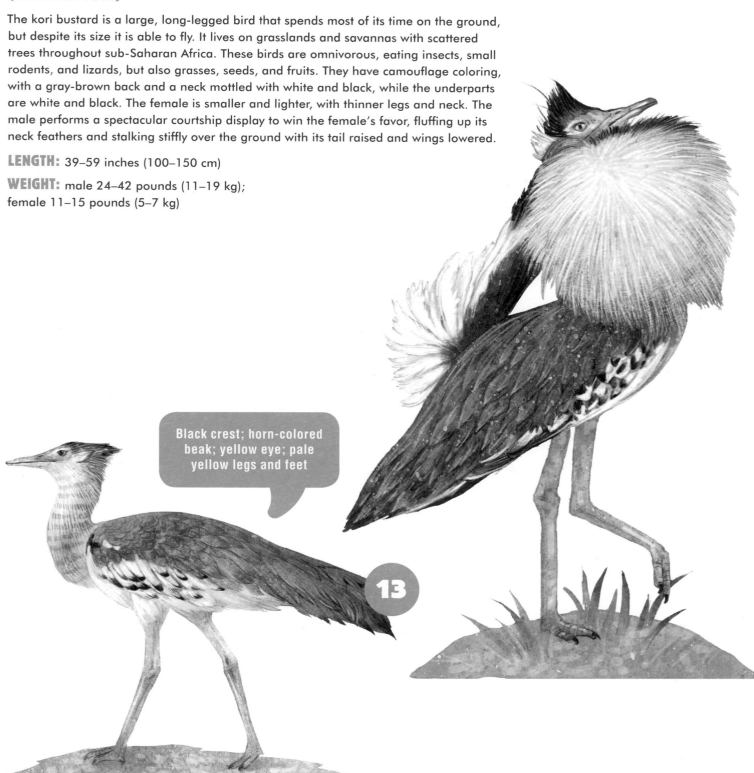

Black crest; horn-colored beak; yellow eye; pale yellow legs and feet

13

Large, curved red and white beak with black edges; black and white plumage; long black and white tail

14. VON DER DECKEN'S HORNBILL
(TOCKUS DECKENI)

Von der Decken's hornbill is a medium-sized bird with a large curved beak. The plumage is black and white in both sexes, but the male's beak is red and ivory white with black edges and tip, while that of the female is all black. Like many members of the hornbill family, they have very distinctive breeding behavior. They nest in a hole in a tree, and when the female begins to lay its eggs it shuts itself inside by reducing the size of the entrance with mud and excrement and leaving only an opening through which the male feeds both the female and the chicks, once they have hatched. When the chicks grow larger and the nest gets too cramped, the female breaks open this "lid" and comes out; it then rebuilds the lid, and both parents continue to feed the chicks through the opening until they are fledged, at about 50 days of age.

LENGTH: 20–24 inches (50–60 cm)

WEIGHT: male 6–7.5 ounces (165–212 g); female 4–5.5 ounces (120–155 g)

15. EASTERN CHANTING GOSHAWK
(MELIERAX POLIOPTERUS)

The eastern chanting goshawk is so called because of the melodious cheeping call it makes in the breeding season. It lives in dry, scrubby grasslands and savannas with scattered trees, where it usually makes its home at the top of a tall tree or bush. Both sexes are similar in appearance, with the female being somewhat larger. The plumage is ash gray on the upper parts and on the breast, the belly is barred with fine gray and white lines, and the undertail is white. The primary feathers are black, and the tail is blackish on top and white barred with gray underneath. Its legs are longer than those of most other birds of prey, and it often hunts by walking through the grass to catch insects, mice, and small reptiles.

LENGTH: 19–22 inches (49–55 cm)

WEIGHT: male 1–1.3 pounds (514–580 g); female 1.5–2 pounds (670–800 g)

Orange tarsi; yellow cere; fine alternating gray and white bars on belly

16. D'ARNAUD'S BARBET
(TRACHYPHONUS DARNAUDII)

The barbets are so named due to the presence of bristles—modified feathers similar to stiff hairs—on the sides of the beak. D'Arnaud's barbet is one of the smallest species in the family and has highly contrasted plumage; the back, wings, and tail are dark brown thickly speckled with white spots; the underparts are whitish with sparsely scattered black spots; the cheeks, nape, and throat are yellow and black, while the forehead is black and the undertail is red. The female is less brightly colored.

They find their food both in the trees and on the ground, eating fruits, berries and their seeds, insects, scorpions, centipedes, and small lizards. In the breeding season males and females perform birdsong duets. They dig their nest into the ground or into a termite mound, at the end of a tunnel that can be more than 3 feet (1 m) long.

LENGTH: 7.5 inches (19 cm)

WEIGHT: 0.5–1.5 ounces (17–39 g)

17. VILLAGE WEAVER
(PLOCEUS CUCULLATUS)

The village weaver is a small songbird belonging to the great family of weaverbirds, so called because the males build very elaborate nests by cleverly weaving together long strips of leaves and green grasses. The nest, hanging at the end of a branch, is spherical with a downward-facing opening. The village weaver is a very social bird, and a single tree may host as many as 100 nests. Once its work is done, the male dangles from the nest, singing and flapping its wings in order to be chosen by a female. Each male may build up to five nests to attract other females, which brood and raise the chicks alone.

LENGTH: 6.5 inches (17 cm)

WEIGHT: 1–1.5 ounces (35–45 g)

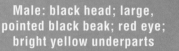

Male: black head; large, pointed black beak; red eye; bright yellow underparts

Female: gray back; yellow and white underparts; red eye

18. GRAY-CRESTED HELMETSHRIKE
(PRIONOPS POLIOLOPHUS)

The gray-crested helmetshrike is a medium-sized songbird with a black back, tail, and wings, a large white area on the shoulders, and a white band on the primaries; the rest of the body is white. The head is very distinctive, with a bright yellow eye surrounded by a black circle, a thick bristly crest of small feathers that runs from the beak to the forehead, and a longer dark gray tuft on the top of the head. These birds live in groups that can number up to 15 individuals that cooperate to defend their territory and also to breed, building one nest together, well hidden in the thickest part of a bush, and working together to brood and feed the nestlings.

LENGTH: 9–10 inches (23–26 cm)

WEIGHT: 1.5–2 ounces (40–50 g)

19. MAGPIE SHRIKE
(UROLESTES MELANOLEUCUS)

The magpie shrike is distinguished by a very long tail (almost twice as long as the body) and black plumage, broken up only by two long white patches on the back (the scapular feathers) and the white tips of the secondaries and primaries. The beak and tarsi are also black, and the eye is brown. Both sexes are similar in appearance, but the female has two white spots on the flanks. It is a bird of the more tree-rich and bush-covered savannas, often seen perched on the top of thorn bushes, from which it observes the ground below, ready to fall upon insects, lizards, and other small animals that it kills with its strong hooked beak.

LENGTH: 18 inches (45 cm)

WEIGHT: 2–3.5 ounces (60–95 g)

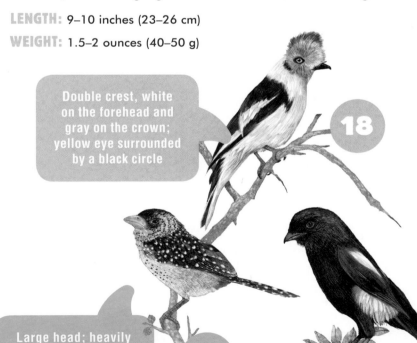

Double crest, white on the forehead and gray on the crown; yellow eye surrounded by a black circle

Large head; heavily built beak surrounded by stiff bristles; red undertail

Black and white plumage; very long, thin, pointed tail; sharp beak, curved at the tip

Looking at a globe, we can see a broad arc of sea lying between Antarctica and the southern tips of the great continents—America, Africa, and Oceania—devoid of any large landmasses. In this vast space of open water, the ceaseless western winds encounter no obstacles and raise huge waves. In the age of sail, these violent winds were a severe danger to ships—so much so that British sailors called the band of sea between the latitudes of 40 and 50 degrees south the Roaring Forties, with the next band, between 50 and 60 degrees south, being nicknamed the Furious Fifties—names that are still used today to indicate those latitudes.

Only a few groups of islands are dotted around these seas, uninhabited or at most populated by the personnel of a few scientific or military bases. One of these is the Crozet Islands, made up of six main islands and several reefs. They are treeless wastelands, battered for many months of the year by storms with winds exceeding 60 miles (100 km) per hour, but the absence of permanent human settlements and the seas rich in fish and shellfish that surround them make them places of great importance for wildlife. The islands host large colonies of seals and sea elephants on their coasts, and are very important breeding sites for numerous bird species. There are about 25 million birds that nest each year in the Crozet Islands: among these are 1 million king penguins and 3 million macaroni penguins, as well as two other penguin species with less numerous colonies. Eight species of albatrosses also breed on the Crozet Islands (in the drawing, the WANDERING ALBATROSS) and some 20 species more among petrels, prions, and storm-petrels—birds of the Procellariidae family that spend their lives on the wing, returning to land only to breed. Penguins also spend the winter (which in these southern latitudes corresponds to the Northern Hemisphere's summer) in the freezing seas around Antarctica, and return to Crozet only to lay eggs and raise their young.

SUBANTARCTIC ISLANDS

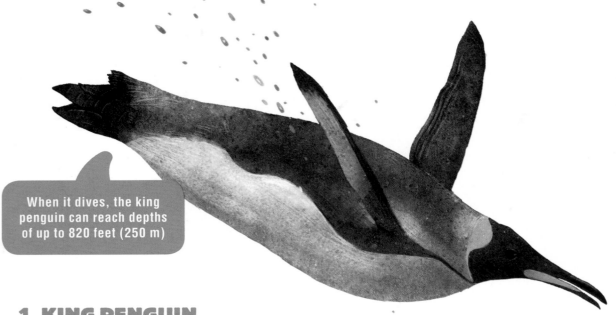

When it dives, the king penguin can reach depths of up to 820 feet (250 m)

1. KING PENGUIN
(APTENODYTES PATAGONICUS)

The king penguin is the largest of the penguins after the emperor penguin, which lives in Antarctica. Its plumage is charcoal gray on the back and white on the underparts; the head is black with an orange spot on the sides of the neck, and there is another orange spot on the throat that shades into yellow toward the breast. Unable to fly, king penguins are highly skilled swimmers and spend the southern winter (our northern summer) in the icy fish-rich waters of the seas around the South Pole, before returning to land to nest on remote islands in colonies that can number as many as tens of thousands of pairs.

LENGTH: 37–37.5 inches (94–95 cm)
WEIGHT: 20–33 pounds (9–15 kg)

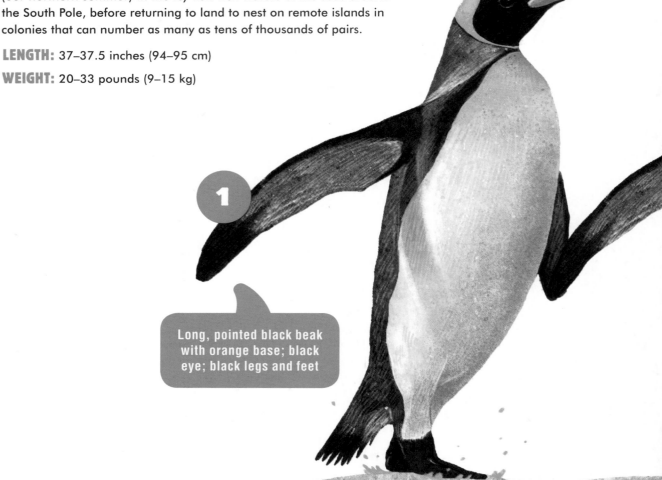

1

Long, pointed black beak with orange base; black eye; black legs and feet

2. GENTOO PENGUIN
(PYGOSCELIS PAPUA)

The gentoo penguin is somewhat smaller than the king penguin and has a stockier build. Its plumage is black on the back, head, and throat and white on the underparts. A white spot extends from the eye to the top of the head, the wings are edged in white, and there is a whitish band across the tail, which is the longest among all the penguins. The gentoo penguin nests in small colonies, often mixed with other penguin species; it nests on the ground, in an area free from snow, protecting the nest with a circle of stones and making it more comfortable with dry grass and moss.

LENGTH: 30–32 inches (76–81 cm)

WEIGHT: 10–19 pounds (4.5–8.5 kg)

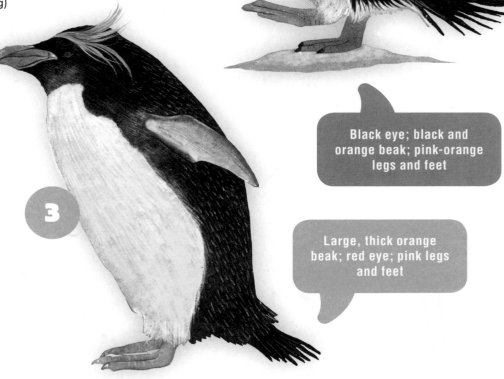

Black eye; black and orange beak; pink-orange legs and feet

Large, thick orange beak; red eye; pink legs and feet

3. MACARONI PENGUIN
(EUDYPTES CHRYSOLOPHUS)

The macaroni penguin is a medium-sized penguin with a stocky build. Its plumage is black on the upper parts, head, and throat, and white on the underparts, and it has two tufts of fine golden-yellow feathers that start on its forehead and extend backward. It is the most numerous penguin species in the world, with some 18 million individuals, 3 million of which are to be found in the Crozet Islands. They form very large colonies, which can number as many as 100,000 pairs. They feed mainly on the tiny crustaceans that make up krill, as well as on fish and squid.

LENGTH: 27.5–28 inches (70–71 cm)

WEIGHT: 7–15 pounds (3–6.5 kg)

4. WANDERING ALBATROSS
(DIOMEDEA EXULANS)

The wandering albatross is an extraordinary flier, able to glide for hours without a single wingbeat. It has the largest wingspan of any species, at over 10 feet (3 m; the established record is 10 feet, 11 inches, or 333 cm). The adults have all-white plumage with the exception of the primaries and the rear edge of the wing, which are black, and a scattering of gray spots, varying in extent, over the shoulders. Up to seven years of age, the plumage shows a varying amount of brown on the back and wings. The wandering albatross feeds mainly on squid and fish that it catches on the surface of the sea. It returns to land only to nest, when the pairs—which stay together for life—greet each other with spectacular displays, with wide-open wings.

LENGTH: 42–53 inches (107–135 cm)

WEIGHT: male 18–25 pounds (8–12 kg); female 15–19 pounds (6.5–8.5 kg)

Dark brown eye; large, heavily built pale pink beak with a hooked end; pink or grayish legs with webbed feet

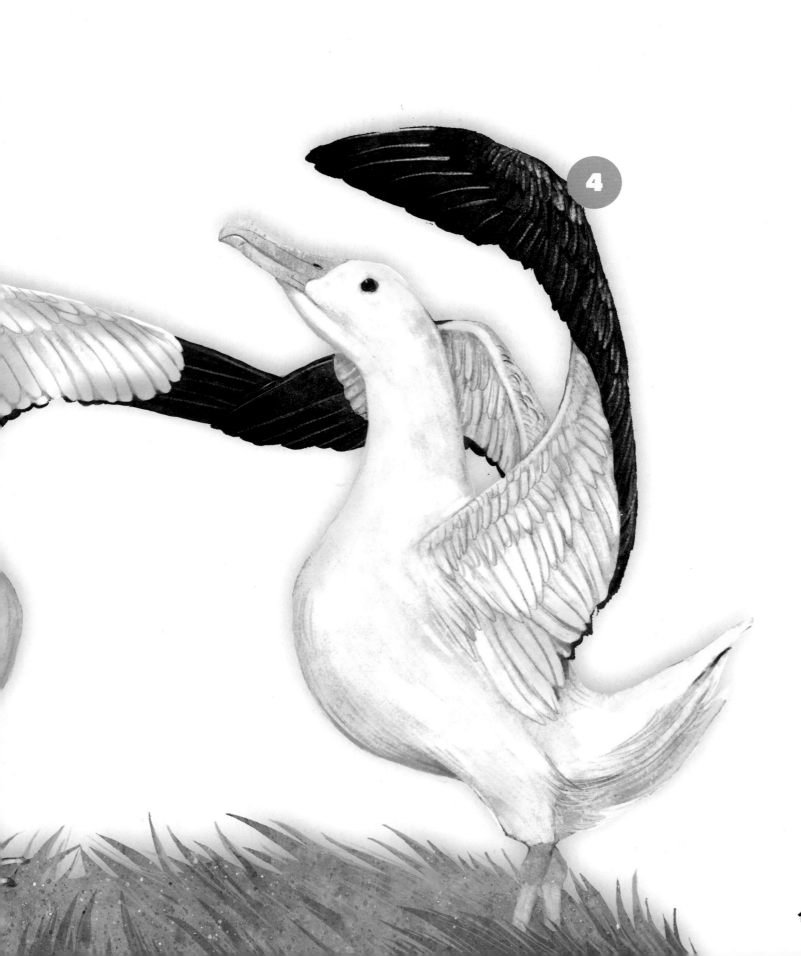

5. SOUTHERN GIANT PETREL
(MACRONECTES GIGANTEUS)

The southern giant petrel (so called to distinguish it from a very similar species that has a more northern distribution) is a large seabird with long wings and a strong, heavily built beak. Its plumage is gray-brown, with a lighter head, neck, and upper breast. The southern giant petrel is primarily a scavenger, taking advantage of the corpses of penguins, elephant seals, and fur seals washed ashore by the waves; dozens of giant petrels will often gather around such carrion and compete violently for the food. Giant petrels will also mount raids on colonies of penguins and other birds to prey on eggs and chicks, as well as catching fish and shellfish and following fishing boats to take advantage of the fish waste.

LENGTH: 33–39 inches (85–100 cm)

WEIGHT: male 11 pounds (5 kg); female 8.5 pounds (4 kg)

6. WILSON'S STORM-PETREL
(OCEANITES OCEANICUS)

Wilson's storm-petrel is a small bird with sooty-brown plumage, with a white area on the rump. The legs are very long in proportion to the body and end in webbed feet. The name refers to the fact that these birds are particularly active when the sea is rough and the waves bring up to the surface more of the small crustaceans or shellfish on which they feed. They have a very light and fluttering style of flight, and when searching for food the storm-petrel looks as though it is walking on the water with its long dangling legs.

LENGTH: 6–8 inches (15–20 cm)

WEIGHT: 1–2 ounces (28–50 g)

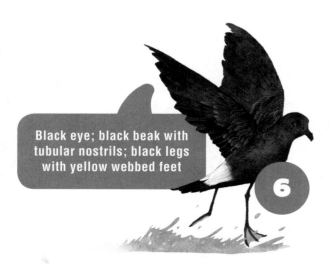

Black eye; black beak with tubular nostrils; black legs with yellow webbed feet

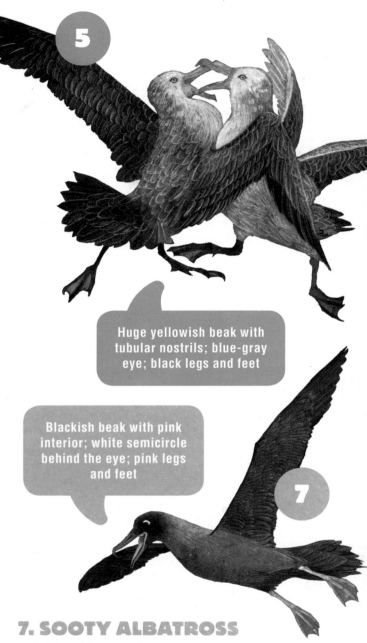

Huge yellowish beak with tubular nostrils; blue-gray eye; black legs and feet

Blackish beak with pink interior; white semicircle behind the eye; pink legs and feet

7. SOOTY ALBATROSS
(PHOEBETRIA FUSCA)

The sooty albatross, as the name suggests, is a medium-sized albatross whose plumage is completely brown, darker on the sides of the head and on the wings. The tail is not square but wedge-shaped, and it has a semicircle of tiny white feathers sticking out around the eye. The sooty albatross forms pairs that stay together for life, and they breed in small colonies, building their nests on cliffs or very steep rock walls. It has a light, agile flight and feeds on fish and shellfish that it usually catches by setting down on the water; it may also follow ships to take advantage of the waste thrown overboard.

LENGTH: 33–35 inches (84–89 cm)

WEIGHT: male 5–7 pounds (2–3 kg); female 4.5–6 pounds (2–3 kg)

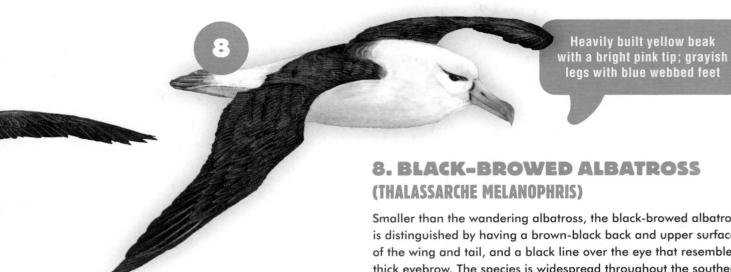

8. BLACK-BROWED ALBATROSS (THALASSARCHE MELANOPHRIS)

Smaller than the wandering albatross, the black-browed albatross is distinguished by having a brown-black back and upper surface of the wing and tail, and a black line over the eye that resembles a thick eyebrow. The species is widespread throughout the southern oceans and breeds in crowded colonies on many subantarctic islands. However, it is showing a worrying decline mainly due to trawling; this type of fishing is done using very long lines equipped with thousands of hooks, and albatrosses and other seabirds, attracted by the cephalopods or fish used as bait, end up caught on these hooks and die by drowning.

LENGTH: 31–37 inches (79–93 cm)

WEIGHT: male 7–10 pounds (3–4.5 kg); female 6–8.5 pounds (3–4 kg)

9. CAPE PETREL (DAPTION CAPENSE)

The Cape petrel is part of the great family of petrels to which the albatrosses also belong; like albatrosses, they spend most of their lives flying over the sea and return to land almost solely to nest and raise their offspring. The Cape petrel is the size of a gull, but is distinguished mainly by the black and white plumage on its upper parts, tail, and wings with a black head and white underparts. It feeds on fish and shellfish but mainly on the small crustaceans that make up krill, and will often follow fishing boats to take advantage of the fish waste thrown overboard.

LENGTH: 15–16 inches (38–40 cm)

WEIGHT: 12–19 ounces (340–528 g)

10. BROWN SKUA OR ANTARCTIC SKUA (CATHARACTA ANTARCTICA)

The brown, or Antarctic, skua is a large seabird with brown-gray plumage, varying in how dark it is from individual to individual, and often flecked with small whitish stripes; it has two large white areas on the primary flight feathers. During the fall and winter these birds stay out on the open sea, feeding on fish, attacking other seabirds to steal their food, and following ships to snatch up refuse and discarded fish. When the breeding season arrives, they make for the subantarctic islands to nest on rocky coasts or deserted islets; they often nest near large colonies of penguins and other seabirds, the more easily to prey on their eggs and chicks.

LENGTH: 20–25 inches (52–64 cm)

WEIGHT: 2.5–4.5 pounds (1–2 kg)

The Himalayas are a gigantic mountain system that stretches for more than 1,500 miles (2,400 km) in length and whose width varies from about 155 to 220 miles (250–350 km), dividing the Indian subcontinent from the Tibetan Plateau. It encompasses the highest mountains on Earth, with as many as nine "eight-thousanders"— peaks over 8,000 meters, or 26,247 feet— including the highest mountain of all, Mount Everest (Chomolungma, or "Mother of the Universe," in Tibetan), which is 29,029 feet (8,848 m) high.

Thanks to the abundant rains of the monsoon season, the slopes of this great mountain range are covered with very rich vegetation. At lower altitudes this takes the form of dense, almost impenetrable jungle, with large trees wrapped in a tangle of vines and covered with mosses and epiphytes, and thick undergrowth with ferns, reeds, and tall grasses. These jungles are still home to the tiger and the Indian rhinoceros. Climbing higher, we come to tropical forest with palms and bamboo, which then gives way to a sparser forest where oaks, evergreen trees, and rhododendrons predominate. As we go up still farther, it is the turn of the coniferous forests, with firs, cedars, and pines that grow even up to altitudes of about 11,500 feet (3,500 m); in the Alps, by comparison, trees grow up to a maximum of just over 6,500 feet (2,000 m). Above the treeline are vast meadows dotted with rhododendrons and other shrubs, and steep rocky slopes, habitat of the extremely rare and mysterious snow leopard.

With this great variety of environments comes an equally large variety of bird species, from those typical of tropical forests to those confined to high-altitude environments. Outstanding among the former we find the red junglefowl, ancestor of all our domestic chickens, unmistakable for its red crest and harsh, loud cry, and the satyr tragopan, whose male performs spectacular displays. Among the latter, we find the HIMALAYAN MONAL (in the drawing), with its splendid green, blue, and copper-colored plumage gleaming with a metallic shimmer.

ASIA

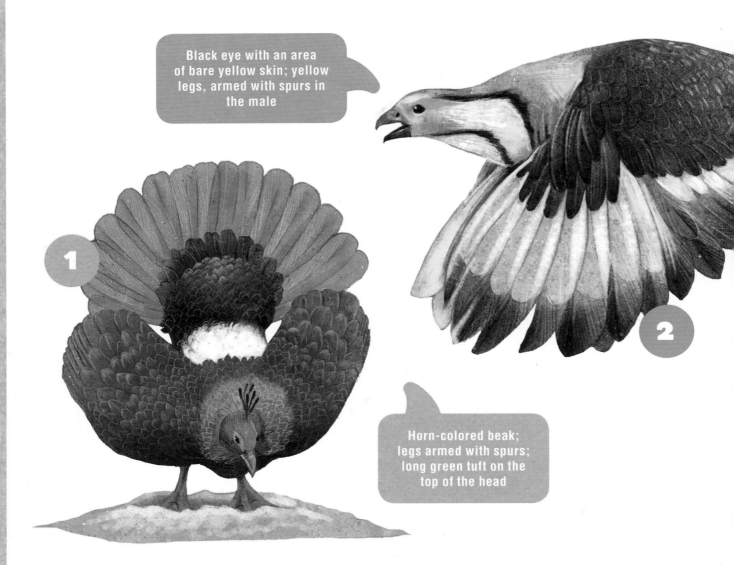

Black eye with an area of bare yellow skin; yellow legs, armed with spurs in the male

Horn-colored beak; legs armed with spurs; long green tuft on the top of the head

1. HIMALAYAN MONAL
(LOPHOPHORUS IMPEJANUS)

The Himalayan monal is a large member of the pheasant family that lives in coniferous forests and high-altitude grasslands. The male has very colorful plumage: blue, green, black, bronze, and tawny with a brilliant metallic shimmer; it has a green head with a long crest (the generic name *Lophophorus* means "crest-bearer"). The female is much less eye-catching, with brown and black plumage. The Himalayan monal live in groups for most of the year, dispersing to form pairs in the breeding season. They eat seeds, roots, berries, and insects. This bird is the national symbol of Nepal and of the Indian state of Uttarakhand.

LENGTH: male 27.5–28 inches (70–72 cm); female 24.8–25.2 inches (63–64 cm)

WEIGHT: male 4.5–5 pounds (2–2.5 kg); female 4–4.5 pounds (1.8–2.2 kg)

2. HIMALAYAN SNOWCOCK
(TETRAOGALLUS HIMALAYENSIS)

The Himalayan snowcock is a large partridge that inhabits the precipitous grassy and rocky slopes of the Himalayan mountain range. These birds live in small groups, foraging for food on the ground as they walk up a slope and then flying to the base of another slope and climbing up it in turn. They feed on grasses, seeds, shoots, and berries. The plumage is mainly gray and chestnut, with striped flanks and a gray breast with small black crescent-shaped spots. There is a white, gray, and chestnut pattern on the throat and head; the undertail is white and the primary flight feathers display a broad white band and black tips. The male and female have similar plumage, but the female is smaller and its legs do not have the spur that distinguishes the males.

LENGTH: 21–28 inches (54–72 cm)

WEIGHT: 4.5–8 pounds (2–3.5 kg)

3. CHESTNUT-BELLIED ROCK THRUSH
(MONTICOLA RUFIVENTRIS)

The chestnut-bellied rock thrush is the size of a blackbird and lives in the sparse forests of conifers and junipers on the rocky slopes of the Himalayas. The male and female have very different plumage. The male has blue upper parts and tawny-red underparts; the cheeks and ear coverts are blackish, and black plumage extends over the throat and behind the neck, shading into dark blue on the back. The female is gray-brown on the upper parts, and light chestnut with thick black crescents on the underparts. The chestnut-bellied rock thrush feeds on insects, even quite large ones.

LENGTH: 8–9 inches (21–23 cm)

WEIGHT: 1.5–2 ounces (48–61 g)

> Blue and fawn plumage; black eye, beak, legs, and feet

> Hooked black beak; black eye; grayish legs and feet; long green-black crest

4. KOKLASS PHEASANT
(PUCRASIA MACROLOPHA)

The koklass pheasant (the name recalls its typical call) lives in mountain forests at altitudes of up to more than 13,000 feet (4,000 m). The male is distinguished by a long crest on the top of the head, which is bottle green and displays two fine ear tufts; there is a white spot that stands out on each side of the neck; the upper parts are silver-gray with a black stripe in the center of each feather, and the underparts are chestnut-colored; the flight feathers and tail feathers are tawny. The female is brown. In both sexes the tail is relatively long and ends in a wedge shape. The koklass pheasant is mainly vegetarian in the fall and winter, while in the breeding season it eats mostly insects.

LENGTH: male 23–25 inches (58–64 cm) plus 8.5–11 inches (22–28 cm) of tail; female 20–22 inches (52–56 cm) plus 6.5–7.5 inches (17–19.5 cm) of tail

WEIGHT: male 2.5–3 pounds (1.13–1.41 kg); female 2–2.5 pounds (930–1,135 g)

5. BLOOD PHEASANT
(ITHAGINIS CRUENTUS)

The blood pheasant takes its name from the vermilion coloring of the male's face and breast, which is very extensive in some individuals and makes the bird look as if it is covered in blood. The upper parts are silver-gray with long white stripes, and the underparts are light green; there is a short grayish crest on the head, and the tail has a white tip with vermilion-red coverts and undertail. The female is brown, with an orange-red face and a gray nape and crest. The blood pheasant lives in sparse forests and rhododendron thickets at high altitude, and feeds almost exclusively on plant materials—moss, leaves, grasses, and shoots. It is the official bird of the Indian state of Sikkim.

LENGTH: male 17–19 inches (44–48 cm) plus 7 inches (18 cm) of tail; female 16–17 inches (39.5–42 cm) plus 6 inches (15 cm) of tail

WEIGHT: 14–23 ounces (410–655 g)

6. COMMON GREEN MAGPIE
(CISSA CHINENSIS)

The common green magpie is the only member of the Corvidae, or crow family, that has bright green plumage all over its body, in sharp contrast to its red beak and legs and feet. The wings also display a chestnut-red color, mainly visible in flight, and there is a black mask that extends from the beak to the nape and surrounds the eye. The forehead and the throat can have tones of golden yellow, which vary in how conspicuous they are. The tail is long and tapered, and the central tail feathers have white tips. The common green magpie lives in the hills at the foot of the Himalayas. It is an opportunistic bird that eats mainly large insects, small reptiles, and little birds and their eggs, but also fruits and berries. It is very noisy, and those kept in captivity can imitate the human voice.

LENGTH: 14.5–15 inches (37–39 cm)

WEIGHT: 4–4.5 ounces (120–133 g)

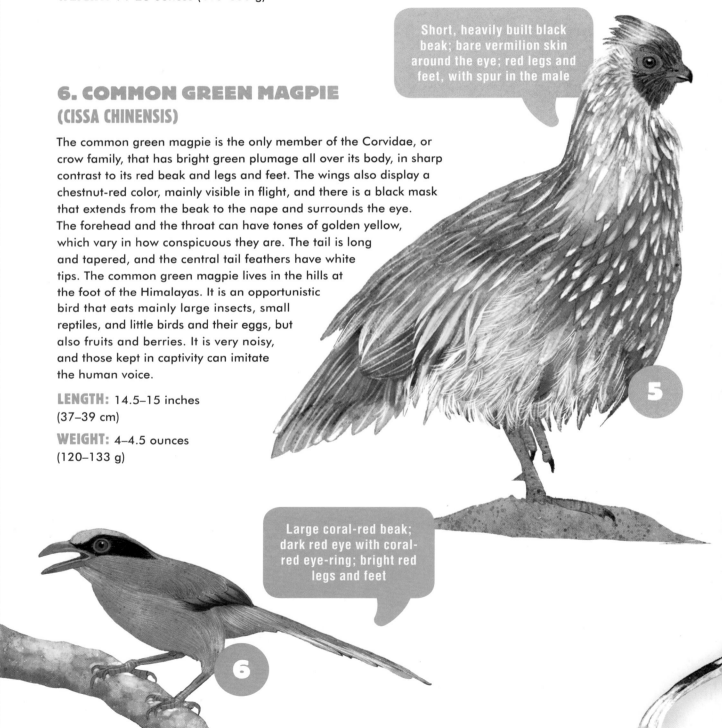

Short, heavily built black beak; bare vermilion skin around the eye; red legs and feet, with spur in the male

Large coral-red beak; dark red eye with coral-red eye-ring; bright red legs and feet

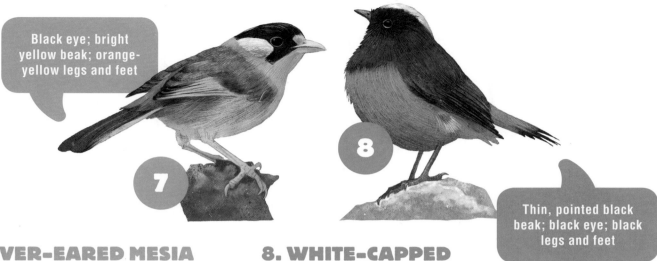

Black eye; bright yellow beak; orange-yellow legs and feet

Thin, pointed black beak; black eye; black legs and feet

7. SILVER-EARED MESIA
(LEIOTHRIX ARGENTAURIS)

The silver-eared mesia is a small bird with colorful plumage that lives in dense undergrowth and the bushy lower story of the humid forests. The name refers to the silver-colored ear coverts that stand out against the black of its head. The throat and neck are orange, the rest of the underparts are orange-yellow with hints of a greenish undertone, and the shoulders, back, wings, and tail are greenish gray, but the rectrices have a bright red band and orange-yellow edges. The rump and undertail of the male are bright red. The female has similar plumage, but the rump and undertail are orange rather than red. Its diet includes insects, larvae, and fruits.

LENGTH: 6–6.5 inches (15.5–17 cm)

WEIGHT: 0.8–1 ounce (22–29 g)

8. WHITE-CAPPED REDSTART
(PHOENICURUS LEUCOCEPHALUS)

The white-capped redstart is a species closely linked to the watercourses on the slopes of the Himalayas. The name emphasizes the main features of its appearance: The crown of the head is white, contrasting with the black plumage on the rest of the head, the throat, the upper breast, and the back. The lower breast and belly are bright red, and the rump is orange-red like the tail, which has a blackish tip and which the bird often raises up and shakes. The white-capped redstart lives near fast-flowing streams with rocky banks and feeds mainly on aquatic insects and their larvae.

LENGTH: 7–7.5 inches (18–19 cm)

WEIGHT: 1–1.5 ounces (24–42 g)

9. SPOTTED FORKTAIL
(ENICURUS MACULATUS)

The spotted forktail is a songbird with a long forked tail. It lives on the banks of cascades and streams in the forests that cover the flanks of the Himalayas, especially where the watercourse flows between rocks and boulders sticking out of the water, forming small pools in which the forktail hunts aquatic insects, larvae, and small mollusks. Its plumage is black and white. The forehead, the belly, a wide band on the coverts of the wings, and the rump are pure white; the back is black with small white crescent-shaped spots; and the neck, throat, breast, and wings are also black. The tail is long and thin; the tail feathers are black with white tips, and because they are of different lengths they give the appearance of a series of white v-shaped patterns on the black tail.

LENGTH: 9.8–10.2 inches (25–26 cm)

WEIGHT: 1–1.5 ounces (34–48 g)

Thin black beak; light pink legs and feet; long black and white tail

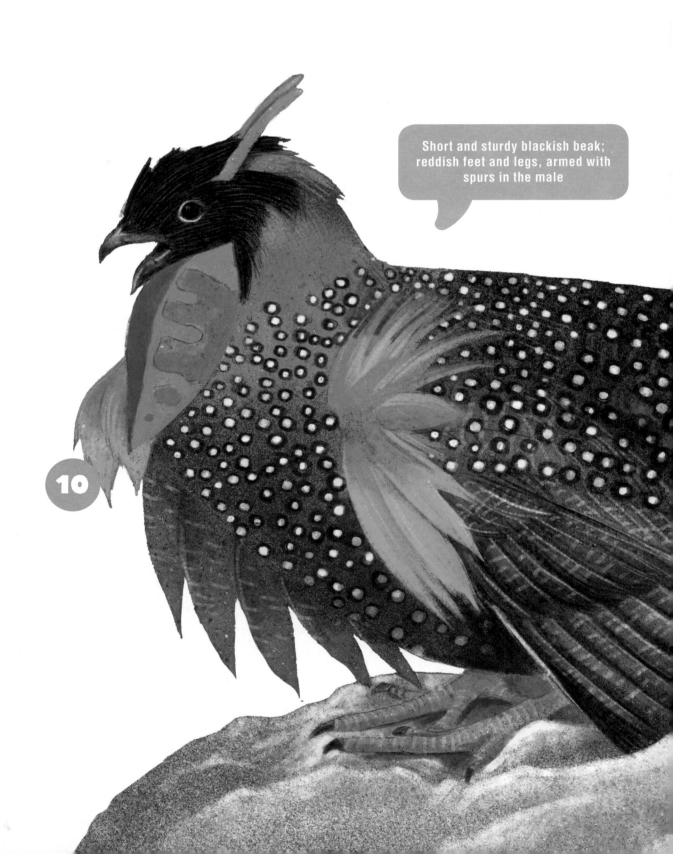

Short and sturdy blackish beak; reddish feet and legs, armed with spurs in the male

10

10. SATYR TRAGOPAN
(TRAGOPAN SATYRA)

The satyr tragopan lives in forest and bush between about 10,000 and 15,000 feet (3,000–4,500 m) above sea level. As with most members of the pheasant family, there are stark physical differences between the sexes. While the female is all brown and thickly dotted with little beige spots over the whole body, the male has a spectacular plumage of bluish-black head, dark blue throat, and red neck, throat, breast, and belly, with white dots circled in black that grow larger as they go down toward the belly. These dots are also present on the back, flanks, and tail coverts, which are brownish gray; the flight feathers are brown with chestnut bars, and the tail feathers are brown with black tips. During courtship, the male inflates two little fleshy blue "horns" on the sides of the head and a large light blue, dark blue, and red caruncle on the throat, which normally remain hidden among the feathers.

LENGTH: male 26–28 inches (67–72 cm) plus 10–14 inches (25–35 cm) of tail; female 23 inches (58 cm) plus 8 inches (20 cm) of tail

WEIGHT: male 3.5–4.5 pounds (1.5–2 kg); female 2–2.5 pounds (1–1.2 kg)

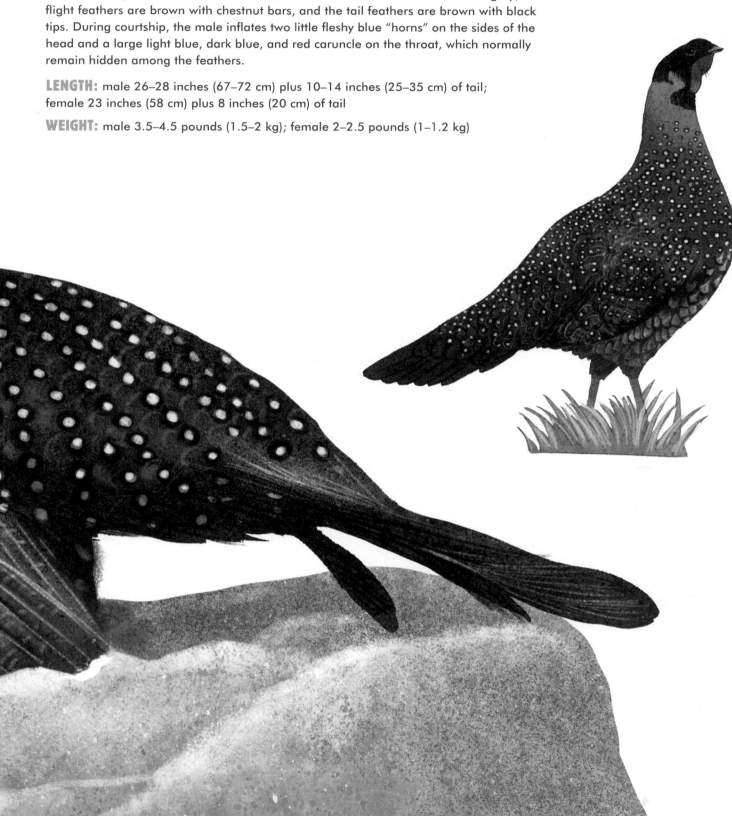

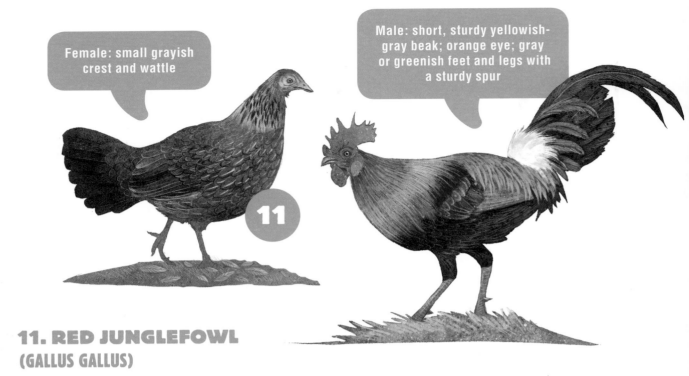

Female: small grayish crest and wattle

Male: short, sturdy yellowish-gray beak; orange eye; gray or greenish feet and legs with a sturdy spur

11. RED JUNGLEFOWL (GALLUS GALLUS)

The red junglefowl is the ancestor of domestic chickens, which humans began to breed and raise around 5,000 years ago. The male has very colorful plumage, predominantly black on the lower parts, golden red on the neck, and iridescent green-black on the tail, which has long, sickle-shaped feathers; the primary flight feathers are orange-red. The male's head is also adorned with a large, jagged fleshy red crest and two red wattles hanging from the chin. The female is smaller and less bright, with brown-gray plumage. The red junglefowl lives in the thick of the undergrowth and is very difficult to observe, though the male's loud, harsh call is readily heard.

LENGTH: male 26–31 inches (65–78 cm); female 16–18 inches (41–46 cm)

WEIGHT: male 1.5–3 pounds (672–1,450 g); female 1–2.5 pounds (485–1,050 g)

12. BLUE-THROATED BARBET (MEGALAIMA ASIATICA)

The blue-throated barbet is a bird with a stocky body, a heavily built conical beak, and predominantly bright green plumage, with shades of gold on the underparts; the face, the throat, and a strip on the top of the head are blue, and the forehead and the nape are red; there is a fine black stripe running over the eye and two small red spots on either side of the breast. Both sexes are similar in appearance. The blue-throated barbet lives in evergreen forests, plantations, and even gardens; it nests in a cavity that both members of the pair dig into a tree trunk with their beaks. Their diet consists of fruits (especially figs) and insects.

LENGTH: 8.5–9 inches (22–23 cm)

WEIGHT: 2–3.5 ounces (51–103 g)

Sturdy whitish and gray beak; brown eye with yellow-orange eye-ring; greenish legs and feet

13. LESSER RACQUET-TAILED DRONGO
(DICRURUS REMIFER)

The lesser racquet-tailed drongo lives in the humid deciduous forests on the southern slopes of the Himalayas. It has blue-black plumage with a metallic shimmer and a broad, flattened beak. The face is black and the feathers of the forehead can be raised to form a small tuft. The males also have two outermost tail feathers that are almost as long as the body; these threadlike feathers open out at the end into a wide tip that looks just like a racquet. The female is similar in appearance but does not have the long outer tail feathers; its tail is square.

LENGTH: male 12–16 inches (30–40 cm); female 10–11 inches (25–27 cm)

WEIGHT: male 1.4–1.7 ounces (39–49 g); female 1.3–1.6 ounces (35.3–44 g)

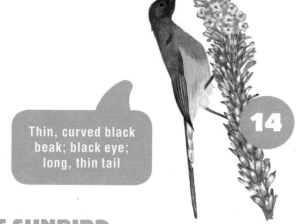

Thin, curved black beak; black eye; long, thin tail

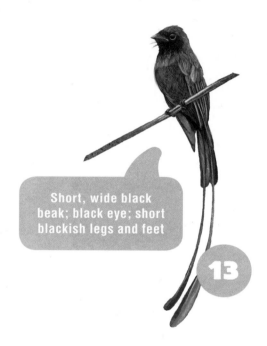

Short, wide black beak; black eye; short blackish legs and feet

14. GOULD'S SUNBIRD
(AETHOPYGA GOULDIAE)

Sunbirds are small birds specialized in feeding on the nectar of flowers. Thanks to their long, thin, curved beaks and long tongues, they can reach the nectar even in flowers with the longest calyx (a flower bud's protective layer). Gould's sunbird was named in honor of the English painter and ornithology illustrator Elizabeth Gould by her collaborator, zoologist and ornithology author Nicholas Vigors, who was a colleague of her husband, the famous ornithologist John Gould. It lives in the humid forests at the foot of the Himalayas. The male is very colorful, sporting a blue-violet face and throat with a metallic shimmer, a red head, neck, and back, yellow rump and underparts, and, depending on the subspecies, a red or yellow breast; the wings are olive green and the tail is light blue, with long, fine central tail feathers. The female is much less colorful, green on top and yellowish underneath with a short tail and also a shorter beak.

LENGTH: male 5.5–6 inches (14–15 cm); female 4 inches (10 cm)

WEIGHT: 0.2–0.3 ounce (6–8 g)

Very large, pale yellow beak with black lateral lines; bare blue skin around the eye; red throat sac

15. RUFOUS-NECKED HORNBILL
(ACEROS NIPALENSIS)

The rufous-necked hornbill inhabits mature forests with large trees offering a wealth of holes in which it can make its nest. The male has a chestnut head, neck, and underparts, while the female is all black. Both sexes have a huge, pale yellow beak with a varying number of black lines on the sides, increasing with age up to a maximum of seven; there is an area of bare blue skin surrounding the eye and the base of the beak, and there is a sac of bare red skin on the throat. The primary flight feathers have white tips, visible only in flight, and the tail is half-white. As with other members of the hornbill family, in this species the female "walls itself up" in the nesting cavity when brooding and is fed by the male through the opening.

LENGTH: 35–39 inches (90–100 cm)

WEIGHT: male 5.5 pounds (2.5 kg); female 5 pounds (2 kg)

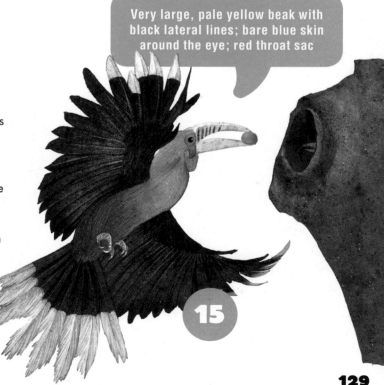

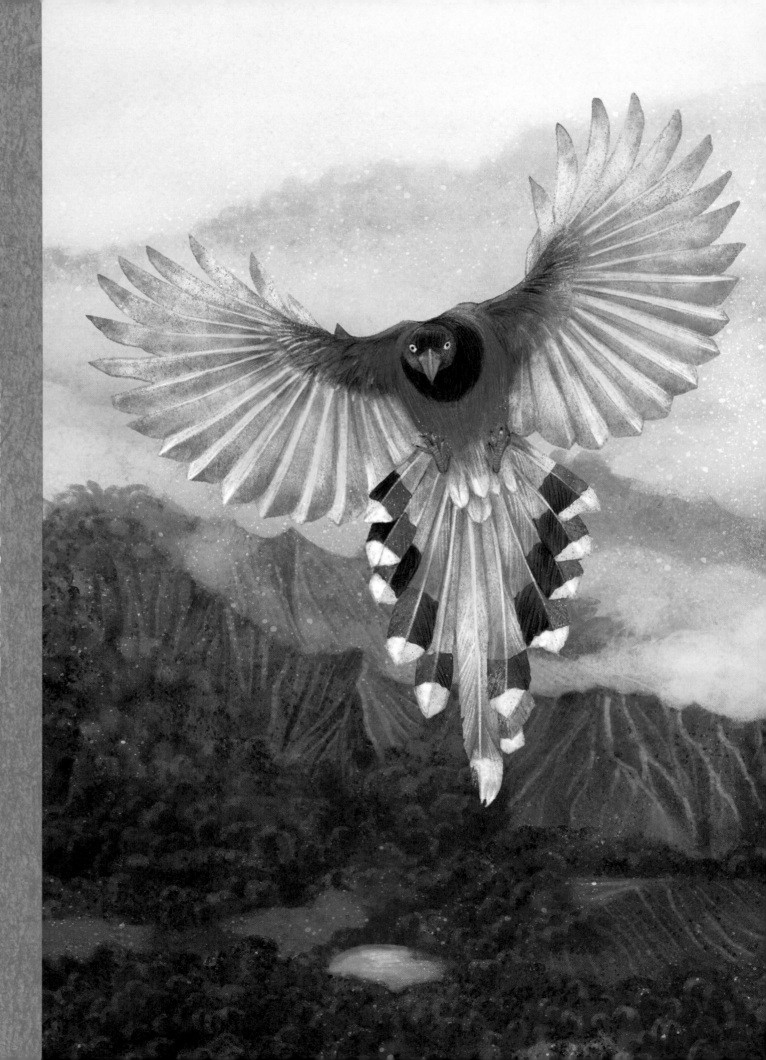

BIRDS OF TAIWAN

Taiwan is a large island (its surface area is roughly equal to that of Massachusetts, Connecticut, and Rhode Island combined) that lies 100 miles (160 km) off the coast of China. The western half is mostly flat and densely populated, while the eastern half is mountainous, with peaks reaching almost 13,000 feet (4,000 m) in height, sparsely populated, and almost completely covered by large forests. The island has also been known as Formosa ("beautiful" in Portuguese), as it was named by the Portuguese who occupied it in the sixteenth century. The climate is influenced by the monsoons that often cause violent storms at the end of summer; high temperatures and high humidity favor the growth of lush vegetation. At lower altitudes tropical forest predominates, while above around 6,500 feet (2,000 m) this gives way to coniferous forests that extend up to around 9,800 feet (3,000 m); higher still lies a kingdom of alpine meadows dotted with low bushes. A distinguishing feature of the island is the spread of lush forests of bamboo, a plant widely used by the local population to make furniture and innumerable other products.

As a geographic region, Taiwan ranks second in the world in terms of the number of bird species present in relation to land area, which makes it a very popular destination for bird-watchers. On the island you can encounter various species also present in China and in the regions of Southeast Asia, but also numerous species and subspecies that are endemic (that is to say, exclusive to this locality). Particularly noteworthy among these are two species of pheasant with predominantly blue plumage, the Swinhoe's pheasant and the Mikado pheasant, and the TAIWAN BLUE MAGPIE (in the drawing), with its blue and white plumage and red beak, legs, and feet. Blue, white, and red are the colors of the Taiwanese flag, and for this reason the blue magpie has been chosen as the island's national bird.

ASIA

1. TAIWAN CUPWING OR TAIWAN WREN-BABBLER
(PNOEPYGA FORMOSANA)

The most noticeable feature of this tiny songbird is the apparent lack of a tail, which makes its body look like an egg mounted on two sturdy legs. It does, in fact, have a tail, but it is very short. The plumage is brown with buff-colored spots on the head and back, uniform brown on the wings, and black on the underparts with white-edged feathers creating a marked fish-scale effect. The Taiwan cupwing lives in humid mountain forests, generally remaining well hidden in the tall grass and among the bushes and revealing its presence by its singing; its call is a thin, high-pitched trill.

LENGTH: 3–3.5 inches (8–9 cm)

WEIGHT: 0.6–0.7 ounce (18–21 g)

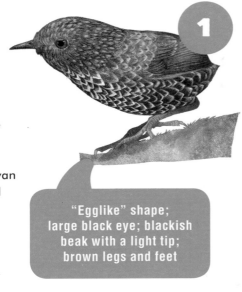

"Egglike" shape; large black eye; blackish beak with a light tip; brown legs and feet

2. TAIWAN PARTRIDGE
(ARBOROPHILA CRUDIGULARIS)

The Taiwan partridge is a member of the Phasianidae family and a species endemic to Taiwan. It has a rounded body, with a short tail and sturdy legs. The plumage is predominantly dark blue-gray, with wing coverts of a tawny color with grayish spots. The head has a brown crown, a black area around the eyes and on the sides of the neck, the cheeks, and the throat, and a narrow white "eyebrow." Both sexes are similar in appearance, but the male is bigger and in the breeding season develops a blood-red patch on its throat that looks like a wound. They live in mountain forests and forage for food on the ground consisting of seeds, berries, earthworms, and insects.

LENGTH: 10.5–11 inches (27–28 cm)

WEIGHT: male 11 ounces (310 g); female 7.5 ounces (210 g)

Whitish beak; light brown eye encircled by large red caruncles; reddish legs and feet

Dark gray beak; black eye; sturdy orange-red legs and feet

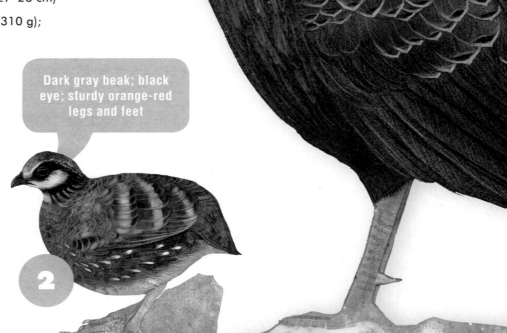

3. SWINHOE'S PHEASANT (LOPHURA SWINHOII)

Swinhoe's pheasant is endemic to the forests of Taiwan. The male has dark blue plumage, with a large white patch flanked by two red-brown areas on the upper part of the back and a short white crest on the nape; the two central tail feathers are white, and the wing coverts have a green metallic shimmer. There are two large red caruncles on the face. The female is brown with yellowish arrowhead-shaped spots. In courtship displays, the male inflates its red caruncles and performs jumps and turns, often shaking its wing feathers to create a loud noise with their vibration.

LENGTH: male 31 inches (79 cm) plus 16–20 inches (40–50 cm) of tail; female 20 inches (50 cm) plus 8–8.5 inches (20–22 cm) of tail

WEIGHT: 2.5 pounds (1 kg)

4. TAIWAN ROSEFINCH (CARPODACUS FORMOSANUS)

The Taiwan rosefinch is distinguished by the plumage of the male, which is almost entirely wine red with blackish-brown wings and tail, an indistinct pale pink "eyebrow," and white spots on the tertial flight feathers. The female is a warm buff color with hints of olive and scattered blackish stripes all over the body. The Taiwan rosefinch is endemic to the island, where it lives in forests with dense undergrowth and has a diet mainly based on seeds.

LENGTH: 5–6.5 inches (13–16 cm)

WEIGHT: 0.7–0.8 ounce (20.5– 24 g)

Sturdy, conical gray beak; reddish eye; gray-pink legs and feet

4

5. WHITE-WHISKERED LAUGHINGTHRUSH (GARRULAX MORRISONIANUS)

The white-whiskered laughingthrush is a large, long-tailed songbird. The plumage is chestnut all over, with blue-gray wings and tail with large orange-yellow areas. The head is gray on the crown, with dark brown cheeks and white "eyebrows" and malar stripes. Both male and female are similar in appearance. The laughingthrush is widespread in the central mountains of the island, where it frequents clearings and bushes. It is migratory, but, unlike most birds, its migration does not depend on the season but on weather conditions: It descends to lower altitudes when the weather is bad.

LENGTH: 10–11 inches (25–28 cm)

WEIGHT: 2.6–2.7 ounces (75–77 g)

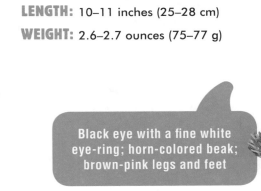

Black eye with a fine white eye-ring; horn-colored beak; brown-pink legs and feet

5

3

6. COLLARED BUSH-ROBIN
(TARSIGER JOHNSTONIAE)

The collared bush-robin is a small songbird endemic to Taiwan's mountain forests. The male has slate-colored plumage on the head, back, wings, and tail, and grayish or light buff on the underparts. It has a rust-red band forming a collar that extends over the back of the neck and joins the scapulars, which are also of the same color, and a marked white "eyebrow" that stands out on the head. The female's plumage is less bright, in gray-brown and buff, and the "eyebrows" are less noticeable.

LENGTH: 4.5 inches (12 cm)

WEIGHT: 0.6–0.7 ounce (15–20 g)

7. FLAMECREST OR TAIWAN FIRECREST
(REGULUS GOODFELLOWI)

The generic name *Regulus*—"little king" in Latin—refers to the distinctive golden or orange crest for which this bird is known. The flamecrest is endemic to Taiwan, where it lives in coniferous forests at higher altitudes. The plumage is golden green on the back, wings, and tail, yellow on the flanks, belly, and rump, and gray on the throat and breast. The head has a striking black and white pattern and a crest, yellow in the female and orange in the male, that is raised when the bird is excited or alarmed. Very lively and always on the move, the flamecrest forages for spiders, small insects, and their larvae on branches and among the needles of conifers.

LENGTH: 3.5 inches (9 cm)

WEIGHT: 0.2 ounce (7 g)

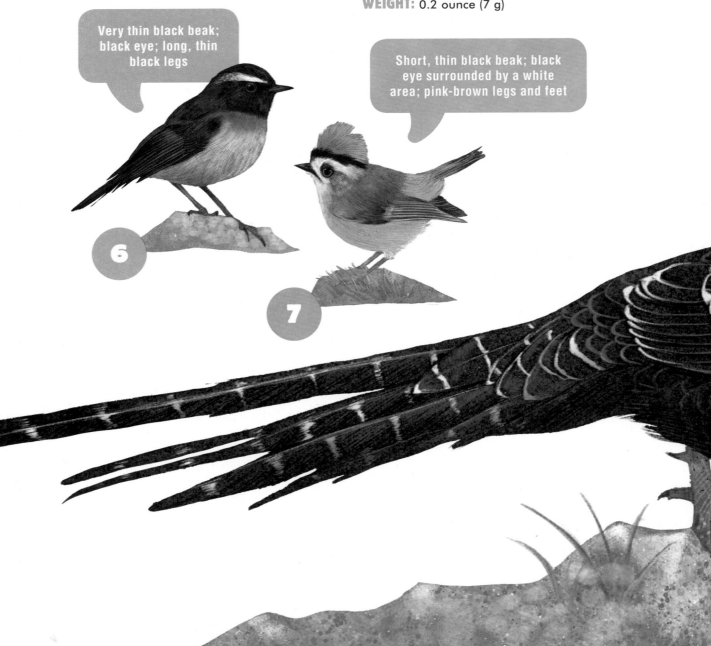

Very thin black beak; black eye; long, thin black legs

Short, thin black beak; black eye surrounded by a white area; pink-brown legs and feet

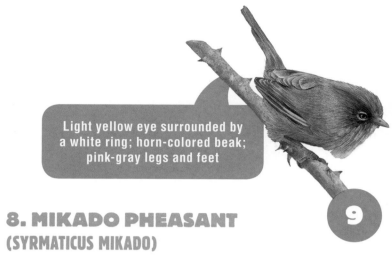

Light yellow eye surrounded by a white ring; horn-colored beak; pink-gray legs and feet

8. MIKADO PHEASANT
(SYRMATICUS MIKADO)

The Mikado pheasant, named in honor of the emperor of Japan, is a large and portly pheasant with a long tail that lives in the forests and bamboo groves of Taiwan's mountains. The male has blue-black plumage, with a metallic shimmer that is particularly noticeable in certain lights; there is a white band on the wings, the tail is barred with white, and the bare skin of the face is red. The female is smaller, with brown plumage flecked with white. The males are territorial and generally remain well hidden in the undergrowth; when in danger, they take refuge in the thick of the vegetation, only rarely escaping by means of short flights.

LENGTH: male 34 inches (87.5 cm) plus up to 21 inches (53 cm) of tail; female 21 inches (53 cm) plus 6.5–8.5 inches (17–22 cm) of tail

WEIGHT: male 3 pounds (1.5 kg); female 2 pounds (1 kg)

9. TAIWAN FULVETTA
(FULVETTA FORMOSANA)

The Taiwan fulvetta is a small songbird with a round body, a relatively large head, and a rather long tail. Its preferred habitat is the undergrowth of coniferous forests and bamboo groves. The head is light brown, with a darker line that passes over the eye and ends at the nape; the throat has dense whitish stripes and the rest of the body is grayish brown with shades of ocher on the coverts of the wings and on the tail. It has a diet based on seeds and insects that it finds mainly on the ground.

LENGTH: 4.5 inches (12 cm)

WEIGHT: 0.5 ounce (10 g)

10. FAIRY PITTA
(PITTA NYMPHA)

The fairy pitta is a medium-sized bird with very colorful plumage and thin legs. The plumage displays various shades of green and blue on the upper parts, wings, and tail, while the breast and the flanks are yellowish and the belly and the undertail are bright red. The head has a brown crown with a black median line, a white "eyebrow" that extends back to the nape, black chin and cheeks, and a white throat. It lives in the undergrowth of moist forest and feeds mainly on earthworms and snails, whose shells it cracks against a stone.

LENGTH: 6.5–8 inches (16–20 cm)

WEIGHT: 2.5–5.5 ounces (67–155 g)

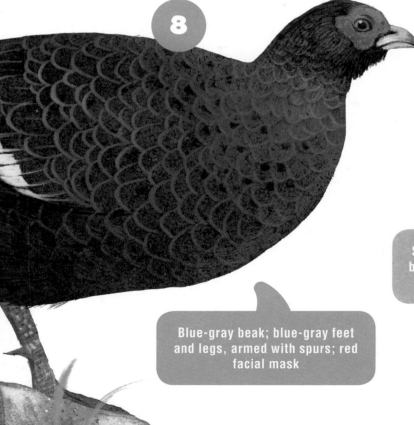

Blue-gray beak; blue-gray feet and legs, armed with spurs; red facial mask

Sturdy and slightly curved black beak; black eye; pale pink legs and feet

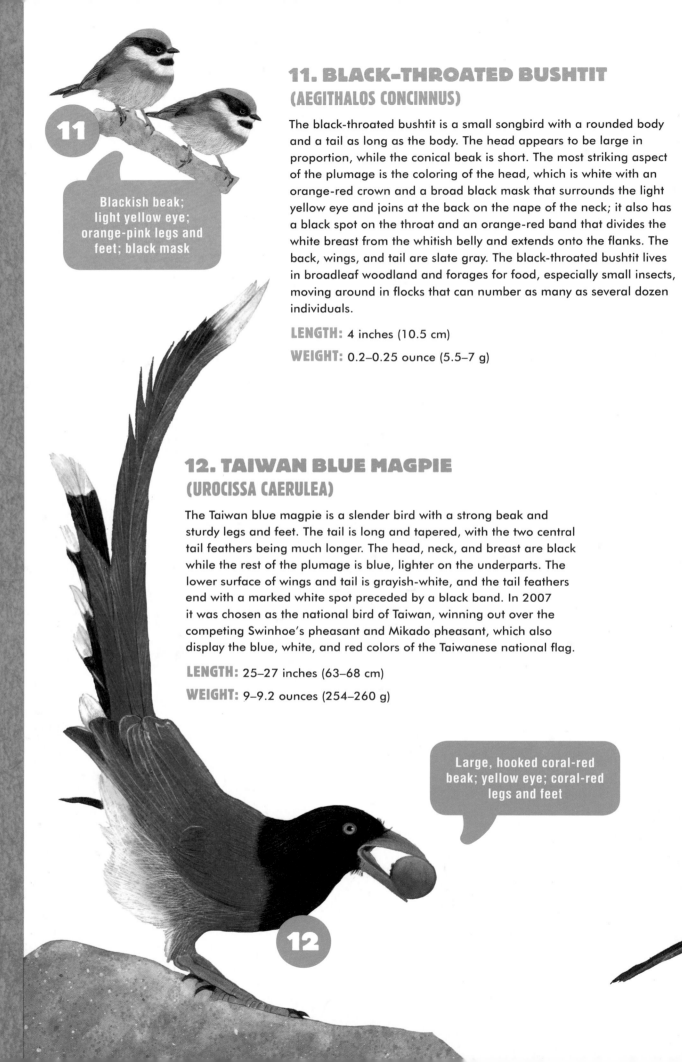

11. BLACK-THROATED BUSHTIT
(AEGITHALOS CONCINNUS)

The black-throated bushtit is a small songbird with a rounded body and a tail as long as the body. The head appears to be large in proportion, while the conical beak is short. The most striking aspect of the plumage is the coloring of the head, which is white with an orange-red crown and a broad black mask that surrounds the light yellow eye and joins at the back on the nape of the neck; it also has a black spot on the throat and an orange-red band that divides the white breast from the whitish belly and extends onto the flanks. The back, wings, and tail are slate gray. The black-throated bushtit lives in broadleaf woodland and forages for food, especially small insects, moving around in flocks that can number as many as several dozen individuals.

LENGTH: 4 inches (10.5 cm)

WEIGHT: 0.2–0.25 ounce (5.5–7 g)

Blackish beak; light yellow eye; orange-pink legs and feet; black mask

12. TAIWAN BLUE MAGPIE
(UROCISSA CAERULEA)

The Taiwan blue magpie is a slender bird with a strong beak and sturdy legs and feet. The tail is long and tapered, with the two central tail feathers being much longer. The head, neck, and breast are black while the rest of the plumage is blue, lighter on the underparts. The lower surface of wings and tail is grayish-white, and the tail feathers end with a marked white spot preceded by a black band. In 2007 it was chosen as the national bird of Taiwan, winning out over the competing Swinhoe's pheasant and Mikado pheasant, which also display the blue, white, and red colors of the Taiwanese national flag.

LENGTH: 25–27 inches (63–68 cm)

WEIGHT: 9–9.2 ounces (254–260 g)

Large, hooked coral-red beak; yellow eye; coral-red legs and feet

13. TAIWAN BARBET
(PSILOPOGON NUCHALIS)

The Taiwan barbet is a sturdily built bird with a strong, heavy beak that enables it to dig out its nest in tree trunks. In the typical configuration of tree-climbing birds, its feet have two toes pointing backward. Its plumage is bright green all over the body, darker on the wings and tail, while the head is very colorful with a yellow forehead, chin, and upper part of the throat; below this yellow is a blue band that extends over the cheeks and ear coverts, and below this again a red stripe. There is a small red spot to be seen at the base of the beak, and a black band above the eye. The Taiwan barbet lives in mountain forests and feeds on seeds and insects.

LENGTH: 8.5 inches (21.5 cm)

WEIGHT: 2.5–4.5 ounces (67–123 g)

14. TAIWAN BARWING
(ACTINODURA MORRISONIANA)

The Taiwan barwing lives in mature deciduous forests in the mountains of the island. Both sexes are similar in appearance, with predominantly chestnut and gray plumage. The crown and the sides of the head are chestnut, and the throat, breast, flanks, and mantle are ocher-gray with close-set whitish stripes. The wings are chestnut with close-set black transverse stripes, and the tail feathers are tawny in the upper part and then gray-brown with white tips. Taiwan barwings often form groups together with similar species to forage for insects and larvae on trees and seem particularly fond of honeysuckle berries.

LENGTH: 7–7.5 inches (18–19 cm)

WEIGHT: 1 ounce (32 g)

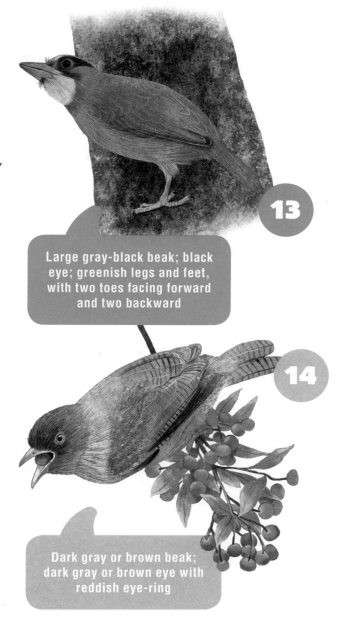

Large gray-black beak; black eye; greenish legs and feet, with two toes facing forward and two backward

Dark gray or brown beak; dark gray or brown eye with reddish eye-ring

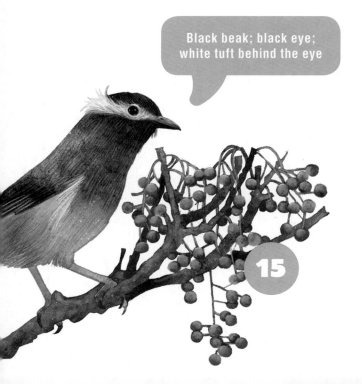

Black beak; black eye; white tuft behind the eye

15. WHITE-EARED SIBIA
(HETEROPHASIA AURICULARIS)

The white-eared sibia is a species endemic to Taiwan, where it lives in conifer forests in the mountains, moving to lower altitudes in winter. It is a slender-bodied bird, distinguished by a white stripe that surrounds the eye and extends into fine, threadlike feathers that stand out against the sooty black of the head. The throat, breast, and back are dark gray, the wings are blue-black with a white band, the tail is also blue-black, and the underparts are a light tawny color. The white-eared sibia feeds on insects, seeds, and berries and is very fond of the nectar of flowers, which it can collect thanks to a tongue equipped with little spiny growths.

LENGTH: 8.5–9.5 inches (22–24 cm)

WEIGHT: 1.5–2 ounces (40–50 g)

okkaidō is the northernmost of the four major islands that make up Japan. It is distinguished by its impenetrable natural terrain, with more than 60 volcanoes and nearly three-quarters of its surface covered by dense forests. In winter the climate is harsh, with frequent snowstorms brought by the icy winds that blow unimpeded straight from Siberia. The Sea of Okhotsk, which bathes its northern coasts, freezes and remains covered by ice for long months.

About 10 percent of the island's surface is protected in the form of six national parks, which safeguard the most untouched natural environments—from the coasts to the marshes and from the lakes to the inland mountains. The magnificent scenery, lush flora, and rich fauna of these protected areas make Hokkaidō a popular destination for nature lovers in every season.

It is winter above all, however, that draws bird-watchers and nature photographers to Hokkaidō, and this great Japanese island does indeed have some exceptional attractions. First and foremost of these are the spectacular dances of the red-crowned or Manchurian crane. Hokkaidō is home to a resident population of these great wading birds with their black and white plumage, and the sight of pairs facing one another in the snow, executing great leaps and jumps in a display that reinforces the bond between them, is a fascinating scene.

Another spectacle that is performed anew each year is that of the WHOOPER SWANS (in the drawing) that, having nested in the tundra of the far north, now migrate toward more favorable climes. In particular, there is a population of these birds that winters on the great Lake Kussharo, which never freezes completely but retains stretches of open water due to the presence of hot springs. As well as these, thousands of Steller's sea eagles gather on the northern coasts of the island in winter—imposing birds of prey with white and brown plumage and huge yellow beaks that catch fish among the floating ice.

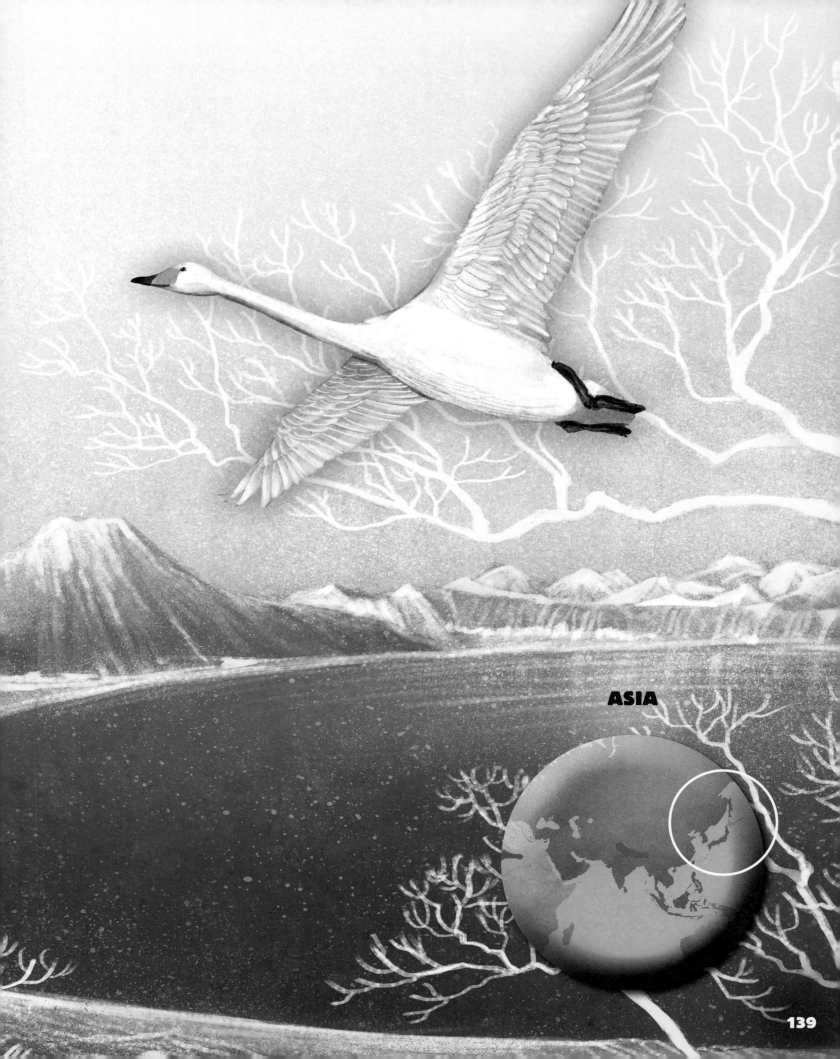

ASIA

1. STELLER'S SEA EAGLE
(HALIAEETUS PELAGICUS)

Steller's sea eagle is the largest of the sea eagles, and one of the largest diurnal birds of prey. Its wingspan exceeds 6.5 feet (2 m) and can reach as much as eight (2.5 m). Its plumage is predominantly blackish brown, against which the white tail, undertail, crural feathers, and two large areas of white on the shoulders stand out. Its imposing beak is the biggest of all the birds. Steller's sea eagle breeds on the northern coasts of Asia, building huge nests of branches on rocks or in large trees. Fish, which it may take alive or scavenge already dead, form the base of its diet, but it also catches large birds.

LENGTH: 33–41 inches (85–105 cm)

WEIGHT: male 11–13 pounds (5–6 kg);
female 15–20 pounds (7–9 kg)

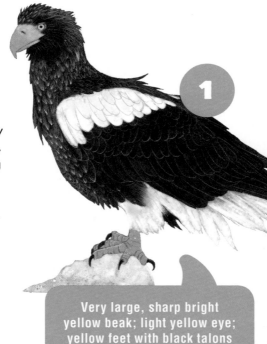

1

Very large, sharp bright yellow beak; light yellow eye; yellow feet with black talons

2. HARLEQUIN DUCK
(HISTRIONICUS HISTRIONICUS)

The harlequin duck is a small diving duck that lives along the northern coasts of America and Asia, in Japan, and in Iceland. It lives near fast-flowing streams of ice-cold, tumultuous water, where it looks for food (crustaceans, mollusks, and small fish) by diving or swimming underwater. In winter it is also found on seacoasts. It owes its name to the plumage of the male: In slate, chestnut, white, and black, it looks as if it were made up of multicolored patches like the costume of the masked classical Italian comedy character Harlequin.

LENGTH: 15–20 inches (38–51 cm)

WEIGHT: male 1.3–1.7 pounds (581–750 g);
female 1–1.5 pounds (485–682 g)

Male: short gray-blue beak; dark red eye; pointed tail

Female: brown plumage; three white spots on the head

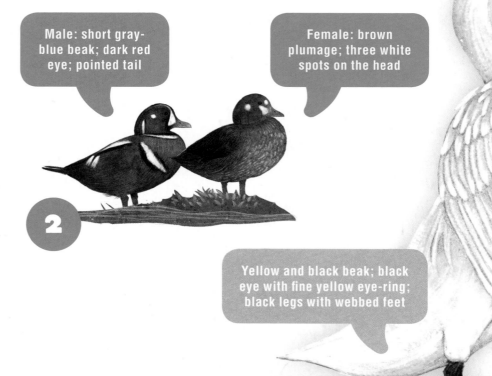

2

Yellow and black beak; black eye with fine yellow eye-ring; black legs with webbed feet

3

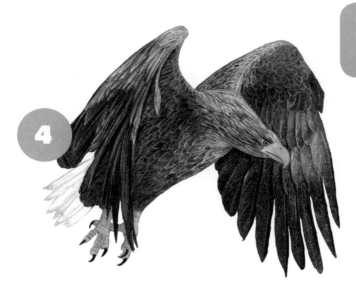

Yellow beak, cere, and eye; yellow feet with black talons

4. WHITE-TAILED EAGLE
(HALIAEETUS ALBICILLA)

The white-tailed eagle is slightly smaller than Steller's sea eagle, but has an equally large wingspan. It has a very wide distribution, ranging from Greenland through Northern Europe and Asia to Japan. The plumage is grayish brown, with the head, neck, and upper part of the breast usually lighter; the wedge-shaped tail is white. It feeds mainly on large fish caught in shallow water, but it can also prey on birds the size of a duck or a seagull, and it usually also eats carrion, especially in winter.

LENGTH: 29–36 inches (74–92 cm)

WEIGHT: male 7–12 pounds (3–5.5 kg); female 8–15 pounds (3.5–7 kg)

3. WHOOPER SWAN
(CYGNUS CYGNUS)

The whooper swan is the national bird of Finland and is depicted on the Finnish one-euro coin. It is a large bird with a long neck and snow-white plumage, with a wingspan of over 6.5 feet (2 m). It is distinguished from other swans by the shape of the beak, which is longer, conical, and yellow over more than half its length, with a black tip and edges. It has a very loud call, bringing to mind the sound of a trumpet. Whooper swans nest in Northern Europe and Asia, on lakes and ponds in forested areas, and migrate south in winter. Thousands of swans winter on the island of Hokkaidō, on lakes where the water never freezes.

LENGTH: 55–65 inches (140–165 cm)

WEIGHT: male 16–34 pounds (7–16 kg); female 12–30 pounds (5.5–13 kg)

5. BLAKISTON'S FISH OWL
(BUBO BLAKISTONI)

Blakiston's fish owl is the largest nocturnal raptor in existence and specializes in catching fish and other aquatic animals. The plumage is brown, with closely set dark streaks on the upper parts and lighter but similarly close-set streaks on the underparts; the flight feathers and tail feathers have alternating dark and light bands. It has ear tufts on its head, which it often keeps lowered to the side. The habitat of the Blakiston's fish owl consists of dense forests on the banks of lakes and rivers. The native Ainu people of Hokkaidō considered this bird a deity, giving it the name of Kotan koru Kamuy, "the god that protects the village."

LENGTH: 24–28 inches (60–71 cm)

WEIGHT: male 7–7.5 pounds (3–3.5 kg); female 7.5–10 pounds (3.5–4.5 kg)

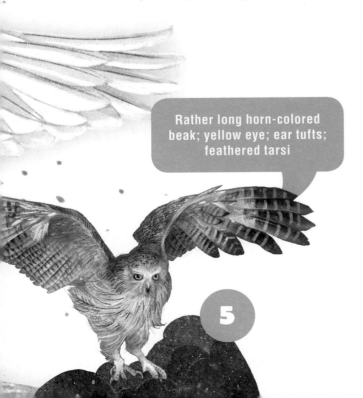

Rather long horn-colored beak; yellow eye; ear tufts; feathered tarsi

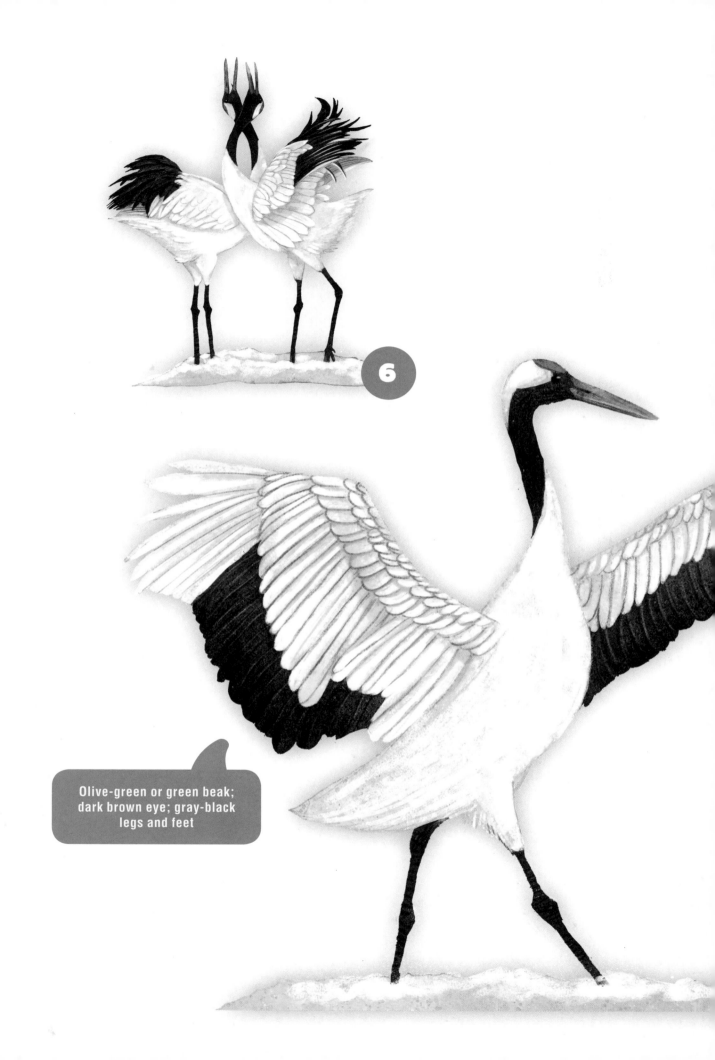

Olive-green or green beak; dark brown eye; gray-black legs and feet

6. RED-CROWNED CRANE OR MANCHURIAN CRANE
(GRUS JAPONENSIS)

The red-crowned or Manchurian crane is a large bird with long legs and a long neck, with black and white plumage and an area of bare red skin on the top of the head. The body is completely white, including the tail, and only the secondary flight feathers and part of the coverts are black; the neck, throat, and cheeks are also black. The species nests in China, Siberia, and Japan, but they number fewer than 3,000 pairs altogether and are considered threatened with extinction. Pairs stay together for life and strengthen their bond with spectacular dances, accompanied by resounding calls. In Japanese, Chinese, and Korean cultures, this crane is considered a symbol of loyalty, peace, and immortality.

LENGTH: 54–60 inches (138–152 cm)

WEIGHT: 15–22 pounds (7–10 kg)

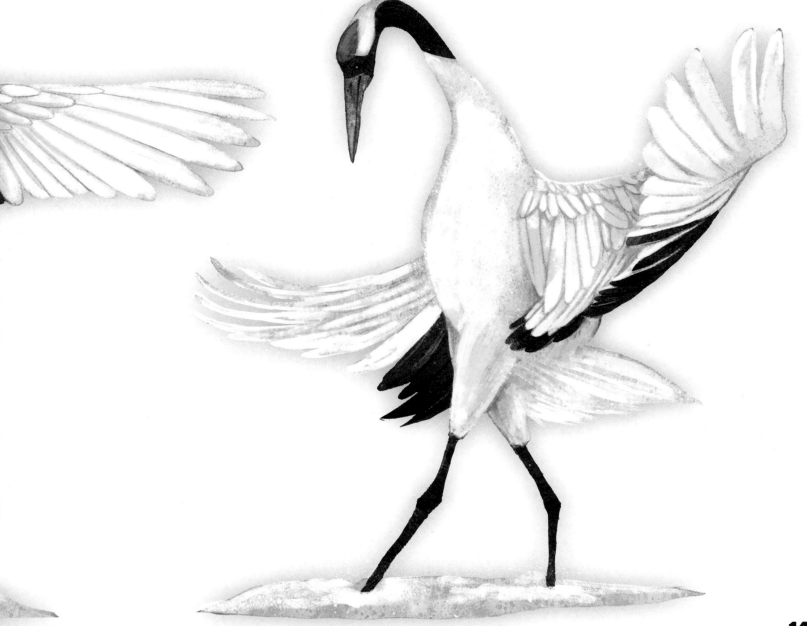

Thin, pointed black beak; black eye; delicate light brown legs and feet

Very small conical black beak; small black eye; fine yellow eye-ring

7. JAPANESE ROBIN
(LARVIVORA AKAHIGE)

The Japanese robin is like the European robin in its overall appearance and in its plumage, with the crown of the head and the upper parts olive-brown in color. The cheeks, the sides of the neck, and the throat are a vivid orange-red, and the breast is gray with a fish-scale pattern gradually becoming less distinct going down toward the belly. It has a bright tawny-colored tail that it flicks upward often. The Japanese robin lives in dense undergrowth in mountain forests, often near a watercourse; it feeds on insects, caterpillars, and, to a lesser extent, berries.

LENGTH: 5.5–6 inches (14–15 cm)

WEIGHT: 0.6–0.7 ounce (18–20 g)

8. LONG-TAILED TIT
(AEGITHALOS CAUDATUS)

A ball of feathers with a long tail: This is what the long-tailed tit looks like as it hops from branch to branch or flits by with its undulating flight. The species has a very wide distribution, from Europe to Japan, and the different populations show some variation in the color of the plumage; in Hokkaidō, the type with the all-white head predominates. The back is black with two chestnut bands on the shoulders, and the tail is black and white. The long-tailed tit builds a very distinctive nest: an oval ball of moss with a small side opening, held together with cobwebs and camouflaged with lichens and little scraps of bark.

LENGTH: 5–6.5 inches (13–16 cm) including 2–4 inches (6–10 cm) of tail

WEIGHT: 0.2–0.4 ounce (6.5–10 g)

9. MANDARIN DUCK
(AIX GALERICULATA)

The mandarin duck is a relatively small duck, originating in China and Japan but widespread in many farms and parks in the rest of the world due to the splendid, colorful plumage of the male. The head is particularly eye-catching, equipped with a voluminous multicolored tuft and a sunburst pattern of orange feathers edged with white on the cheeks, and the male also has its brick-colored "sails," a distinctively shaped extra-large twelfth flight feather that sticks up on either side of the back. The female is grayish brown on the upper parts, and spotted with white on the underparts.

LENGTH: 16–20 inches (41–51 cm)

WEIGHT: male 1.3–1.5 pounds (571–693 g); female 1–1.3 pounds (428–608 g)

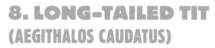

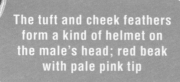

The tuft and cheek feathers form a kind of helmet on the male's head; red beak with pale pink tip

10. BLUE-AND-WHITE FLYCATCHER
(CYANOPTILA CYANOMELANA)

The male blue-and-white flycatcher has blue plumage on the upper parts, brighter on the top of the head, with blue-black cheeks and throat; the belly and undertail are pure white, the flight feathers are black with a bright blue edge, the central tail feathers are blue, and the lateral ones are blue with black tips. Both males and females sing at dawn and dusk, with loud, fluting notes. The female is brown-gray on the upper parts and grayish on the underparts. Their main prey are flies, butterflies, bees, and small beetles, usually caught on the wing by launching from an exposed perch.

LENGTH: 6.3–6.7 inches (16–17 cm)

WEIGHT: 1 ounce (25 g)

11. RUDDY KINGFISHER
(HALCYON COROMANDA)

The ruddy kingfisher is distinguished by its rust-red plumage, darker on the wings and tail and lighter on the underparts; the rump is sky blue and the heavily built beak is bright red. It lives in dense evergreen forests, preferably, though not necessarily, near a watercourse; in this habitat it is difficult to see the kingfishers and easier to hear their song, a series of melancholy whistles and trills. They catch fish and shrimp, but in the forest they feed mainly on frogs and large insects. They are very rare in Japan, and the population migrates to the Philippines in winter.

LENGTH: 10–11 inches (25–27) cm

WEIGHT: 2–3 ounces (60–92 g)

12. WHITE-BELLIED GREEN PIGEON
(TRERON SIEBOLDII)

The white-bellied green pigeon is one of a large group of species called "green pigeons" due to the predominant color of their plumage. This species in particular has green upper parts with a large violet-red spot on the shoulders and a golden shade on the forehead and breast; the belly is whitish and the flight feathers are blackish. The white-bellied green pigeon lives in mixed forests and beechwoods and is famous for an unusual habit: At the end of summer, it flies to the sea every day to drink salt water. It is the only pigeon species known to exhibit this behavior.

LENGTH: 13–14 inches (33–36 cm)

WEIGHT: 8–9 ounces (220–250 g)

Thin, pointed black beak; black eye; brown legs and feet

Large, straight bright red beak; black eye; red legs and feet

Black and white pattern on the face; red throat; black beak; brown legs and feet

Light blue beak with gray tip; black eye surrounded by a red ring and an area of light blue bare skin; deep pink feet

13. SIBERIAN RUBYTHROAT
(CALLIOPE CALLIOPE)

A bird with long legs and a thin beak, the Siberian rubythroat looks like a nightingale. The plumage is olive-brown on the upper parts and grayish on the underparts, but the male has a red throat edged with black, a clearly defined white "eyebrow," a black lore, and a white stripe at the base of the cheeks. The female has similar plumage but does not have a colorful head, displaying only the white "eyebrow" and the whitish throat. They nest in forests with dense undergrowth and often remain hidden among the bushes, revealing their presence by their song: a rapid, musical twittering.

LENGTH: 5.5–6.5 inches (14–16 cm)

WEIGHT: 0.5–1 ounce (16–29 g)

New Guinea is the second largest island in the world, after Greenland. It is located in the Pacific Ocean, north of Australia, and is divided politically into two: The eastern part forms the independent state of Papua New Guinea, while the western part is under the control of Indonesia. There is a long mountain range running west to east across the island, with "four-thousanders"—peaks higher than 4,000 meters, or 13,123 feet. The territory is covered almost entirely by dense tropical vegetation. These forests, almost impenetrable and still partly unexplored, are populated by many species of birds; more than 800 have been identified, with dozens upon dozens of instances of endemism: species present only in specific, limited areas of the island.

The bird life of New Guinea includes, among others, three species of cassowaries (huge birds related to ostriches and similarly unable to fly), dozens of pigeons and doves with flamboyant plumage, parrots, kingfishers, and a variety of small, brightly colored songbirds.

birds of paradise and the bowerbirds. The birds of paradise are distinguished by the presence, in the males, of very elaborate plumage with long tails, threadlike trailing feathers, and bibs or collars with a metallic shimmer. This plumage is exhibited to attract females, accompanied by songs, dances, and spins that serve to better highlight it. There are 34 different species of birds of paradise in New Guinea (in the drawing, the RAGGIANA BIRD OF PARADISE).

Bowerbirds, on the other hand, do not use flamboyant plumage to impress females but instead build bowers or a walkway of small branches that lead to a little clearing; here they assemble a collection of colored objects: the elytrons (wing cases) of insects, berries, flowers, pebbles, shells, and even human artifacts like bottle caps or pieces of colored plastic. There are 10 species of bowerbird present in New Guinea, and each of them not only builds a different design of bower but, above all, selects specific colors for the collection of objects in the display.

OCEANIA

Long, thin blackish beak; red eye surrounded by grayish bare skin; dark pink legs and feet

1. TWELVE-WIRED BIRD OF PARADISE
(SELEUCIDIS MELANOLEUCUS)

The "twelve wires" referred to in the name of this bird of paradise are 12 very long, threadlike feathers that extend from the male's flanks, six on each side. In addition to this ornament, the male sports shiny black plumage on the head, breast, back, and wings, and sulfur yellow on the belly, flanks, and tail. The female has a black head, cinnamon-brown upper parts, and whitish underparts with dark bars. For its displays, the male chooses a vertical perch and, having attracted the attention of a female with loud calls, performs by rotating around this perch, shaking its head and tail and ruffling up its breast feathers.

LENGTH: male 13 inches (33 cm); female 14 inches (35 cm)

WEIGHT: male 6–7.5 ounces (170–217 g); female 5.5–6.5 ounces (160–188 g)

2. RAGGIANA BIRD OF PARADISE
(PARADISAEA RAGGIANA)

The Raggiana bird of paradise is one of the most spectacular birds of paradise. The male is brown on the back, wings, tail, and belly, with a sulfur-yellow head and neck, emerald-green throat, and black breast; it has a dark green ring encircling the beak. It has extra-long wispy orange-red feathers on its flanks that form two long trains, and the two central tail feathers are very long and threadlike. The female's plumage is the same as that of the male but less bright, and without the spectacular feathers on the flanks. In the breeding season, several males will gather on a big tree where they attract the females' attention with loud calls and display by jumping and bowing with open wings, fluffing up the feathers on their flanks.

LENGTH: 13 inches (34 cm) both male and female, excluding the threadlike feathers of the tail

WEIGHT: male 8–11 ounces (234–300 g); female 4.5–8 ounces (133–220 g)

Yellow eye; steel-blue beak; brownish-pink legs and feet

3. KING BIRD OF PARADISE
(CICINNURUS REGIUS)

The king bird of paradise is one of the smallest birds of paradise. The male has carmine-red plumage on the upper parts, head, throat, and wings, and white on the underparts; it has an iridescent green band separating the red of the throat from the white of the breast, and on either side of the breast are feathers edged in white and green. The tail is black, with two long and threadlike central feathers ending in an iridescent green spiral. The female is brown. The males choose an exposed perch to perform their spectacular courtship displays, exhibiting themselves in eye-catching dances and displaying their iridescent feathers; the females will visit several different males before choosing which to mate with.

LENGTH: 6.5 inches (16 cm) plus 6 inches (31 cm) with central tail feathers

WEIGHT: male 1.5–2.5 ounces (43–65 g); female 1.5–2 ounces (38–58 g)

Yellow beak; light blue eye with black "eyebrow"; blue legs and feet

4. WESTERN PAROTIA
(PAROTIA SEFILATA)

The western parotia takes its specific name of *sefilata* (a Latin word meaning "possessing six threads") from the six threadlike feathers, three on each side, that extend behind the male's ears and end with little spatula-like tips. The male has jet-black plumage with a metallic shimmer, and with green and bronze iridescence on the breast and on the nape. The female is brown, lighter in color, and barred on the underparts. For their displays, the males clear a patch of ground and dance, spinning around with their feathers spread out to form a sort of wheel and shaking their heads to highlight these threadlike feathers and their iridescent throats.

LENGTH: 13 inches (33 cm)

WEIGHT: male 6–7 ounces (175–205 g); female 5–6.5 ounces (140–185 g)

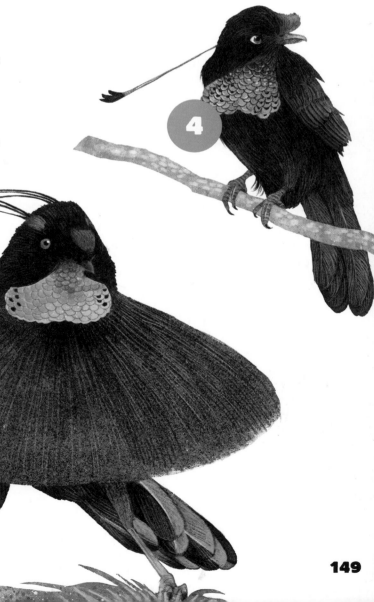

Black beak; light blue eye; grayish legs and feet

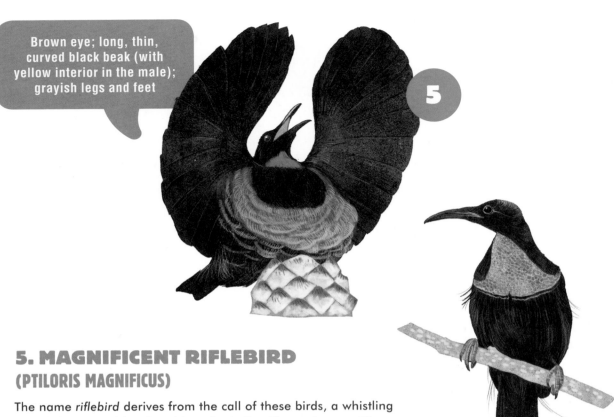

Brown eye; long, thin, curved black beak (with yellow interior in the male); grayish legs and feet

5

5. MAGNIFICENT RIFLEBIRD
(PTILORIS MAGNIFICUS)

The name *riflebird* derives from the call of these birds, a whistling sound that resembles the whine of a bullet. The male magnificent riflebird has shiny black plumage, with the chin, throat, and the upper part of the breast an iridescent light blue; the two central tail feathers are also light blue. The female has much less striking plumage, with brown and whitish bars. In courtship, the male raises its wings above its head to form a crescent and throws its head back to highlight its bright blue throat.

LENGTH: male 13 inches (34 cm); female 11 inches (28 cm)

WEIGHT: male 5–8 ounces (143–230 g); female 3.5–6.5 ounces (94–185 g)

6. WILSON'S BIRD OF PARADISE
(CICINNURUS RESPUBLICA)

The Wilson's bird of paradise is one of the smallest of the birds of paradise, but the male's plumage is among the most colorful of any bird. The head, belly, and tail are black, the back and wings (excluding the brown primaries) are red, and the breast is iridescent green. The top of the head has six areas of bare skin, which are bright blue and edged in black, while the two central tail feathers are long and curled into a distinctive spiral coil. The female is brown on the upper parts, and yellowish with dark bars on the underparts. In its displays, the male performs on a vertical perch, spinning around with the iridescent feathers of the breast spread open to form a shining semicircle.

LENGTH: 6.5 inches (16 cm) plus 2 inches (5 cm) with central tail feathers

WEIGHT: 2–2.5 ounces (52–67 g)

6

Steel-colored beak with green interior; black eye; blue legs and feet

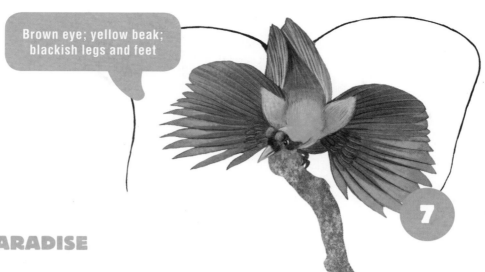

Brown eye; yellow beak; blackish legs and feet

7. RED BIRD OF PARADISE
(PARADISAEA RUBRA)

The red bird of paradise takes its name from the color of the elongated wispy feathers of the male's flanks and tail, which are bright red. The rest of the male's plumage is deep brown on the back, breast, belly, wings, and tail and yellow on the crown of the head, the neck, the upper part of the back, and the breast; the throat and cheeks are green, with black at the base of the beak and forming a mask on the face. The feathers at the base of the beak puff out to form two distinctive swellings, and the two central tail feathers look like long black ribbons. The female has a black face and throat, and the rest of its body is brown and beige. In the breeding season, several males will gather in a group of trees and display themselves by flapping their wings, puffing up their feathers, and dangling upside down.

LENGTH: male 13 inches (33 cm);
female 12 inches (30 cm)

WEIGHT: male 5.5–8 ounces (158–224 g);
female 4–7.5 ounces (115–208 g)

8. GREATER LOPHORINA
(LOPHORINA SUPERBA)

Also known as the greater superb bird of paradise, this species, too, has males and females with different coloring. The female is brown with lighter underparts with dark stripes. The male has shiny black plumage with a purple shimmer, a green-blue forehead and crown, and a crescent of the same color on the breast; the feathers of the breast, flanks, and back are elongated and form a sort of cape. In their mating displays, the males occupy a small territory in which they perform; having attracted the females' attention with loud calls, they dance in a circle while raising the feathers of the breast and flanks to form a disk around the head. Each female may visit as many as 15–20 males before making its choice.

LENGTH: male 10.2 inches (26 cm);
female 9.8 inches (25 cm)

WEIGHT: male 2–3.5 ounces (60–105 g);
female 2–3 ounces (54–85 g)

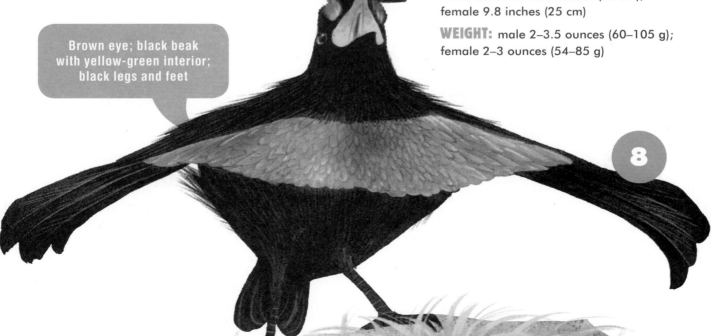

Brown eye; black beak with yellow-green interior; black legs and feet

BIRDS OF NEW GUINEA

9. VOGELKOP BOWERBIRD
(AMBLYORNIS INORNATA)

The Vogelkop bowerbird (*Vogelkop* is the name of a peninsula in western New Guinea) is an inconspicuous bird with yellowish plumage. Bowerbirds do not display the spectacular combinations of colors and plumage of the birds of paradise; instead, to attract females the male builds a bower, a kind of canopy of sticks and twigs in which the bird arranges a collection of colored objects: fruits, berries, flower petals, and pebbles, but also metal objects, pieces of glass, or fragments of plastic found in the forest. After visiting several "bowers," the female chooses the male that has displayed the richest and most colorful collection.

LENGTH: 10 inches (25 cm)

WEIGHT: 3.5–5.5 ounces (105–155 g)

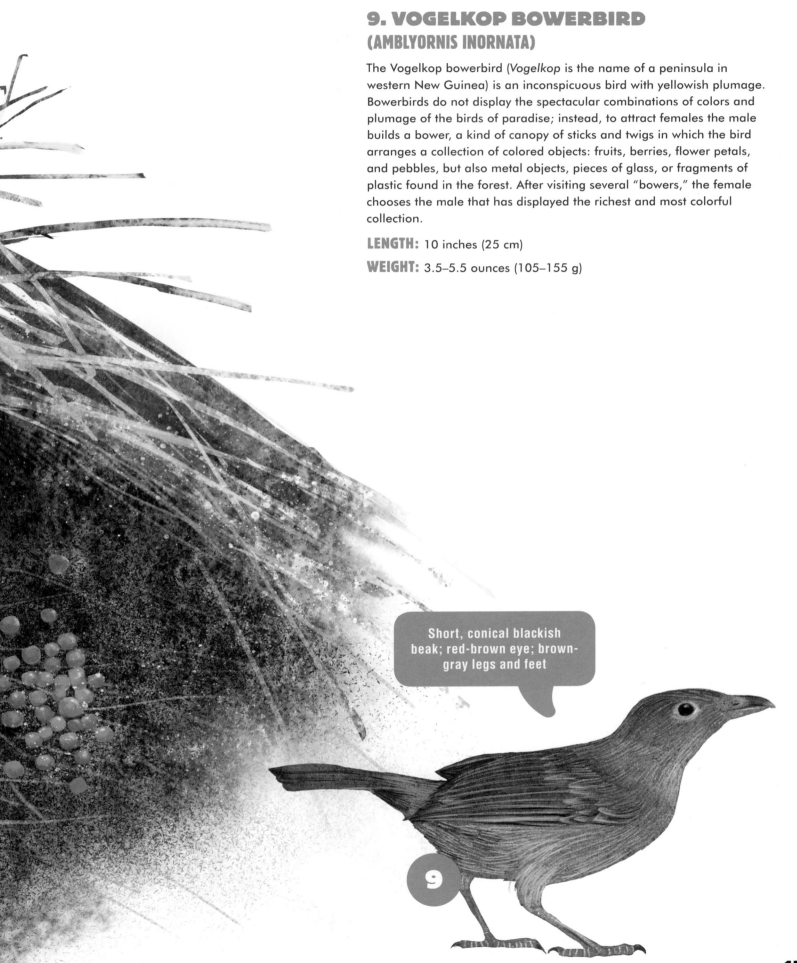

Short, conical blackish beak; red-brown eye; brown-gray legs and feet

9

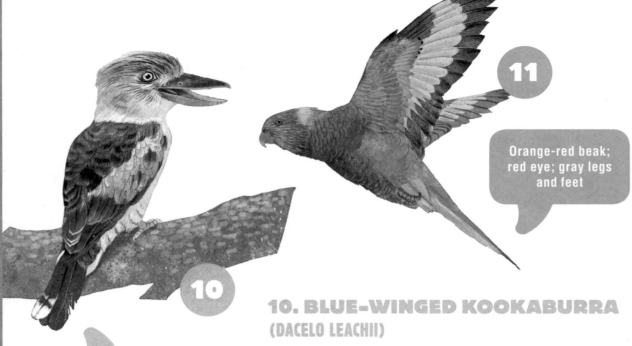

Very large beak, brown on top and reddish underneath; white eye; very short yellowish legs

Orange-red beak; red eye; gray legs and feet

10. BLUE-WINGED KOOKABURRA (DACELO LEACHII)

This kingfisher, distinguished by its very large and heavily built beak, lives in forests and thickets that may be far from water, as it feeds mainly on lizards, snakes, spiders, scorpions, and large insects, but also on small mammals and nestlings. Its plumage is cream-colored on the head and underparts, with stripes of color, varying in how dark they are—brown on the wings, and light blue on the wing coverts and rump. The tail is blue in the male and tawny with dark bars in the female, who is also slightly larger. This is a very territorial species, and the young remain with their parents for a long time, working together to defend the territory and also helping to brood and raise the chicks of the next clutch.

LENGTH: 15–16 inches (38–41 cm)

WEIGHT: 9–13 ounces (250–370 g)

11. RAINBOW LORIKEET (TRICHOGLOSSUS MOLUCCANUS)

The reference to the rainbow in the name of this small parrot is well deserved, as its plumage sports blue, yellow, red, and green feathers distributed over various parts of the body. The head is dark blue, contrasting both with a yellow-green crescent on the back of the neck and with the color of the breast, which is red with some feathers edged in blue, forming a fish-scale pattern. The back, wing coverts, and tail are green, the belly is dark blue, and the undertail is yellow barred with green. The flight feathers display a yellow band that creates a striking contrast on the underside of the wing with the red lower coverts and the black tips of the primaries. This parrot feeds mainly on nectar and flower pollen, which it supplements with seeds, fruits, shoots, and, to a lesser extent, small insects.

LENGTH: 10–12 inches (25–30 cm)

WEIGHT: 4–5 ounces (109–137 g)

12. PALM COCKATOO (PROBOSCIGER ATERRIMUS)

The palm cockatoo is closely linked to palm groves; its sturdy beak allows it to feed on their fruits, as well as many hard-shelled nuts and seeds. It is a large parrot distinguished by very dark gray plumage, black on the head, and a huge beak; it has a six-inch-long (15 cm) crest that it can raise, especially to indicate alarm or excitement. Palm cockatoos live in low-altitude humid forests. They form pairs that stay together for life, often assembling into small flocks that move around together in search of food.

LENGTH: 20–25 inches (51–64 cm)

WEIGHT: 1–2 pounds (550–1,000 g)

Very large dark gray beak; bare red skin on the cheeks; long black crest

13. WOMPOO FRUIT-DOVE
(PTILINOPUS MAGNIFICUS)

The wompoo fruit-dove has very colorful plumage, which is similar in both sexes. The back and wings are green, with a bright yellow band on the shoulders; the throat, breast, and belly are violet, the lower belly is yellow, and the head is light gray. This species lives in forests, moving short distances to areas offering greater availability of food; it feeds in the trees, eating the fruits of various plants. It also builds its nest in a tree, constructing a small but robust platform of twigs where the female lays a single egg. Both parents take care of brooding the egg and raising the chick.

LENGTH: 14–18 inches (35–45 cm)

WEIGHT: 9–17 ounces (250–470 g)

Orange-red eye; orange-red beak with yellow tip; grayish legs and feet

Orange-red beak; orange eye with fine gray eye-ring; pink-yellow legs and feet

Coral-red beak; black eye; grayish legs and feet

14. PAPUAN LORIKEET
(CHARMOSYNA PAPOU)

The Papuan lorikeet is a medium-sized parrot with a very long, thin tail. The plumage is bright red on the head, the upper part of the back, the breast, the belly, the rump, and the undertail, and green on the lower part of the back and the wings, with black on the lower part of the belly; the tail is green on top and yellow underneath. There is a blue patch on the top of the head and a black band that runs across the nape from eye to eye. Widespread throughout New Guinea, Papuan lorikeets live mainly in mountain forests; they move in pairs or in small groups in search of food, which consists mainly of fruits, buds, and flowers rich in nectar.

LENGTH: 14–17 inches (36–42 cm)

WEIGHT: 2.5–4 ounces (74–113 g)

15. COMMON PARADISE KINGFISHER
(TANYSIPTERA GALATEA)

The common paradise kingfisher is distinguished by a tail with two very long, thin central tail feathers, each widening at the end into a spoon-shaped tip. The plumage is pure white on the underparts, dark blue on the upper parts, and white on the rump, with a brilliant blue on the crown of the head and the shoulders; the tail is white, but the thinner part of the central tail feathers is blue. This kingfisher lives in humid forests, but it is not confined to living near water. It feeds on insects, snails, earthworms, and other invertebrates that it catches on the ground, diving down from a low branch where it waits immobile in ambush.

LENGTH: 13–17 inches (33–43 cm)including tail

WEIGHT: 2–2.5 ounces (55–69 g)

16. NORTHERN CASSOWARY
(CASUARIUS UNAPPENDICULATUS)

The northern cassowary is a very large and heavily built bird, and it is unable to fly. The specific name *unappendiculatus*, or "one-wattled," refers to the caruncle that hangs from its neck; in this species there is only one, while in the southern cassowary, which lives in Australia, there are three caruncles. Its plumage consists of dense, stiff black feathers; the powerful legs and feet end with three toes and the claw of the innermost toe is as long and sharp as a dagger. The female is bigger than the male, and having laid eggs in a nest built by the male, it departs, leaving the male to the task of hatching them and raising the chicks. The northern cassowary lives in low-lying forests and feeds mainly on seeds and small animals.

LENGTH: 47–59 inches (120–150 cm)

WEIGHT: male 66–82 pounds (30–37 kg); female 110–132 pounds (50–60 kg)

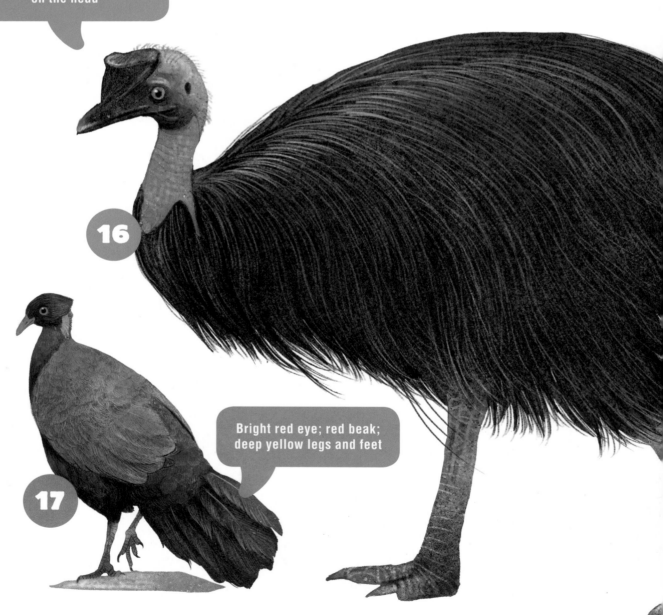

Blue head, bare of feathers; bare orange-yellow neck with a caruncle; horny helmet on the head

Bright red eye; red beak; deep yellow legs and feet

16

17

17. PHEASANT PIGEON
(OTIDIPHAPS NOBILIS)

The pheasant pigeon has the build and habits of a pheasant, but its small head resembles that of a pigeon, and it is to these distinctive features that its common name refers. The plumage is glossy, bright, and iridescent: dark blue on the head, underparts, and laterally compressed (flattened from side to side) tail, violet on the breast and rump, and violet-red on the back and wing coverts. The head has a small tuft toward the rear, and there is an iridescent blue-green spot that stands out on the nape. The pheasant pigeon is a shy and solitary bird that lives in the thick of the rain forest and feeds on seeds and fruits that it gathers on the ground.

LENGTH: 17–20 inches (42–50 cm)

WEIGHT: 1 pound (500 g)

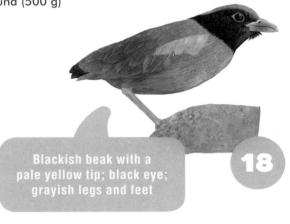

Blackish beak with a pale yellow tip; black eye; grayish legs and feet

18

Gray beak; red eye surrounded by dark gray-blue bare skin; large fluffy crest

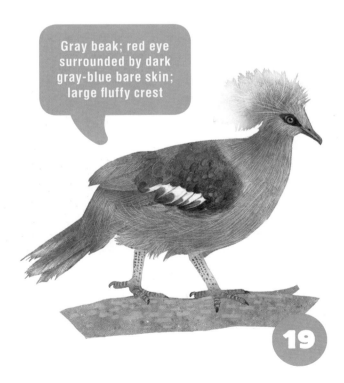

19

18. HOODED PITTA
(PITTA SORDIDA)

Pittas are relatively small birds with compact bodies and sturdy beaks. The hooded pitta has a wide distribution range, from India to New Guinea. It is distinguished by a black head with a chestnut crown, and a predominantly bright green body; the lower belly and undertail are red, the rump and tail are bright blue, and there is a sky-blue band running across the wing coverts. This bird usually leads a solitary life, coming together with a partner only for the short breeding season. It lives in the rain forest, keeping mainly to dense undergrowth and feeding primarily on earthworms and snails.

LENGTH: 6.5–7.5 inches (16–19 cm)

WEIGHT: 1.5–3 ounces (42–80 g)

19. WESTERN CROWNED PIGEON
(GOURA CRISTATA)

The western crowned pigeon is a large pigeon endemic to the western regions of Papua New Guinea, distinguished by a crest of fine feathers that look like lace. The plumage is blue-gray, with the wing coverts and a central band on the back of a violet-brown color. The tip of the tail is lighter, and there is a white spot that stands out on the brown of the wing; the crest is blue-gray and lighter than the rest of the plumage. The western crowned pigeon lives in lowland humid forests, where it feeds mainly on fallen fruits. It makes a nest out of twigs, palm stems, and leaves, and the single egg is brooded by both parents, who also work together to raise the chick.

LENGTH: 26–30 inches (66–75 cm)

WEIGHT: 4–5.5 pounds (2–2.5 kg)

Australia is the largest country in Oceania and the the sixth largest country in the world, with a surface area of almost 3 million square miles (7.8 million km²), but a population of only 25 million inhabitants; by way of comparison, California is 18 times smaller but has almost 40 million inhabitants. Only 6 percent of the land area of Australia is cultivated, and most of the population is concentrated in the major cities and on the southeastern coast, where the climate is more favorable. The rest of the land is mostly arid, with true desert areas alongside steppes, thorny scrub, and forests of drought-resistant plants such as eucalyptus and acacia. Only in the northeastern coastal corridor are there rain forests with dense undergrowth and mangrove forests in the coastal marshes.

Australia is famous, above all, for its unique terrestrial fauna, composed of marsupials such as koalas and kangaroos, and the only two mammals in the world that lay eggs (the platypus and the echidna). As for birds, 830 different species have been counted—

rising to almost 900 when birds on the small surrounding islands, which are in any case part of the Australian nation, are taken into account. The list ranges from seabirds such as the Australian pelican to species typical of marshes and inland waters such as the black swan, and to those at home in the bush, on arid steppes, and in forests. Australia has 56 species of parrot in particular, including 14 species of cockatoo (in the drawing, the MAJOR MITCHELL'S COCKATOO). Other typical species are the little penguin, the smallest of the penguin family, which breeds on the southern coasts; the Australian brush-turkey, which builds a large mound of earth and dead leaves where it lays its eggs, which are "brooded" by the heat of the sun and the fermenting leaves; and the superb lyrebird, capable of imitating not only the songs of other birds but almost any kind of sound, from the barking of a dog to a car horn or the ringtone of a cell phone.

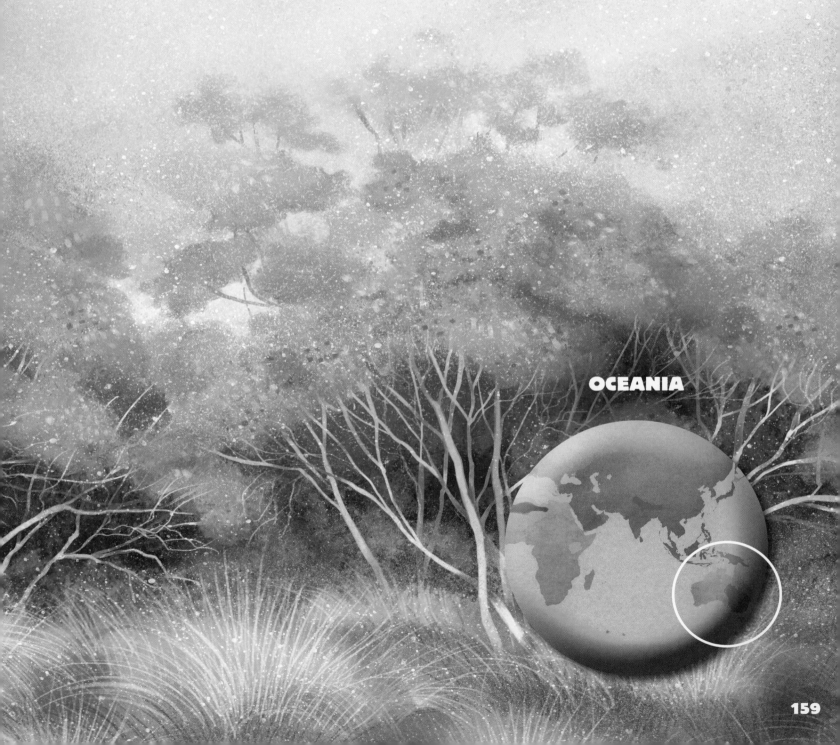

OCEANIA

Red beak with a white band; red eye; black legs with webbed feet

1. BLACK SWAN
(CYGNUS ATRATUS)

The black swan is a large aquatic bird distinguished by its all-black plumage, apart from the primaries, which are white but can only be seen in flight or when it stretches out its wings. The neck is very long and thin, and the wingspan can reach 6.5 feet (2 m). The black swan lives on marshes, lakes, and brackish lagoons, where it finds plenty of food consisting of grasses and other aquatic vegetation. It generally forms pairs that stay together for life; the nest is a mound of reeds and marsh vegetation, usually built in shallow water or on islets, which can be up to 5 feet (1.5 m) in diameter. Both members of the pair brood the eggs and take care of the chicks.

LENGTH: 43–55 inches (110–140 cm)

WEIGHT: male 8.5–19 pounds (4–9 kg); female 8–16 pounds (3.5–7 kg)

Red beak, frontal shield, eye, legs, and feet

2. AUSTRALASIAN SWAMPHEN
(PORPHYRIO MELANOTUS)

The Australasian swamphen is a bird with a solidly built body and long, strong legs and feet; long toes enable it to move around easily by grasping the reeds. The plumage is black on the head, back, wings, and tail, and violet-blue on the underparts; the undertail is white. It has a sturdy triangular beak topped by a frontal shield, which is red like the legs. Swamphens live in both freshwater and saltwater marshes with abundant vegetation, surrounded by reeds. They feed mainly on plant materials (the leaves, buds, roots, flowers, and seeds of aquatic plants) which they supplement with mollusks, insects, and tadpoles.

LENGTH: 15–20 inches (38–50 cm)

WEIGHT: male 2.5 pounds (1.09 kg); female 2 pounds (880 g)

3. LITTLE PENGUIN OR BLUE PENGUIN
(EUDYPTULA MINOR)

The little penguin, or blue penguin, is a small penguin that lives on the coasts and on the coastal islets off southern Australia, where it nests in colonies in holes among the rocks or in tunnels dug into the sand dunes or at the base of bushes. The upper parts are blue-gray, which may be lighter or darker in tone, and the underparts are white; the rear edge of the wing is white. These penguins leave their colonies at dawn to feed in the sea, hunting small fish and crustaceans, and return to shore, in groups, at sunset.

LENGTH: 12.5–13.5 inches (32–34 cm)

WEIGHT: 1–4.5 pounds (500–2,100 g)

Gray-black beak; light gray or hazel eye; pink legs with webbed feet, black on the underside

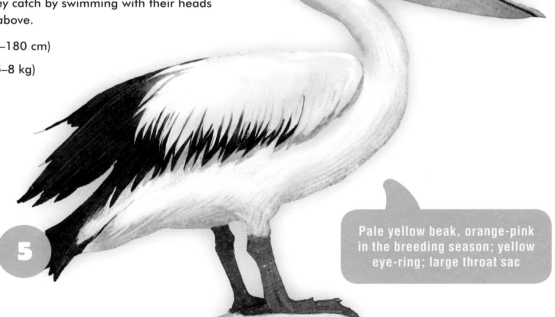

4. RED-TAILED TROPICBIRD
(PHAETHON RUBRICAUDA)

The red-tailed tropicbird is a sturdy-looking seabird with almost completely white plumage, and with two very long, thin red central tail feathers. It has a black mask running from the base of the beak across the eyes to the ear coverts. The red-tailed tropicbird is an agile and fast flier, but moves very laboriously when on the ground due to its short legs. It feeds on fish and shellfish that it catches in the water by diving from above, as well as flying fish, which it catches midflight. These birds nest in sparse colonies on rocky slopes and beaches, laying a single egg in a dip in the ground and brooding it for six weeks.

LENGTH: 35–42 inches (90–107 cm)
plus 18–22 inches (45–56 cm) of tail

WEIGHT: 1.5 pounds (700 g)

Red beak, black near the nostrils; dark brown eye; pale violet legs with black feet

5. AUSTRALIAN PELICAN
(PELECANUS CONSPICILLATUS)

Pelicans are large waterbirds distinguished by a sizable sac of bare skin under the beak, in which they trap fish when they feed by dipping their heads underwater. The Australian pelican has black and white plumage: The tail, primary flight feathers, back, and wing coverts are all black, except for a central white area. The beak is up to 20 inches (50 cm) long, the longest of any bird, and pale yellow except in the breeding season, when it turns orange-pink; the throat sac also takes on a more intense color. Despite its weight the Australian pelican is an excellent flier, with a wingspan of up to eight feet (2.5 m). They eat even large fish, which they catch by swimming with their heads immersed or by diving from above.

LENGTH: 63–71 inches (160–180 cm)

WEIGHT: 10–18 pounds (4.5–8 kg)

Pale yellow beak, orange-pink in the breeding season; yellow eye-ring; large throat sac

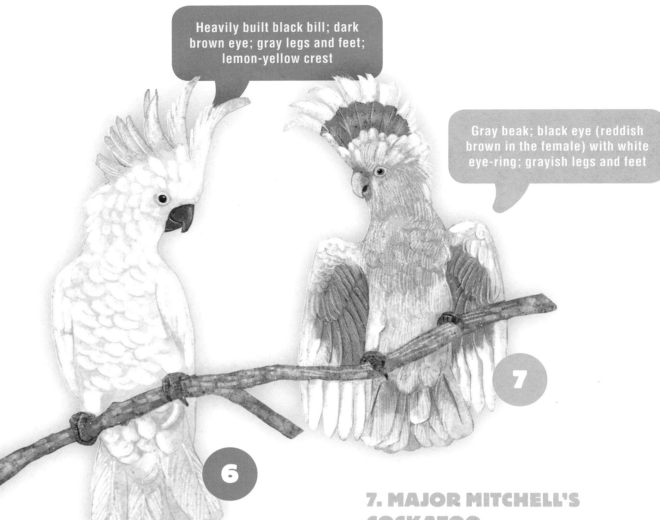

Heavily built black bill; dark brown eye; gray legs and feet; lemon-yellow crest

Gray beak; black eye (reddish brown in the female) with white eye-ring; grayish legs and feet

6. SULPHUR-CRESTED COCKATOO
(CACATUA GALERITA)

The sulphur-crested cockatoo is a sizable parrot with white plumage, with a large lemon-yellow crest that it can raise or lower at will; the wings and tail can also have shades of lemon yellow. The male and female are similar in appearance. This parrot prefers to spend its time in the trees, but often forages for food on the ground as well; it eats mainly fruits and seeds, including those with hard woody shells, and sometimes raids corn and wheat fields to eat the grains. It has a very strong, large beak with which it can crack even the hardest shells, and which it has to keep in constant use, stripping the bark from branches and then tearing it to shreds, or gnawing on other hard objects.

LENGTH: 18–22 inches (45–55 cm)
WEIGHT: 1.8–2.1 pounds (815–975 g)

7. MAJOR MITCHELL'S COCKATOO
(CACATUA LEADBEATERI)

The Major Mitchell's cockatoo is a medium-sized parrot with white plumage, with shades of pink on the wings and back and a more intense pink color on the head, neck, and breast. The head is adorned with a large crest, which the bird can raise to reveal a striking red and yellow band when it opens. Both sexes are similar in appearance, but the female has a reddish-brown eye while in the male it is black. This cockatoo lives in the central semidesert areas of Australia; it feeds on seeds, fruits, tubers, buds, and flowers, but also on insects and their larvae.

LENGTH: 13–16 inches (33–40 cm)
WEIGHT: 13–17 ounces (360–480 g)

8. GALAH
(EOLOPHUS ROSEICAPILLA)

The galah, also known as the pink and gray, is a medium-sized cockatoo with gray and pink plumage; the back is light gray, like the wing coverts, while the flight feathers and tail feathers are dark gray; the head and the underparts are deep pink. The head is adorned with a short, wide, light pink crest that the bird can raise and lower. The galah is one of the most common Australian parrots, widespread throughout almost the entire continent as long as there are trees to nest in. It can also be found in parks and gardens in many cities. These cockatoos feed mainly on seeds, including sunflower seeds and cereal crops, which is why they are often hunted by farmers.

LENGTH: 13.8–14.2 inches (35–36 cm)

WEIGHT: male 12 ounces (345 g); female 11 ounces (311 g)

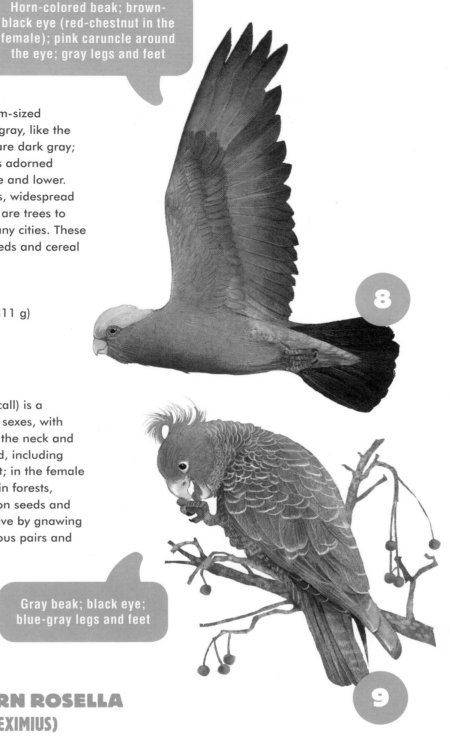

Horn-colored beak; brown-black eye (red-chestnut in the female); pink caruncle around the eye; gray legs and feet

9. GANG-GANG COCKATOO
(CALLOCEPHALON FIMBRIATUM)

The gang-gang cockatoo (the name refers to its typical call) is a medium-sized parrot. The plumage is blue-gray in both sexes, with the edges of the feathers lighter in color—especially on the neck and wings—giving it a distinctive scaly look. The male's head, including the cheeks and throat, is scarlet red, with a fringed crest; in the female the head and crest are gray. This parrot lives in mountain forests, descending to lower altitudes in winter. It feeds mainly on seeds and fruits, but like many parrots it always keeps its beak active by gnawing on hard objects. Gang-gang cockatoos form monogamous pairs and make their nest in the hollow of a tree.

LENGTH: 13–15 inches (32–37 cm)

WEIGHT: 10 ounces (280 g)

Gray beak; black eye; blue-gray legs and feet

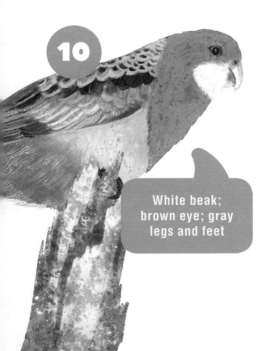

White beak; brown eye; gray legs and feet

10. EASTERN ROSELLA
(PLATYCERCUS EXIMIUS)

The eastern rosella is one of several species of rosella living in Australia and is distinguished by its white cheeks, which stand out against the bright red of the head, neck, and upper part of the breast. The rest of the underparts are yellow, fading into the green of the lower belly. The feathers on the back are black, generously edged with yellow so that it has a fish-scale look. The rump is green, the undertail is red, the wings are blue, and the long, narrow tail is green with blue outer tail feathers. This parrot is widespread in the southeastern part of Australia, found in eucalyptus groves, parks, and gardens, where it feeds mainly on seeds and shoots.

LENGTH: 12 inches (30 cm)

WEIGHT: 3–4 ounces (90–120 g)

11. SUPERB LYREBIRD
(MENURA NOVAEHOLLANDIAE)

The superb lyrebird takes its name from the distinctive shape of the male's tail, which is formed by 16 tail feathers: Twelve are long, white, and threadlike; the two central ones are long, thin, and gray; and the two outermost ones—whitish, with brown bands and black tips—are curved into an S, creating a shape reminiscent of the musical instrument called a lyre. The plumage on the body is reddish brown on the upper parts and grayish brown on the underparts. In courtship, the male bends down over its legs and tips its tail forward so that it completely covers the body like a fan, and shakes it while uttering a rich variety of sounds, including imitations.

LENGTH: male 33–41 inches (85–103 cm); female 30–31 inches (76–80 cm)

WEIGHT: male 2.5 pounds (1.09 kg); female 2 pounds (890 g)

Sharp black beak; brown eye; very sturdy gray-brown legs and feet

Thin, pointed black beak; black eye; black legs and feet

12. SUPERB FAIRY-WREN
(MALURUS CYANEUS)

The superb fairy-wren is a small songbird with a long tail, often held vertically upright. The male has very eye-catching plumage, with bright blue on the forehead and the top of the head, cheeks, and upper part of the back, a black mask around the eyes, black on the nape and back, blue-black on the throat and breast, grayish underparts, brown wings, and a blue tail. The female is gray-brown with lighter-colored underparts. This is a very active bird, widespread from forests with dense undergrowth to gardens. It feeds mainly on insects, supplementing its diet with seeds.

LENGTH: 6–8 inches (15–20 cm)

WEIGHT: 0.3–0.5 ounce (9–14 g)

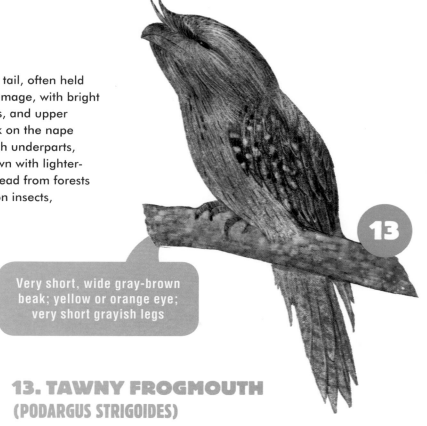

Very short, wide gray-brown beak; yellow or orange eye; very short grayish legs

13. TAWNY FROGMOUTH
(PODARGUS STRIGOIDES)

Frogmouths are nocturnal birds with extremely well-camouflaged plumage and a large mouth that looks like a frog's—hence their English name. The tawny frogmouth has light chestnut-brown or grayish plumage, paler on the underparts, with spots and fine brown and blackish stripes. By day, standing motionless with its elongated body and its eyes closed, the frogmouth looks like nothing so much as a dry branch; it becomes active at nightfall, hunting moths and other large insects, spiders, scorpions, and snails.

LENGTH: 13–22 inches (34–55 cm)

WEIGHT: 7–24 ounces (200–680 g)

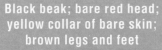

Black beak; bare red head; yellow collar of bare skin; brown legs and feet

14. AUSTRALIAN BRUSH-TURKEY
(ALECTURA LATHAMI)

The Australian brush-turkey bears no relationship to actual turkeys, but there is a similarity in the body and the large, fan-shaped tail. The plumage is black-brown, with the underparts splashed with white and a red head and neck, bare of feathers. At the base of the neck there is a ring of bare yellow skin, larger and flaccid in the male. Pairs stay together for life and build large mounds of earth and dead leaves, where the female lays eggs. Heat builds up inside this heap, due to the effect of the sun and the rotting leaves, and this keeps the eggs warm; the male checks the temperature with its beak and adds or removes material to keep it consistent until the eggs hatch.

LENGTH: 24–28 inches (60–70 cm)

WEIGHT: male 4.5–6.5 pounds (2–3 kg); female 4.5–5.5 pounds (2–2.5 kg)

INDEX

IF YOU ENJOYED THIS BOOK, CHECK OUT BUGS OF THE WORLD!

BY FRANCESCO TOMASINELLI
ILLUSTRATIONS BY YUMENOKAORI

BUGS OF THE WORLD

250 CREEPY CRAWLY CREATURES FROM AROUND PLANET EARTH

Cesare della Pietà is an ardent ornithologist and photographer, and a graduate in classical literature. After many years of teaching, since 1985 Cesare della Pietà has devoted himself to science communication in relation to the natural world as editor-in-chief and scientific director of the monthly magazines *Aqua*, *Silva*, and *Airone*, where he has worked for 18 years. He is a member of several nature conservation associations, and he is a regular speaker at conferences and courses on ornithology and bird-watching. His many books include *Il giardino con le ali: nidi, cibo e acqua per attirare gli uccelli attorno a casa* ("Wings in Your Garden: Nests, Food and Water to Attract the Birds Around Your Home"), *Quelli della notte: gufi e civette* ("Night Birds: Long-Eared Owls and Little Owls"), *Animali della montagna* ("Mountain Animals"), and *Uccelli: morfologia, movimento, habitat* ("Birds: Morphology, Movement, Habitat").

Shishi Nguyen is a Vietnamese artist, illustrator, and designer who specializes in depicting nature in all its forms. She has illustrated various children's books and published her expressive and sophisticated work in major magazines all over the world. She is considered one of the best nature artists in Southeast Asia, has taken part in numerous exhibitions devoted to nature illustration, and has won several awards for her work.

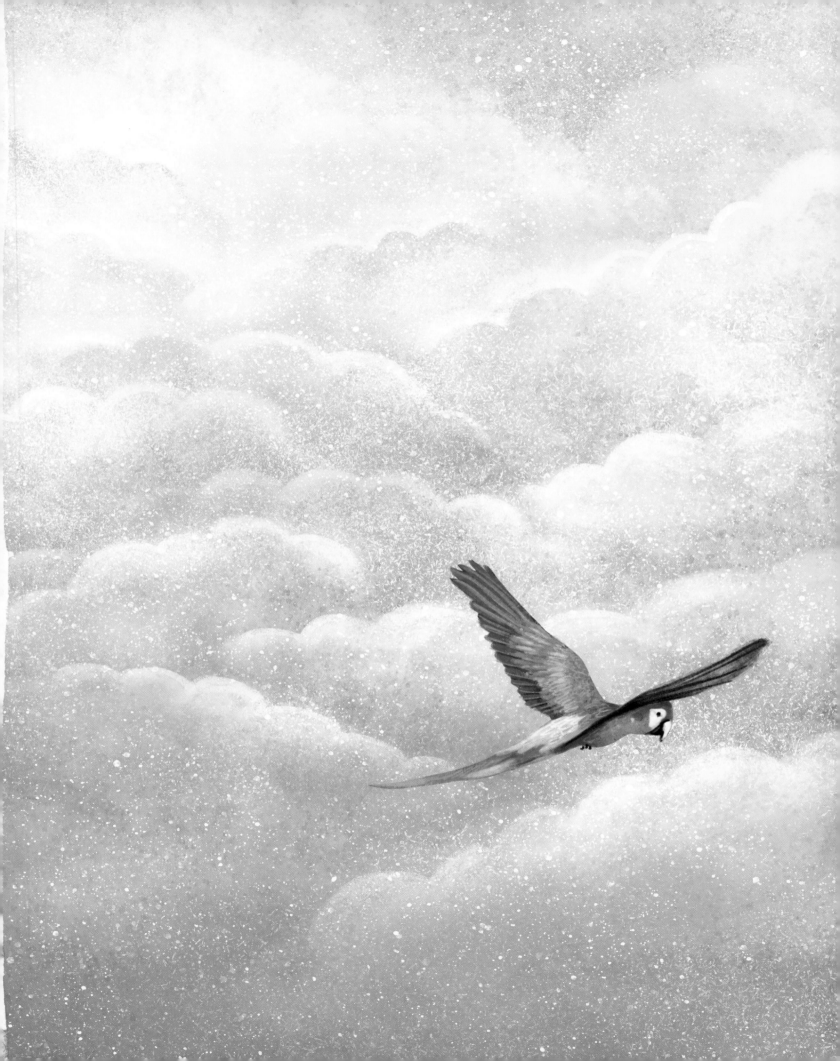

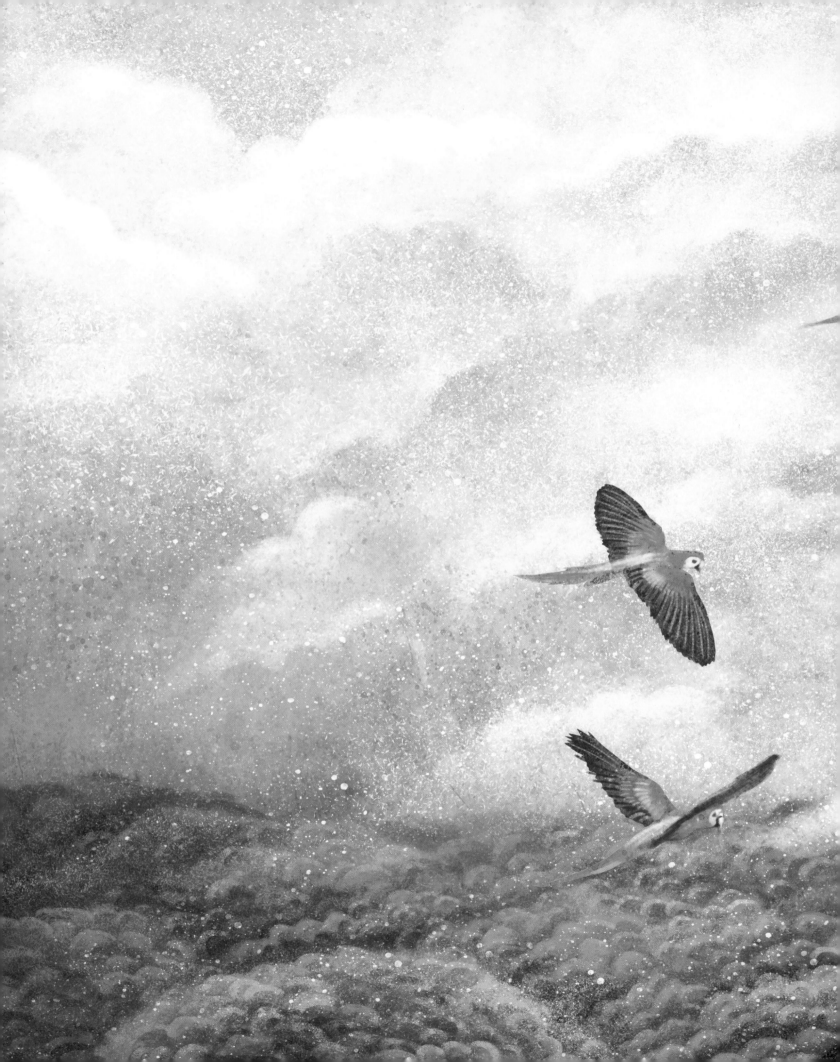